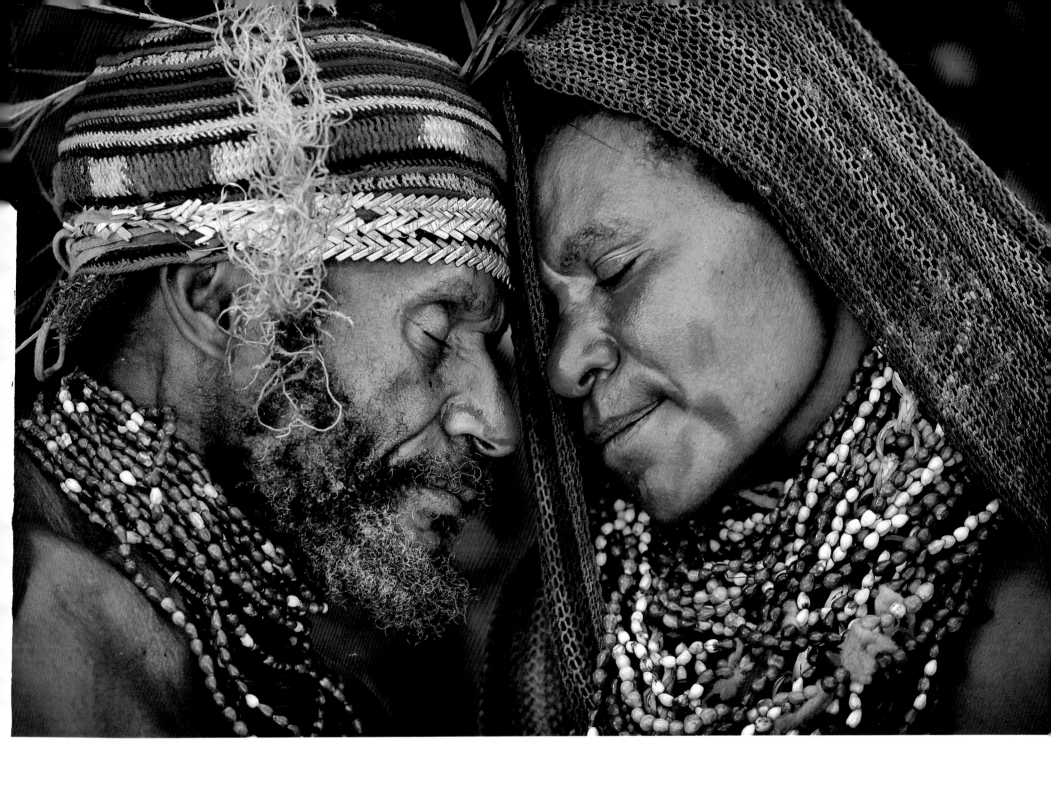

Journey Four

A collection of images from Travel Photographer of the Year

Travel Photographer of the Year Ltd — The Photographers' Press

Publisher/Editor/Author — Chris Coe
Editor/Author — Karen Coe
Editor - Emma Thomson
Designer — Terry Steeley

First published by Travel Photographer of the Year Ltd
20 Yew Tree Courtyard, Earl Soham, Suffolk IP13 7SG, UK
www.tpoty.com

First edition published in June 2012
ISBN 13: 978-0-9549396-4-9

Reproduced, printed and bound by Connekt Colour, Berkhamstead, HP4 1EH, UK
Designed by Iridius Limited, Banbury, Oxfordshire OX16 9PA, UK

Front cover photograph: Wapusk National Park, Manitoba, Canada.
Daisy Gilardini, Switzerland

Frontispiece photograph: Courtship ritual, Central Highlands, Papua
New Guinea. Timothy Allen, UK

Back cover photographs (clockwise from top left):

Northern Lights over Hudson Bay, Canada. Thomas Kokta, Germany

London, UK. Malgorzata Pioro, Poland

Festival of Holi, Mathura, Uttar Pradesh, India. Poras Chaudhary, India

Pen Hadow on Catlin Arctic Survey, Cornwallis Island, Canada. Martin Hartley, UK

Mass ordination of 34,000 monks, Pathum Thani, Bangkok, Thailand. Luke Duggleby, UK

Playful beluga whale, White Sea, Northern Russia. Franco Banfi, Switzerland

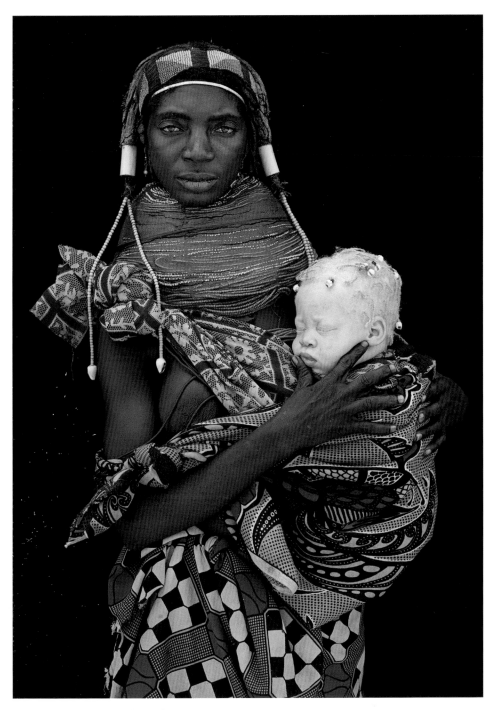

Mwila woman and albino baby, Chibia, Angola. Eric Lafforgue, France

CONTENTS

This fourth collection of images from the international Travel Photographer of the Year awards takes us on another fascinating journey around the world; this time through the winning images of the 2010 and 2011 awards. As always, this latest adventure transports us in many different directions around the globe, capturing every aspect of life, landscape and more than a few wild moments along the way.

Together with the previous portfolios, Journey One, Two and Three, this new collection depicts our world through the eyes of talented, inspiring photographers from across the continents. As Travel Photographer of the Year moves into its tenth year, these journeys have borne witness not only to a rapidly changing world, but also to the most radical – and probably the most rapid – changes the world of photography has seen in its 150-year history. Not only has film been widely superseded by digital, but now the worlds of still and moving images have started to converge into a single camera. Exciting times, but ones which will present their own challenges!

We are now firmly entrenched in a digital age. One where images are not only captured, but also shared without geographical boundaries via the internet, websites and social media in considerably less time that it used to take to develop a roll of film, let alone print it. While this visibility and accessibility has its advantages, it is not always good for photography: new generations are increasingly viewing images as both transient and disposable. It is in moments like this that the printed image takes up the mantle and shows what truly great photography is all about.

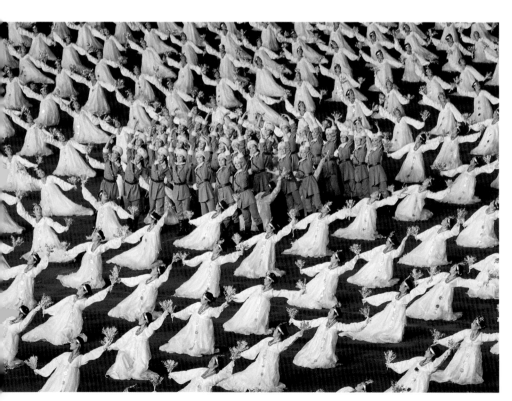

Arirang Mass Games, Pyongyang, North Korea. Christian Aslund, Sweden

As you turn these pages, dive into the images. Not every picture has instant impact and so often the intrigue is in the less obvious detail. Take a moment to explore them, experience them, feel them. They will transport you not only to foreign lands, but also into the enchanting world of the still image and of moments frozen in time. These were the defining moments which the photographers chose to share with us all. The others,

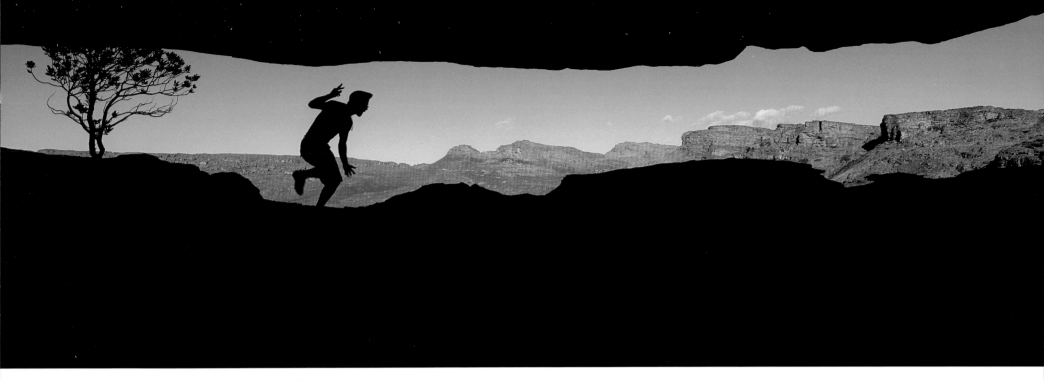

Cederberg Mountains, Western Cape, South Africa. Jamie Maddison, UK

immediately before and after, are now lost forever; that's the photographer's craft with the camera, choosing when to press the shutter, to draw you in to the photograph. Hopefully, these captured moments will spark your imagination and inspire you.

Every time we start to select pictures for a 'Journey' portfolio book we cannot help but be inspired as the images come together to form a collection. In laying them out on the page, they move from the transient to the tangible. Each image stays with you until you choose to turn the page. While it is there before you it has a richness, permanence and tactile quality which eludes the on-screen image — perhaps even imprinting itself on your memory. Long live the printed photograph!

This portfolio includes places Travel Photographer of the Year has never visited before, from the painted architecture of Burkina Faso and the mesmerizing beauty of dawn at Venezuela's Angel Falls, to the cultures of West Africa's Cameroon and the fringes of Eastern Europe.

So sit back... turning these pages will transport you to amazing places and introduce you to fascinating people. Let us tempt you to dive with beluga whales in Russia's White Sea, battle with the elements in sub-zero landscapes, or bask in the tropical climes of Papua New Guinea. Come, meet the peoples of the world. Marvel at our amazing wild planet and travel for the sheer joy of the journey.

What are you waiting for? The world awaits...

TRAVEL PHOTOGRAPHER OF THE YEAR 2011

So often photography leaves little to the imagination and images are quickly dismissed if they don't create an immediate impact. Louis Montrose's winning photographs have just enough punch to engage the viewer, but are also laced with intriguing detail and texture which makes you return to them again and again, each time finding something new. His two portfolios contrast dramatically in style and feel while maintaining this common connection. Here the devil is in the detail!

Sponsors of this award:

Adobe, Lexar, Plastic Sandwich, TPOTY

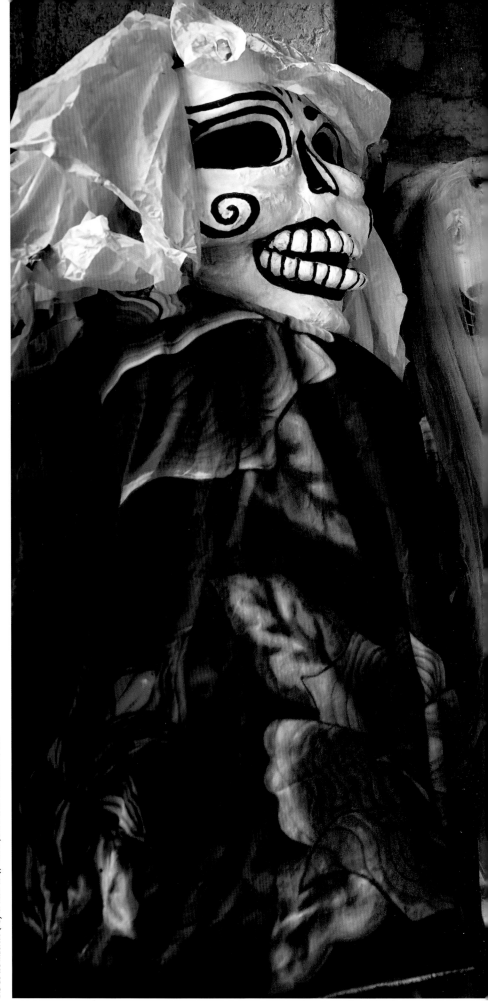

Día de los Muertos (Day of the Dead), Oaxaca, Mexico. Louis Montrose, USA

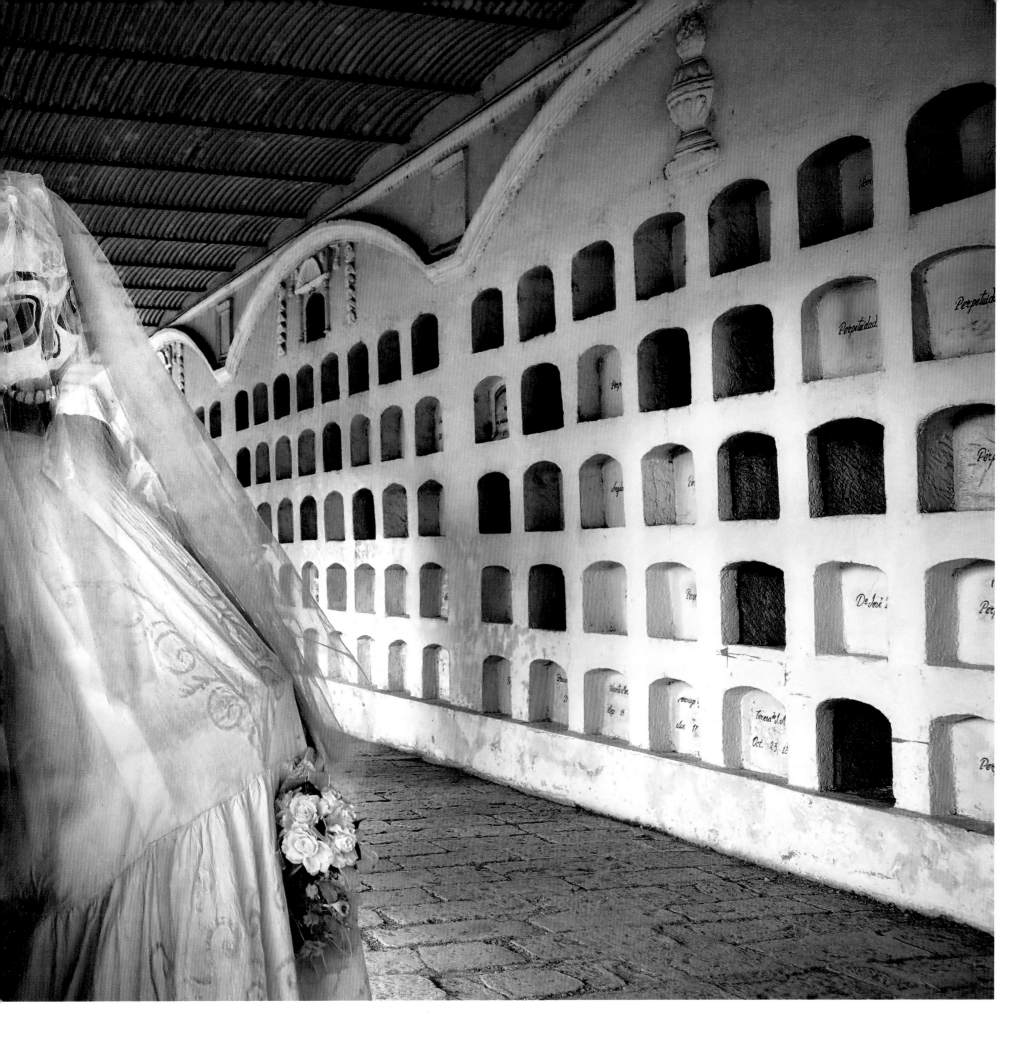

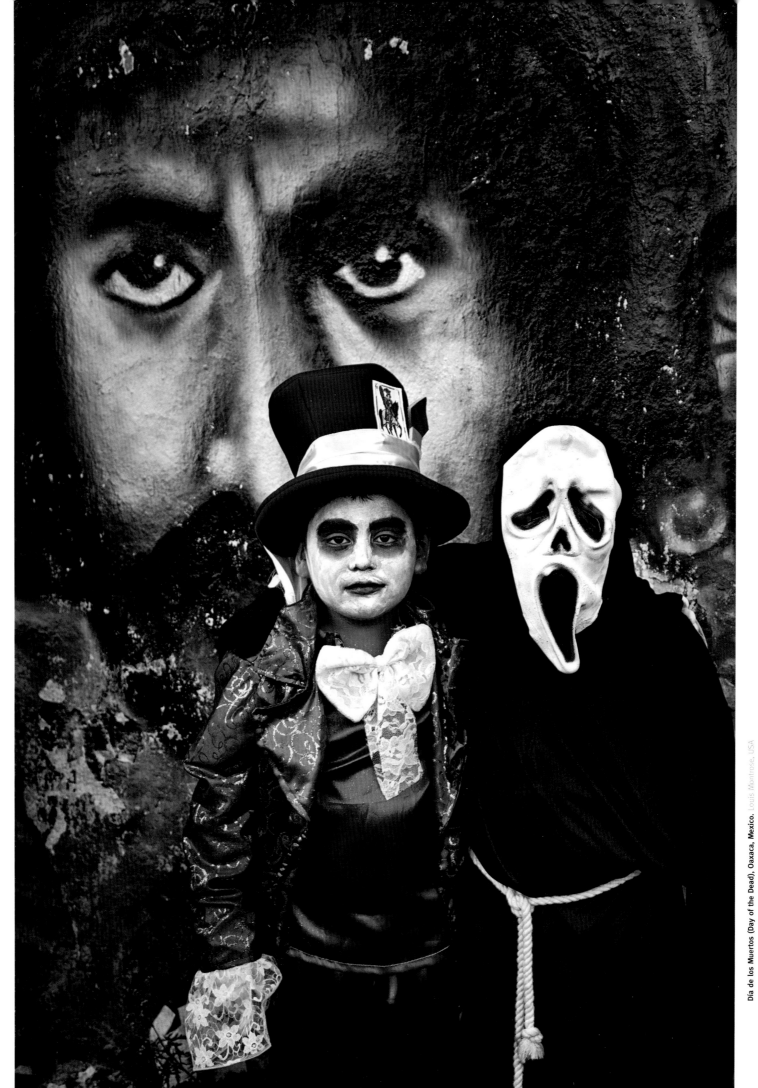

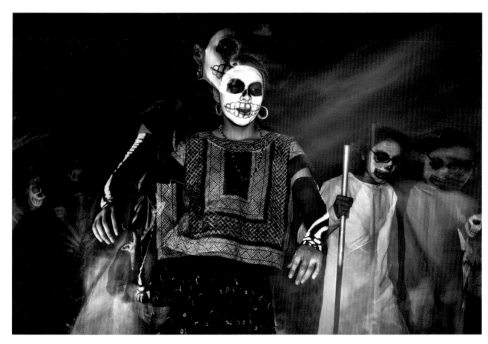

Día de los Muertos (Day of the Dead), Oaxaca, Mexico. Louis Montrose, USA

TRAVEL PHOTOGRAPHER OF THE YEAR 2011

Louis Montrose USA
Winner

Louis Montrose was born in London, grew up in New York City, and has lived in the San Diego area of southern California for many years. His engagement as a visual artist springs from a passion for creating and viewing images that began in childhood. During a successful academic career in the humanities, he also wrote and taught about the history and cultural power of images.

Formerly an Elizabethan scholar and professor at The University of California, he now pursues his calling as a photographer full time. He works in a number of photographic genres, including cityscape, environmental portrait, travel, and night photography. As someone with a compelling interest in the power of photographs to capture the vibrancy and diversity of human cultures, he values colour as an essential expressive and communicative medium. At the same time, he remains deeply drawn to the formal power and tonal richness of black and white, and to the challenge of creating strong black and white images through digital capture and digital inkjet printing. His work has been exhibited in shows in London, Madrid, Copenhagen, and Buenos Aires as well as in California, Colorado, and Ohio; and has been published in LensWork, Black & White, COLOR, and other fine art photography publications.

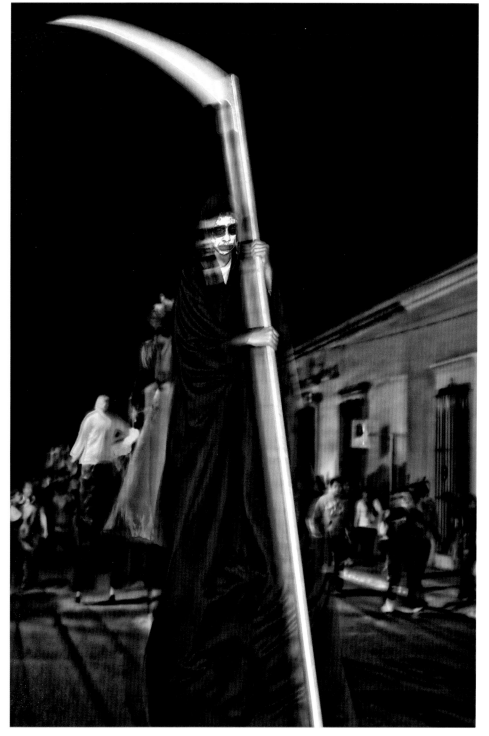

Día de los Muertos (Day of the Dead), Oaxaca, Mexico. Louis Montrose, USA

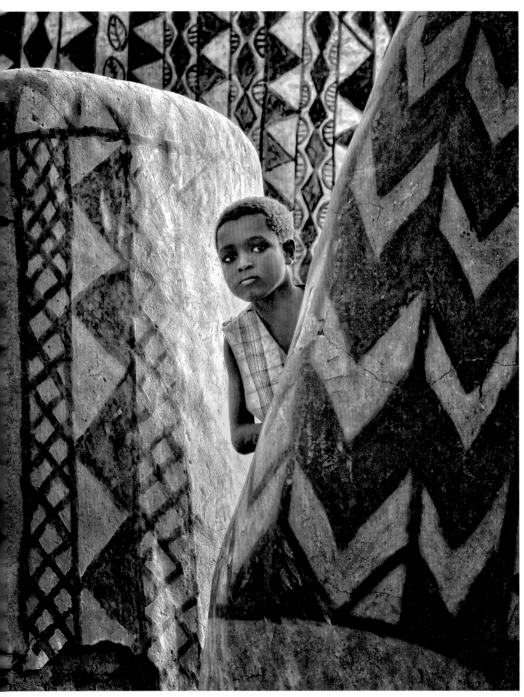

The painted village of Tiebele, Burkina Faso. Louis Montrose, USA

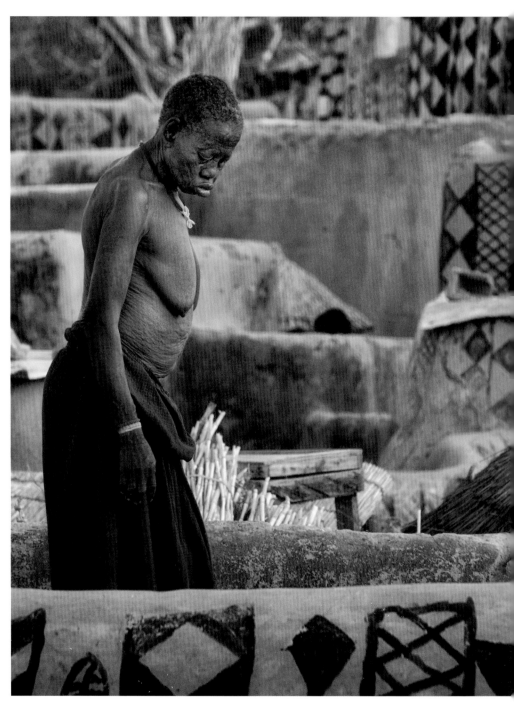

The painted village of Tiebele, Burkina Faso. Louis Montrose, USA

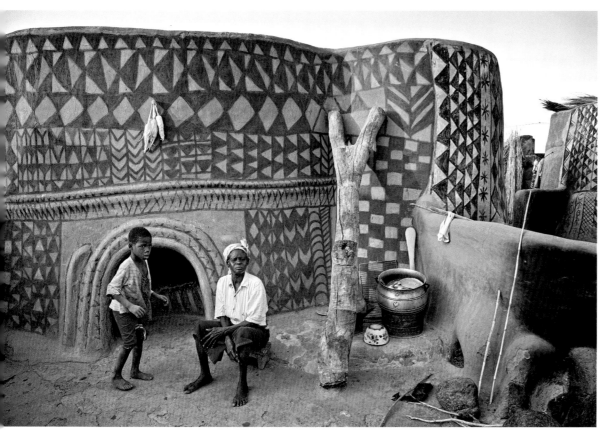

The painted village of Tiebele, Burkina Faso. Louis Montrose, USA

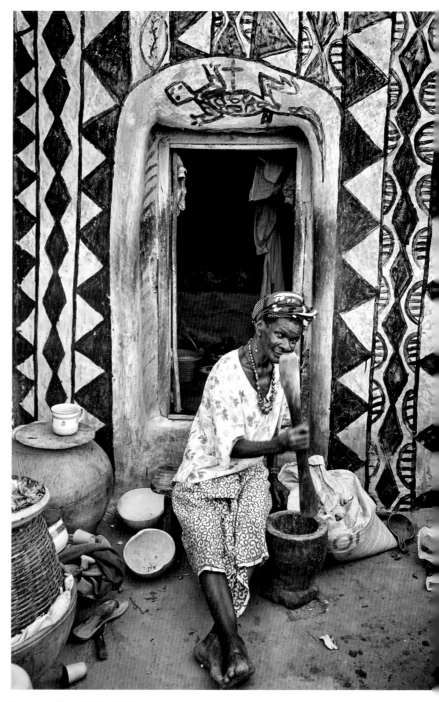

The painted village of Tiebele, Burkina Faso. Louis Montrose, USA

YOUNG TRAVEL PHOTOGRAPHER OF THE YEAR 2011

Green: The skill of telling a rounded story using images is often neglected by photographers, so it is especially heartening and unusual to see it in one so young. Seventeen-year-old Arne Hansen has taken the simple colour interpretation of the theme and cleverly combined it with an environmental slant, but he has also constructed a narrative. This is what a portfolio is all about and it is great to see such thought and craft go into creating a set of well-considered themed images.

Sponsors of this award:

Adobe, Lexar, Plastic Sandwich, TPOTY, Young Photographers' Alliance

Garzoni Castle Gardens, Collodi, Italy. Arne Hansen, Germany

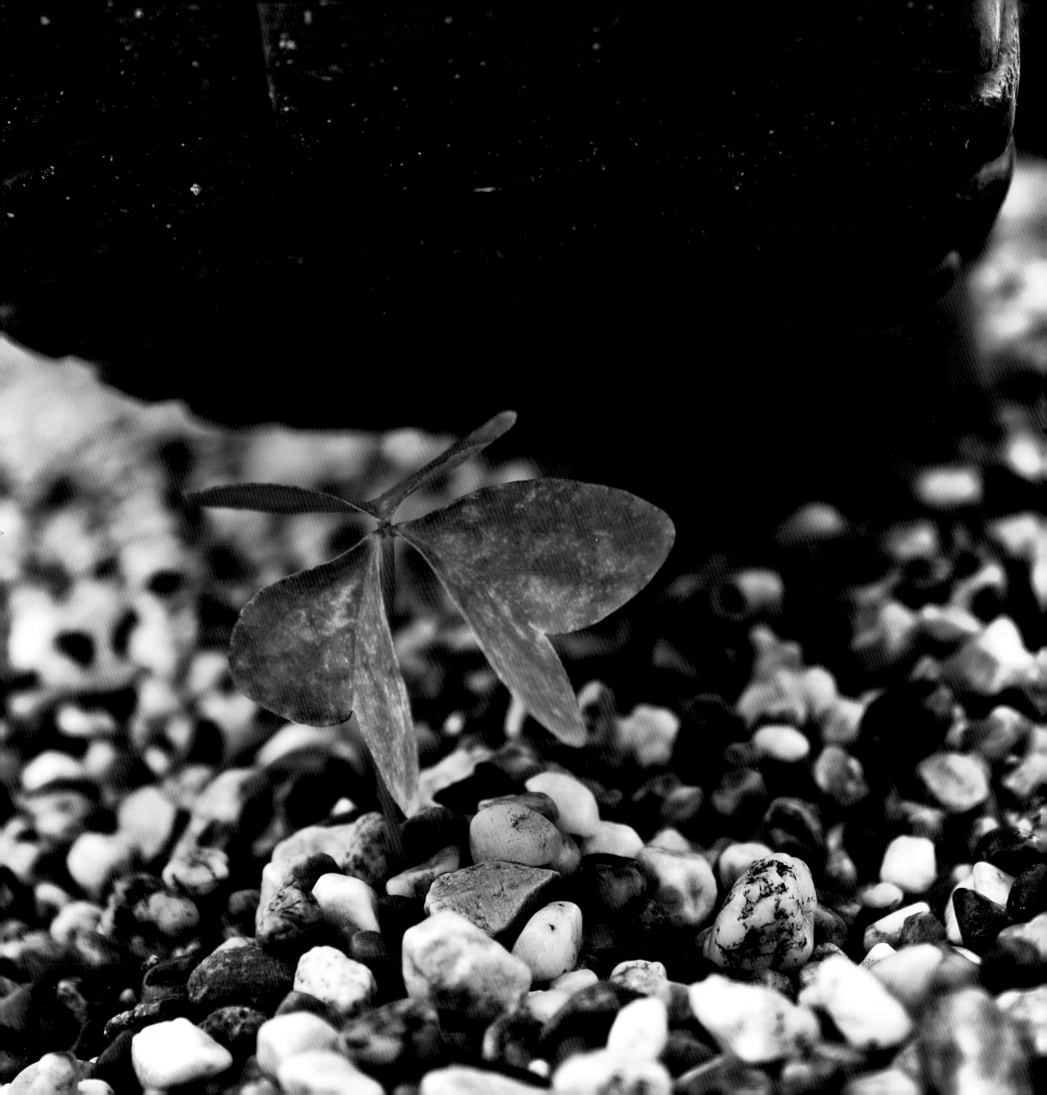

YOUNG TRAVEL PHOTOGRAPHER OF THE YEAR 2011

Arne Hansen (age 17) Germany
Winner

The first time Arne was really confronted with photography was a few years ago when he got Adobe Photoshop. He was fascinated with the idea of creating artworks with a photorealistic look. But in order to get a good result in Photoshop you first need to take a good picture, so he started learning. In 2010 he went to the USA as an exchange student and took a photography class - and at the end of year he won the All-County High School Art Exhibition. For Christmas his host-parents gave him an SLR-camera, which was the beginning of his love of photography.

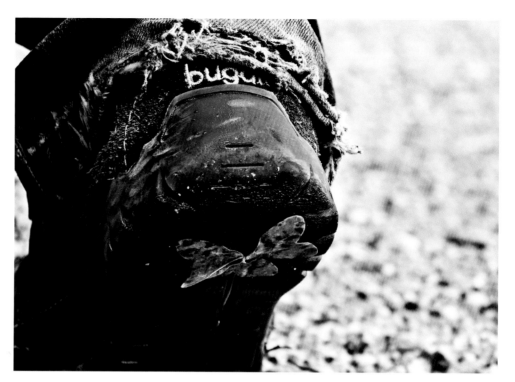

Garzoni Castle Gardens, Collodi, Italy. Arne Hansen, Germany

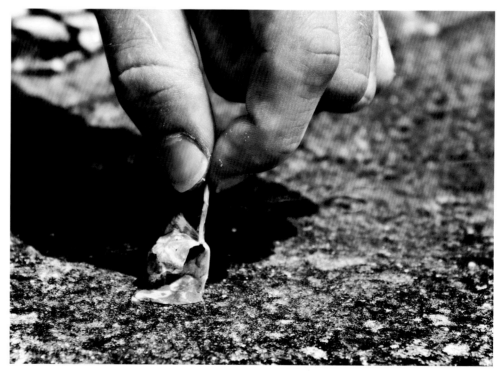

Garzoni Castle Gardens, Collodi, Italy. Arne Hansen, Germany

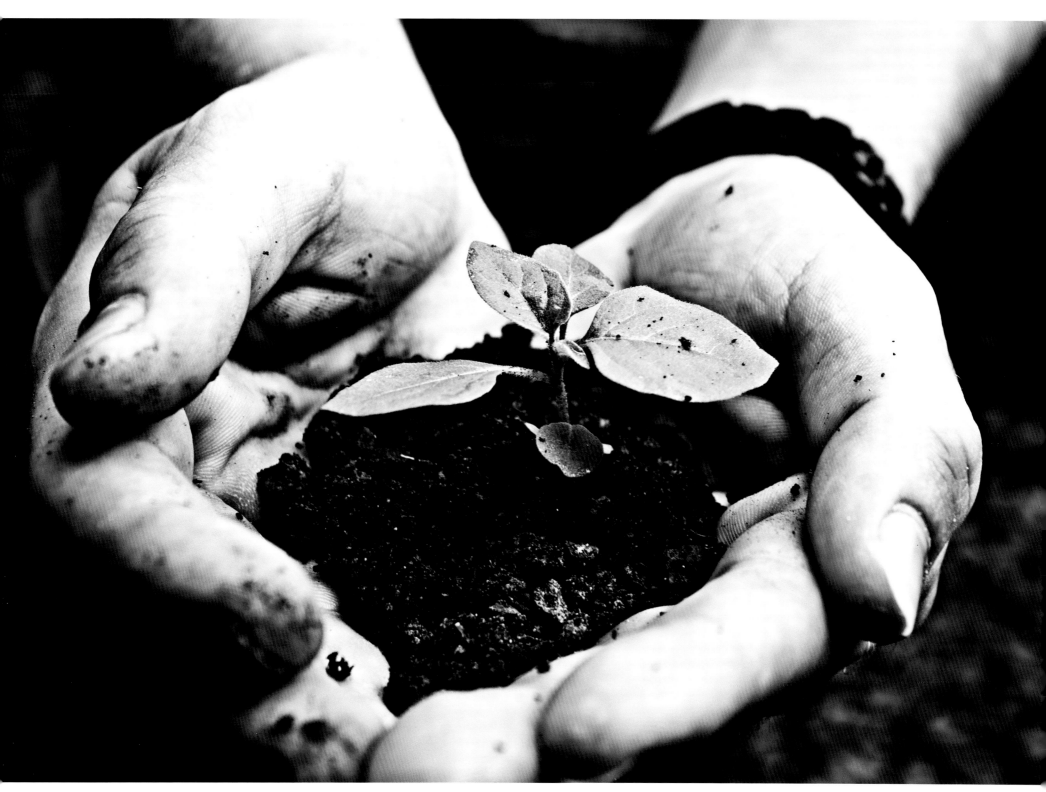

Garzoni Castle Gardens, Collodi, Italy. Arne Hansen, Germany

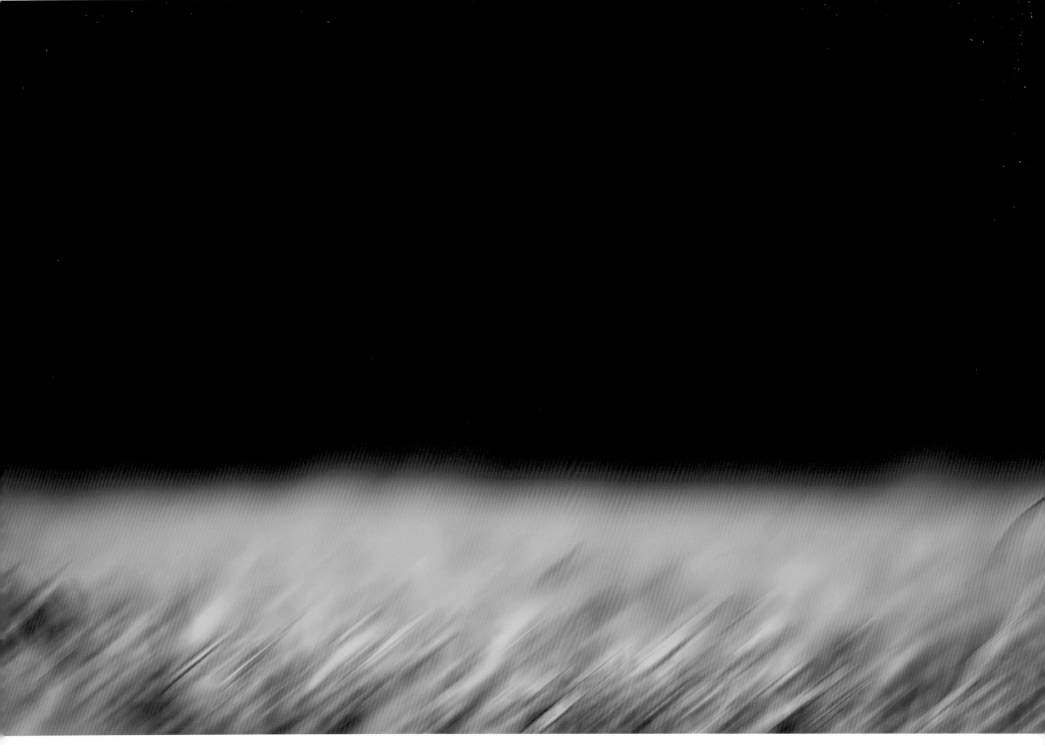

Abstract impression of grass, Gillingham, Kent, UK. Joel Biddle, UK

The Emerging Talent Award is about nurturing talent and potential. It is refreshing and rare to find a photographer who is willing to experiment, both with their own skills and vision, but in this year's winner we have discovered just such a talent. While Joel's photography is very much in its infancy, he shows great potential. His images are essentially abstract, but in experimenting with technique and movement, he has created images which already have commercial appeal in both advertising and creative stock photography.

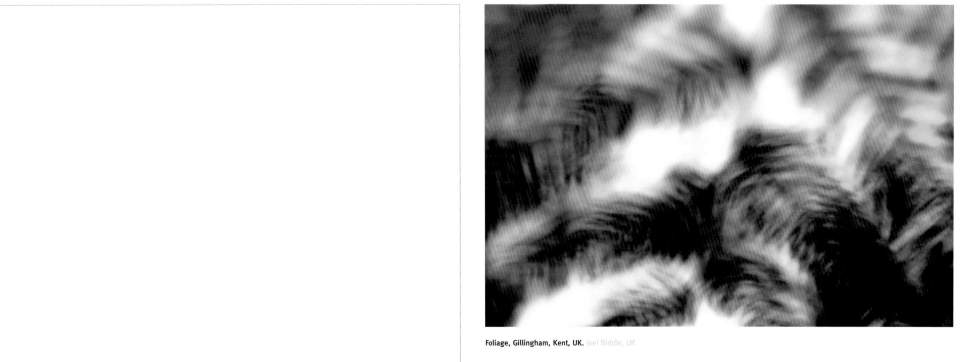

Foliage, Gillingham, Kent, UK. Joel Biddle, UK

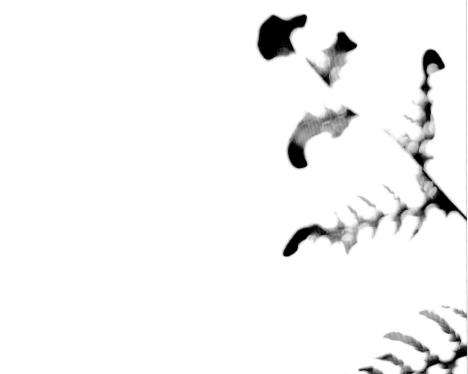

Shape and form of a fern leaf, Gillingham, Kent, UK. Joel Biddle, UK

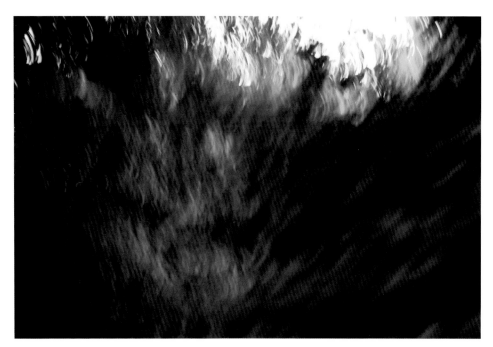

Shrubs, Gillingham, Kent, UK. Joel Biddle, UK

YOUNG TRAVEL PHOTOGRAPHER OF THE YEAR 2011

Joel Biddle (age 17) UK
Winner — 15–18 age group. Winner of the Young Photographers Alliance Emerging Talent Award

Joel Biddle is a student at The Howard School in Rainham, Kent, England who first became aware of his talent for photography three years ago when he took it as a GCSE. He has decided to pursue photography as a career, and hopes to start by studying it at degree level. His winning photographs are all about capturing the elements in a minimalistic way, observing the scenery for basic shapes and patterns found in nature. Achieving a sense of simplicity is often the objective in his work, something that was inspired by photographers Ciro Totku and Steen Doessing.

YOUNG TRAVEL PHOTOGRAPHER OF THE YEAR 2011

Tom Spence (age 17) UK
Runner Up — 15–18 age group

Elegant lines and a graceful curve make Tom's image striking.

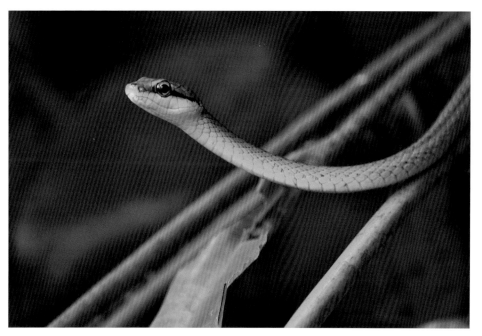

Green tree snake, Manuel Antonio National Park, Puntarenas Province, Costa Rica. Tom Spence, UK

YOUNG TRAVEL PHOTOGRAPHER OF THE YEAR 2011

Seamus Crowley (age 14) USA
Winner — Under 14 age group

Seamus Crowley was born and raised in the outdoorsy mountain town of Aspen, Colorado in the United States. He discovered his love of photography on a backpacking trip deep into mountainous backcountry in the fall of 2009. Since then his photography has progressed greatly and his range of subjects include landscape, portrait, sport, urban landscape, wildlife, and travel. He has only been a photographer for two years, but has loved every minute of it.

His portfolio caught the judges' attention because of his good use of the graphic elements of design in his compositions.

YOUNG TRAVEL PHOTOGRAPHER OF THE YEAR 2011

Lisa Gehrig (age 9) Switzerland
Runner Up — Under 14 age group

Green on green – an interesting interpretation of the theme with a splash of contrasting colour, which is even more amazing given the chameleon's ability to match its environment.

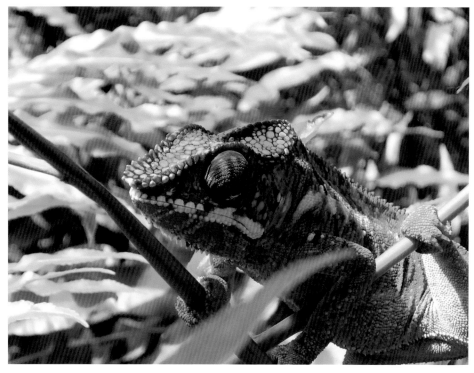

Chameleon, Zürich Zoo, Switzerland. Lisa Gehrig, Switzerland

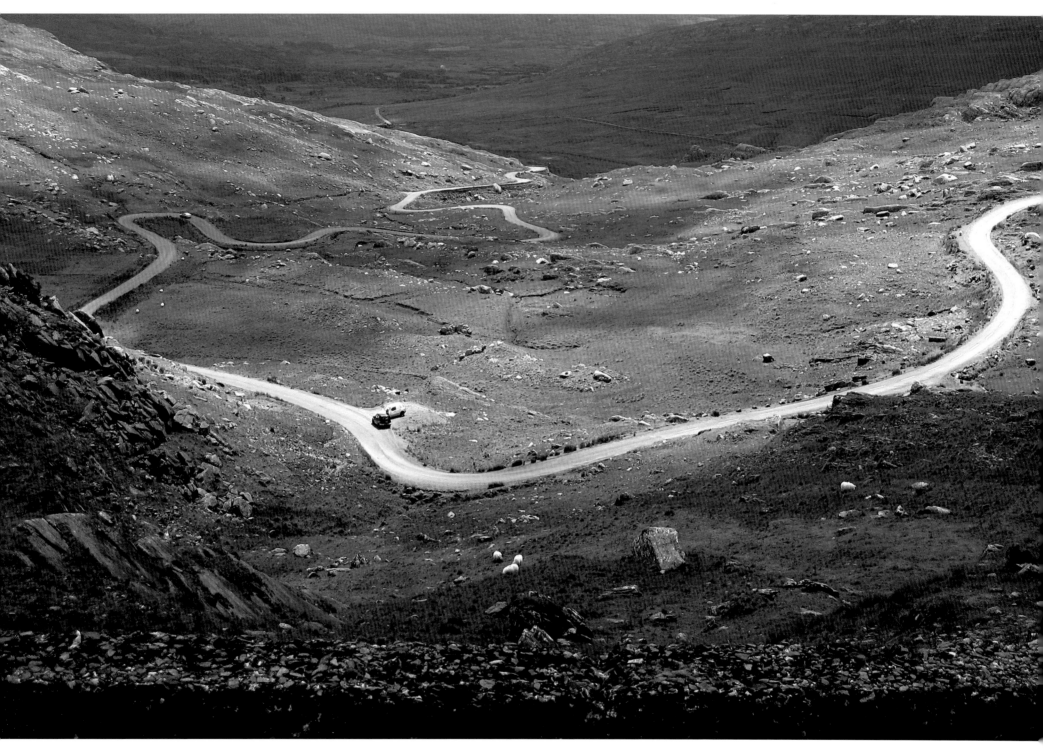

Winding road in Southern Ireland. Seamus Crowley, USA

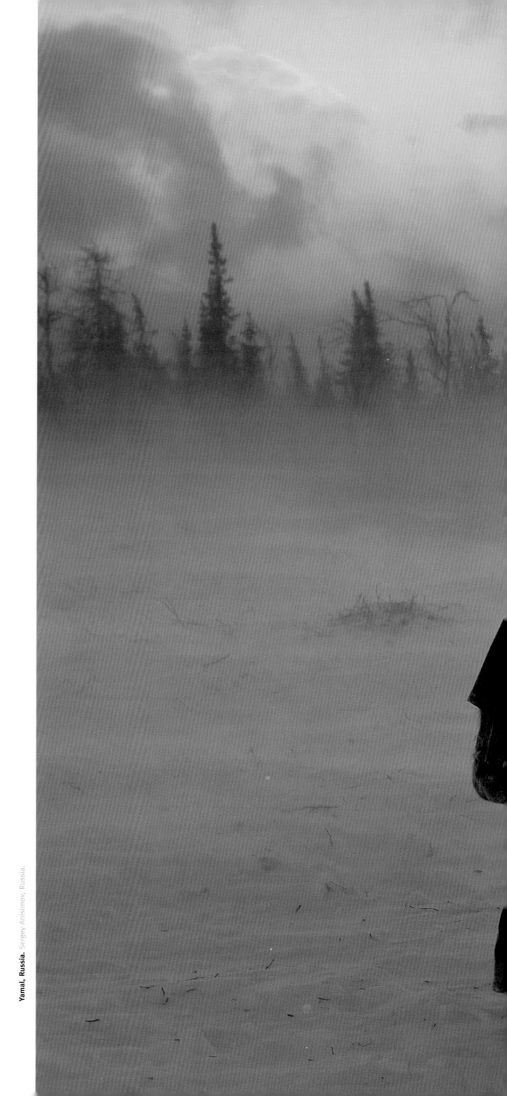

CULTURES AND TRADITIONS PORTFOLIO 2011

Sergey Anisimov's portfolio provides an insight into how technology creeps into the lives of those living in extreme climates in the remotest regions of the planet. It is fascinating to see how the traditional way of life is upheld even when facilitated by modern transport – albeit, essentially, as cargo. It's a delicate balance. At what point does culture become subverted, or compromised, by convenience?

Sponsors of this award:
Explore, Adobe, Lexar

Yamal, Russia. Sergey Anisimov, Russia.

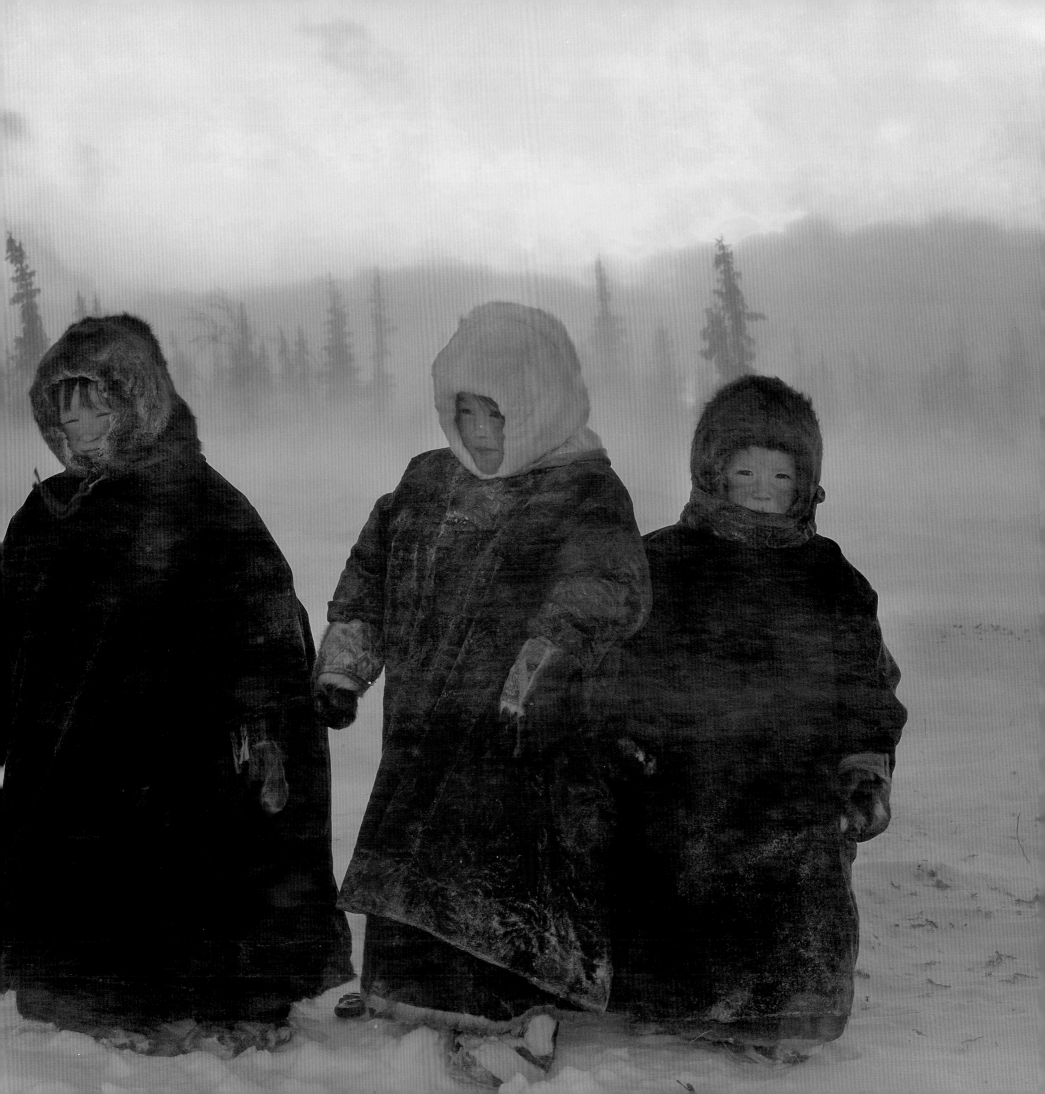

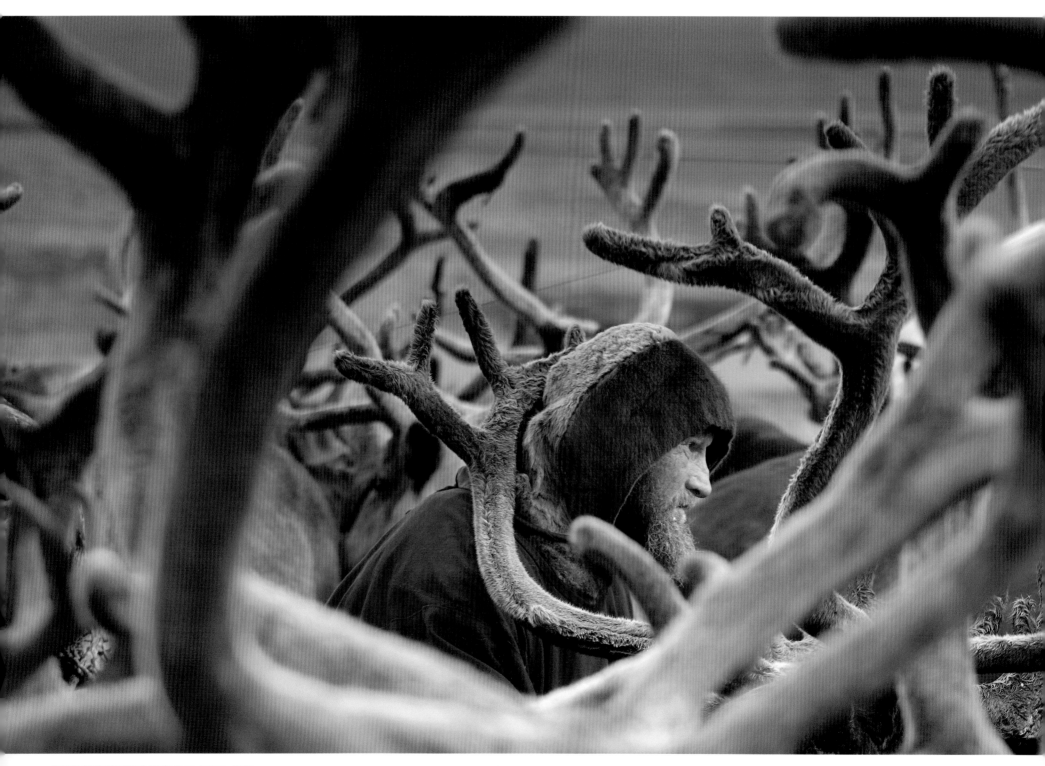

Nomadic deer herder, Yamal, Russia. Sergey Anisimov, Russia.

CULTURES AND TRADITIONS

Sergey Anisimov Russia

Winner

Sergey Anisimov graduated from Kiev National Aviation University and spent 18 years working as an engineer in a Salekhard aviation enterprise. Today he is a CEO of a technical company. Photography is a favourite hobby, as is travel. He has visited many countries around the world, and his favourite places for taking pictures are the northern and Arctic areas, including Franz Josef Land, Greenland, Spitsbergen, Wrangel island, Canada and Norway. But, for him, the most perfect place is his native land – Yamal.

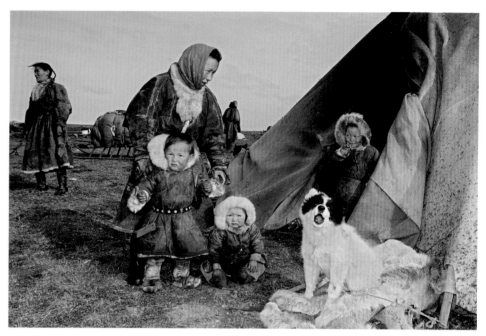

Yamal, Russia. Sergey Anisimov, Russia.

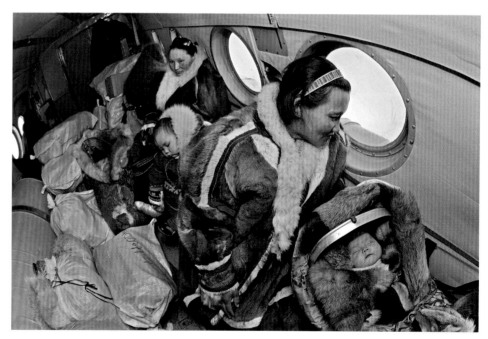

Yamal, Russia. Sergey Anisimov, Russia.

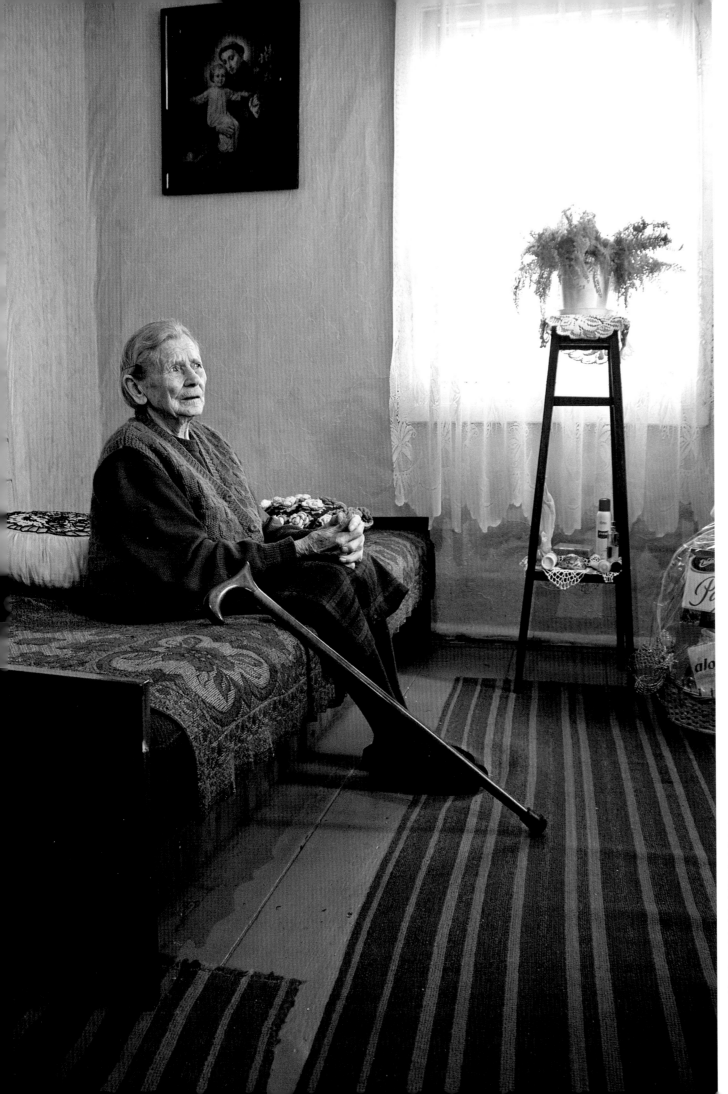

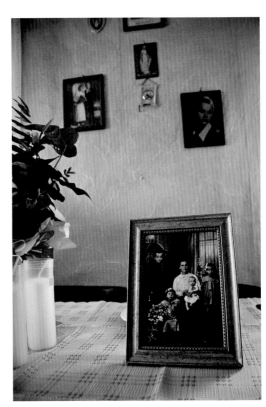

Rokitno, Eastern Poland. Marcin Mikolajczuk, Poland

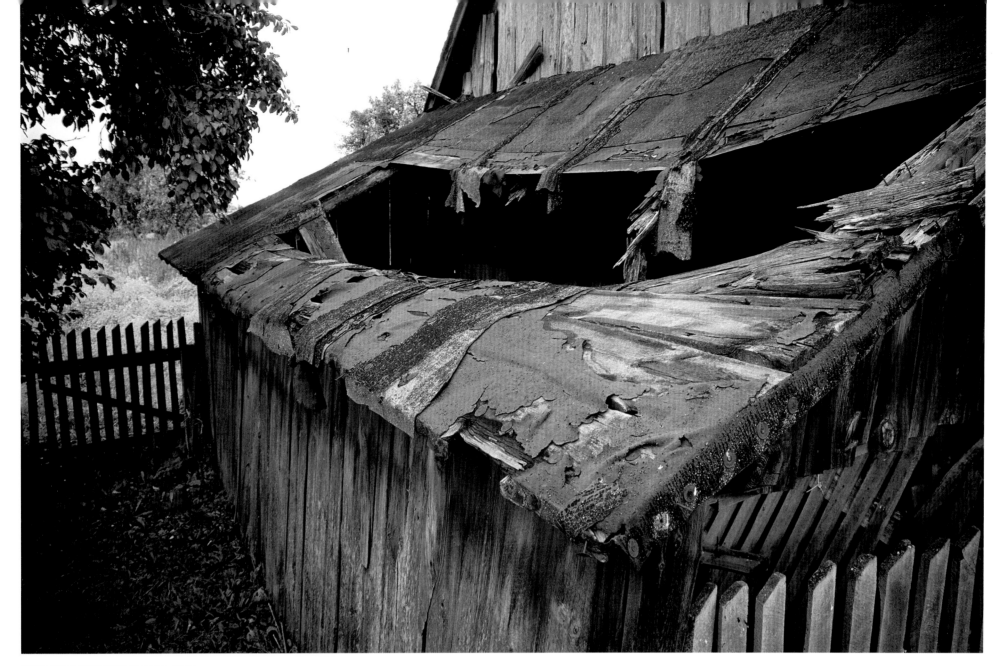

Rokitno, Eastern Poland. Marcin Mikolajczuk, Poland

CULTURES AND TRADITIONS

Marcin Mikolajczuk Poland
Runner Up

In many countries, traditional ways of living are being lost at an alarming rate as younger generations move from rural areas to towns in search of jobs. Photography plays an important role in preserving these memories for future generations. Marcin's portfolio poignantly captures the vestiges of a simpler life.

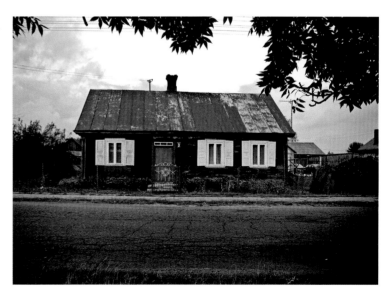

Rokitno, Eastern Poland. Marcin Mikolajczuk, Poland

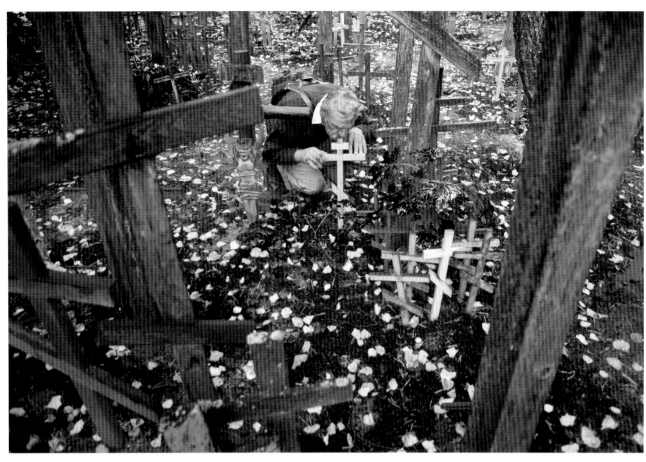

Catholics celebrate the Transfiguration, Grabarka, Poland. Yurian Quintanas Nobel, Spain

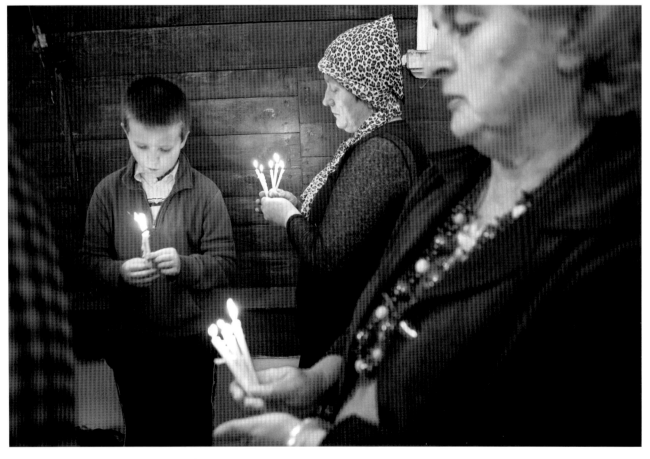

Catholics celebrate the Transfiguration, Grabarka, Poland. Yurian Quintanas Nobel, Spain

CULTURES AND TRADITIONS

Yurian Quintanas Nobel Spain
Highly Commended

In Yurian's images there is a moving story about religious culture which captures an intimate perspective on how these people's beliefs touch and shape their lives.

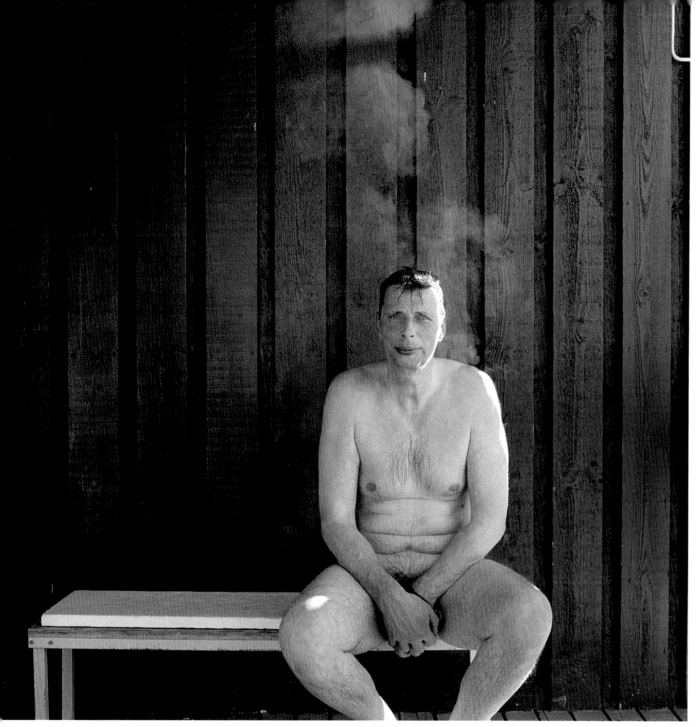

Vuorilammen Sauna, Jyväskylä, Finland. Tessa Bunney, UK

CULTURES AND TRADITIONS

Tessa Bunney UK

Commended

It cold outside! In Tessa's portfolio there is a real sense of both the pain and the pleasure.

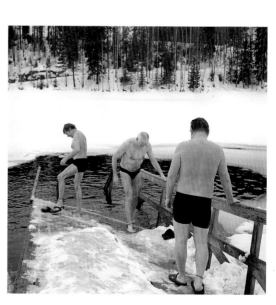

Vuorilammen Sauna ice swimming hole, Jyväskylä, Finland. Tessa Bunney, UK

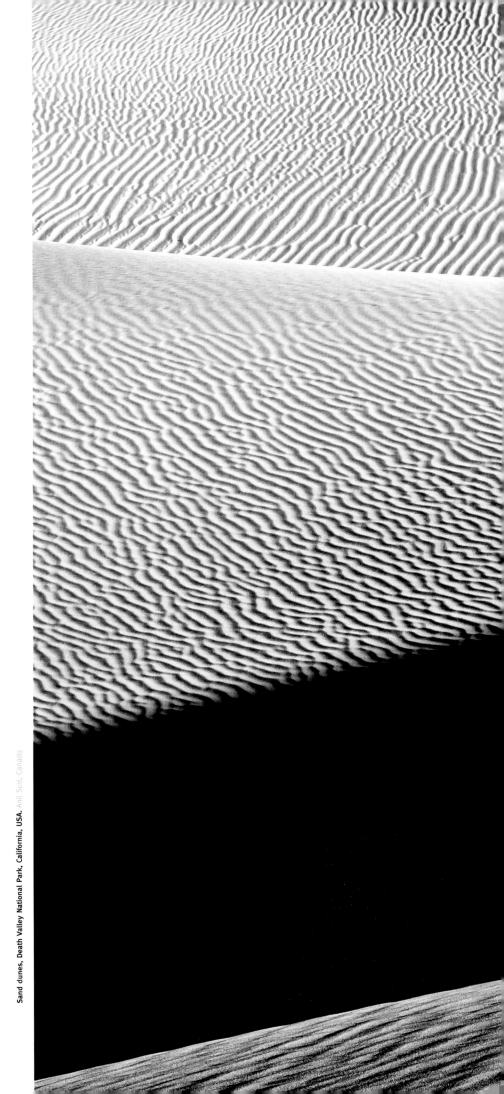

NATURAL ELEMENTS PORTFOLIO 2011

Anil Sud's use of light and shadow enhances and isolates the contours of this desert landscape, creating graphic images which come alive through the black-and-white medium. Stark yet graceful lines give these images a simple elegance.

Sponsors of this award:

Oman Air, Oman Ministry of Tourism, Adobe, Lexar

Sand dunes, Death Valley National Park, California, USA. Anil Sud, Canada

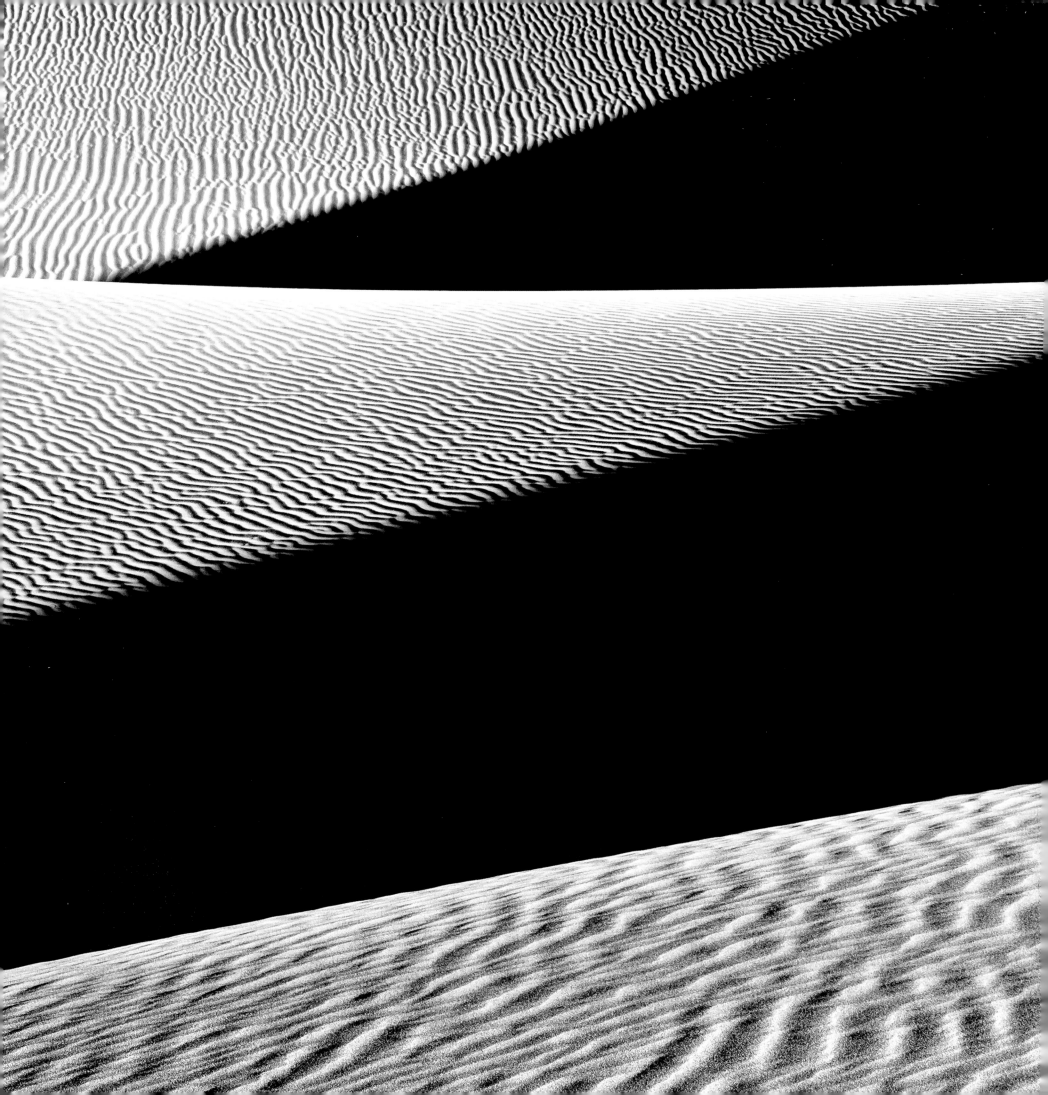

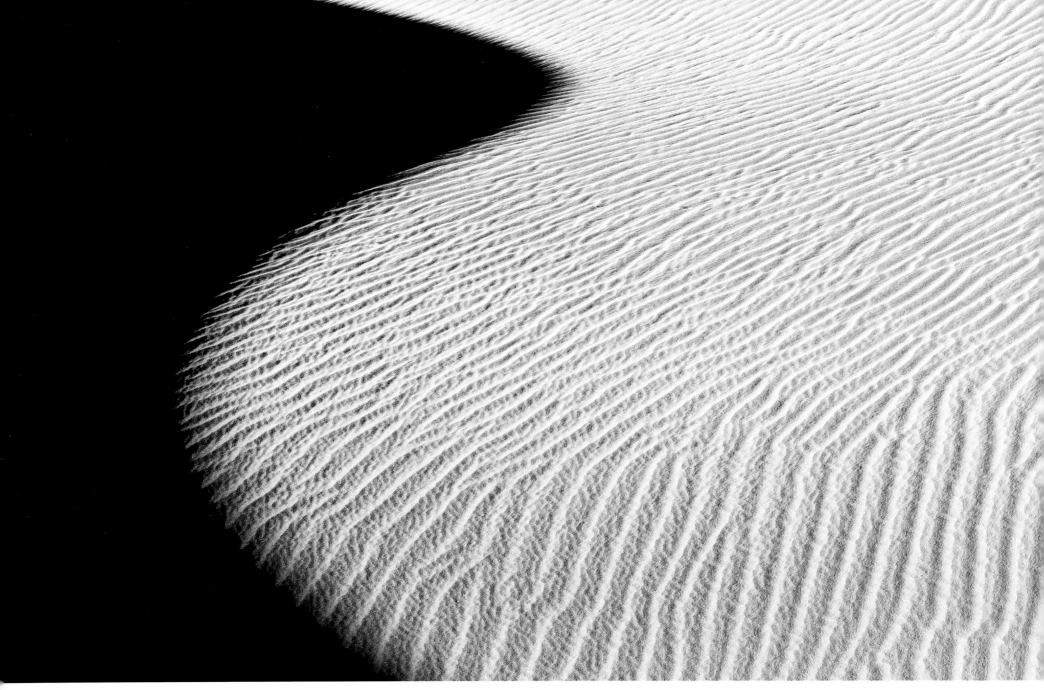

Sand dunes, Death Valley National Park, California, USA. Anil Sud, Canada

NATURAL ELEMENTS

Anil Sud Canada
Winner

A family physician by profession, Anil Sud has been an avid photography enthusiast since his teenage years when his father first handed him a Canon AE-1. Growing up in a small town, he taught himself everything he could about photographic technique and artistic vision by reading books and magazines and lots of experimentation.

Over time, he developed a passion for colour and design in his art; something that resonates with him deeply. It was only recently that he discovered the world of monochrome and the power that an image can convey without the assistance of colour to carry it.

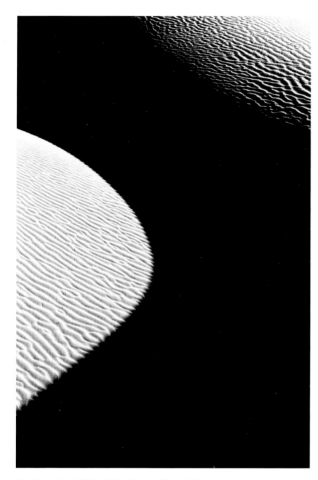

Sand dunes, Death Valley National Park, California, USA. Anil Sud, Canada

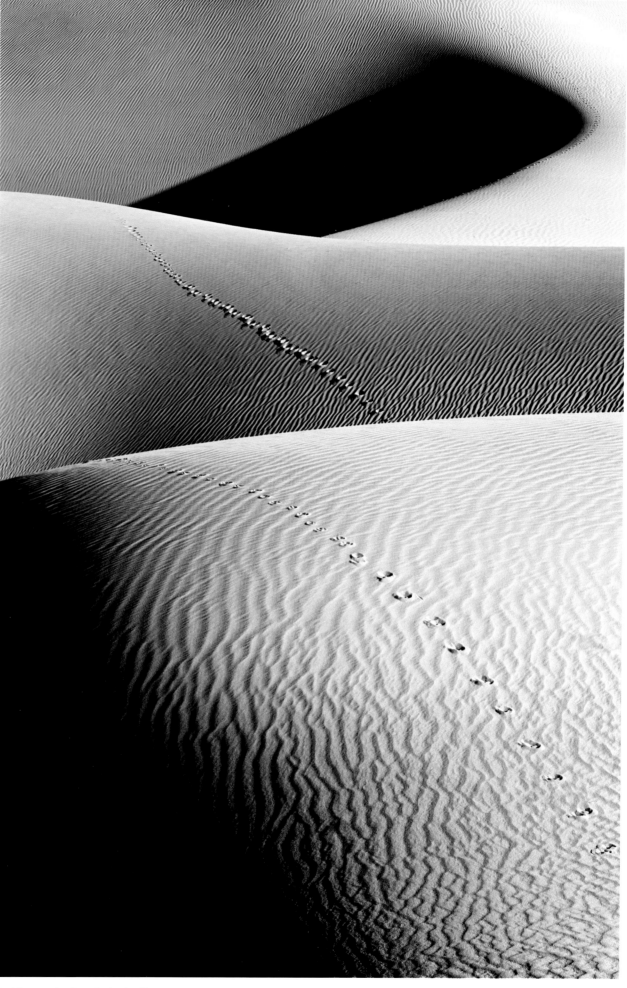

Sand dunes, Death Valley National Park, California, USA. Anil Sud, Canada

NATURAL ELEMENTS

Peter Karry UK
Runner Up

As well as shaping the natural landscape, the elements also have an impact on manmade features, often returning them to their elemental form. This process is captured in Peter's portfolio, as the harsh textures of nature's half-eaten feast.

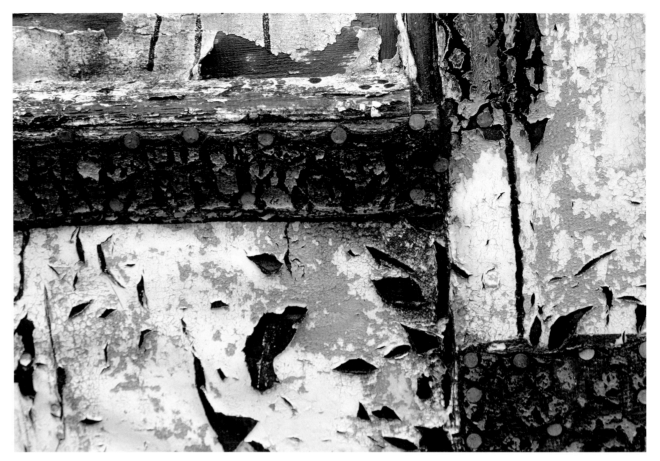

Window, breaker's yard in the Scottish Highlands. Peter Karry, UK

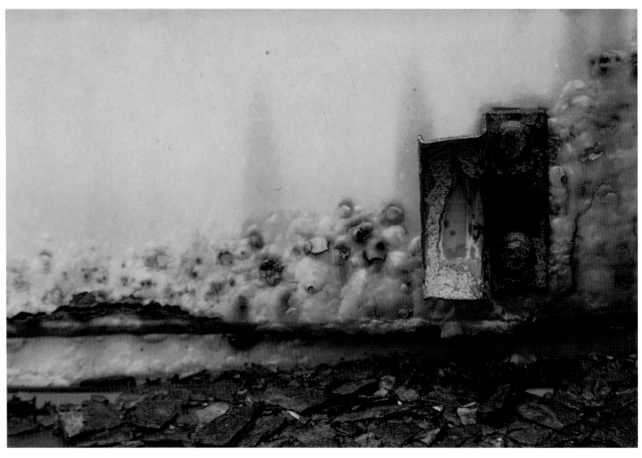

Pink Cadillac, breaker's yard in the Scottish Highlands. Peter Karry, UK

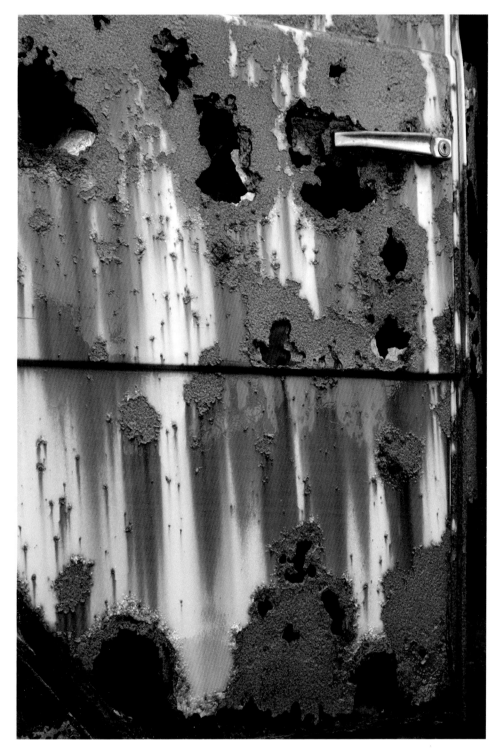

Old lorry door, breaker's yard in the Scottish Highlands. Peter Karry, UK

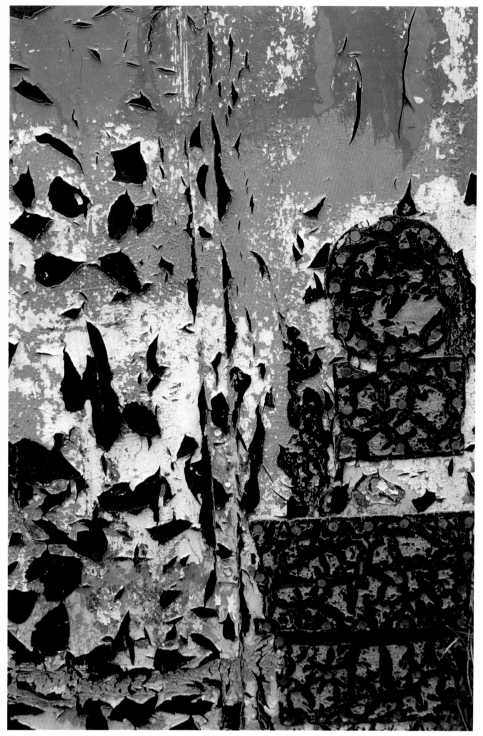

Old shed door, breaker's yard in the Scottish Highlands. Peter Karry, UK

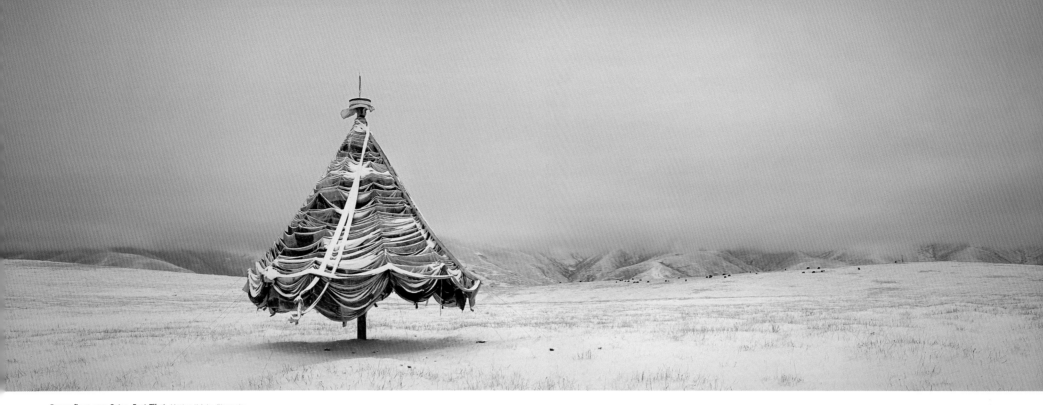

Prayer flags near Gatse, East Tibet. Matjaz Krivic, Slovenia

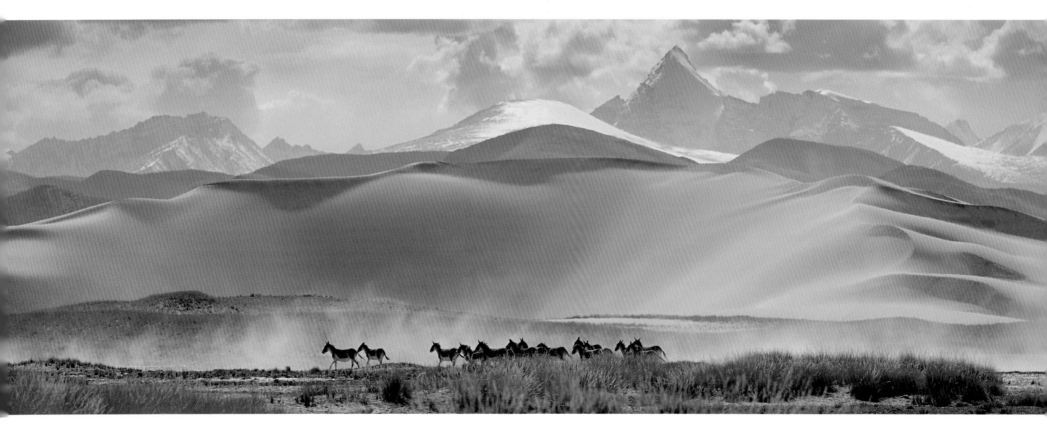

Tibetan wild donkeys near Paryang, West Tibet. Matjaz Krivic, Slovenia

NATURAL ELEMENTS

Matjaz Krivic Slovenia
Highly Commended

Shaped by the forces of nature, Tibet's majestic landscape is captured elegantly in Matjaz's images.

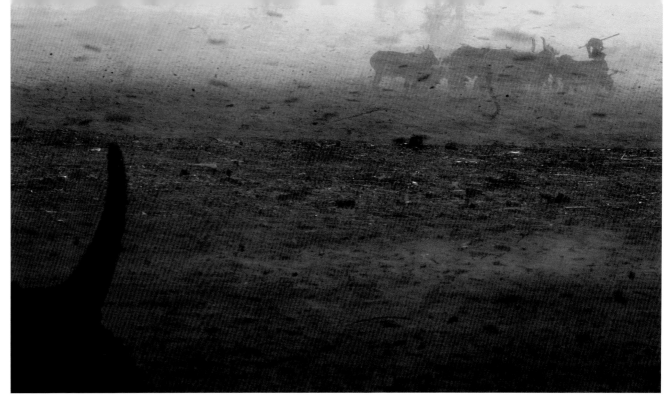

Life on the plains south of Ed Damazin, Blue Nile State, Sudan. Johnny Haglund, Norway

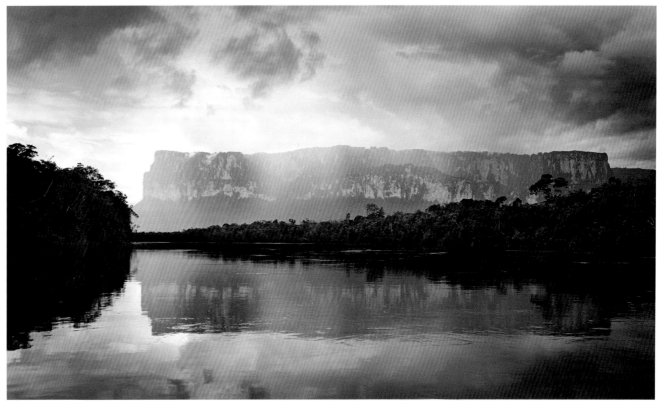

Canaima National Park, Venezuela. Philip Lee Harvey, UK

NATURAL ELEMENTS

Johnny Haglund Norway
Commended

This portfolio captured the harshness of the elements – wind, sun and water – which shape the land.

Philip Lee Harvey UK
Commended

A lost world, the inspiration for Sir Arthur Conan Doyle's novel, rises serenely from the clouds in timeless beauty.

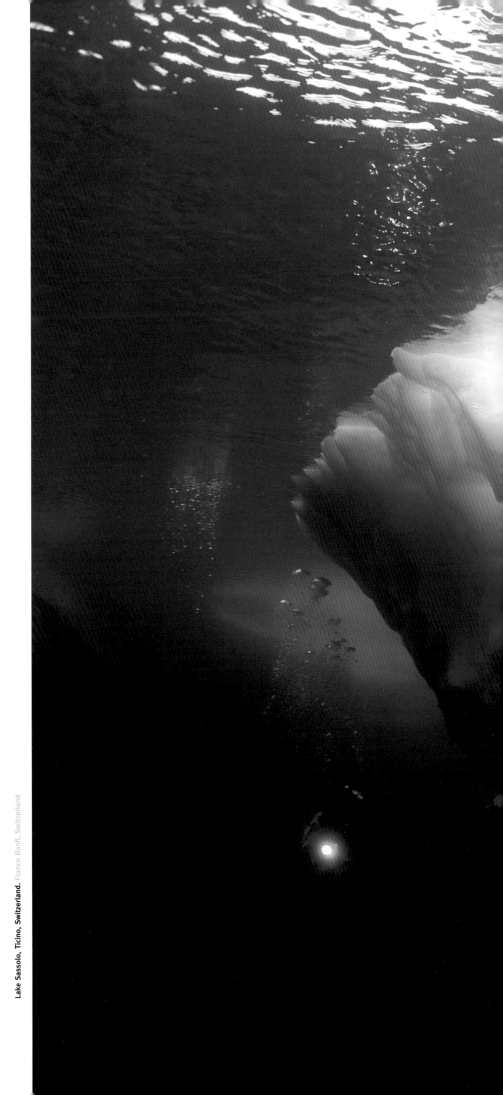

SPIRIT OF ADVENTURE PORTFOLIO 2011

Franco Banfi takes his camera into a world which few of us have seen first hand. His simple, almost monochrome, images are majestic works of art. Their apparent tranquility is only shattered by the realisation that these giant blocks of ice are moving and could shift – with fatal consequences for the divers – at any time.

Sponsors of this award:
Cutty Sark Blended Scotch Whisky, Adobe, Lexar

Lake Sassolo, Ticino, Switzerland. Franco Banfi, Switzerland

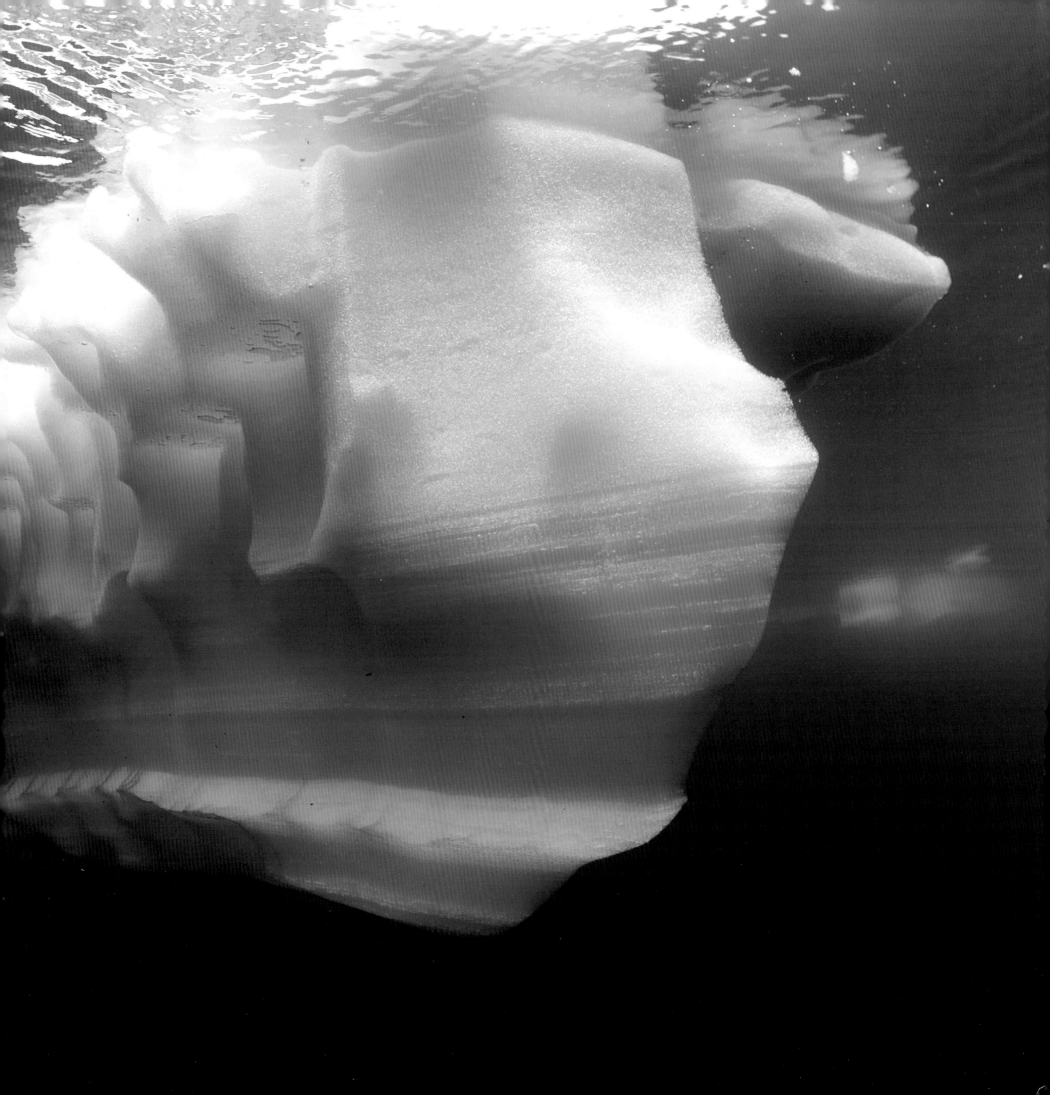

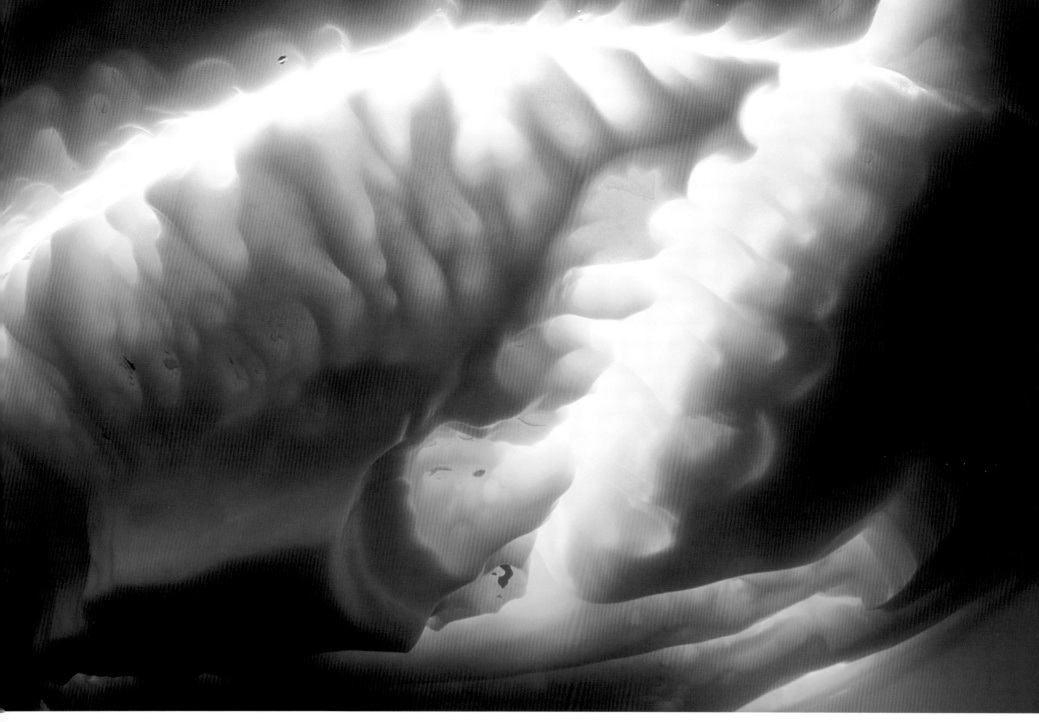

Ice formations, Lake Sassolo, Ticino, Switzerland. Franco Banfi, Switzerland

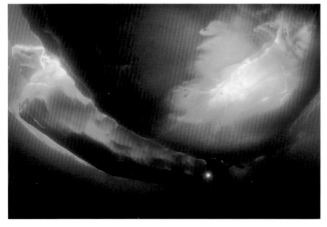

Scuba diver, Lake Sassolo, Ticino, Switzerland. Franco Banfi, Switzerland

SPIRIT OF ADVENTURE

Franco Banfi Switzerland
Winner

Franco Banfi is an award-winning professional photographer and photo-journalist, specialising in underwater wildlife and environments, nature and travel. For many years he has been known around the world for his versatility, expertise and accuracy in underwater imaging. Shooting in environments ranging from the Equator to the Poles, he has meticulously documented a lot of uncommon animals and locations and explored the relationship between humans, wildlife and nature. Franco's reportages have been published in countless publications and renowned magazines around the world and his work has been recognised by – amongst others – Wildlife Photographer of the Year, and now Travel Photographer of the Year.

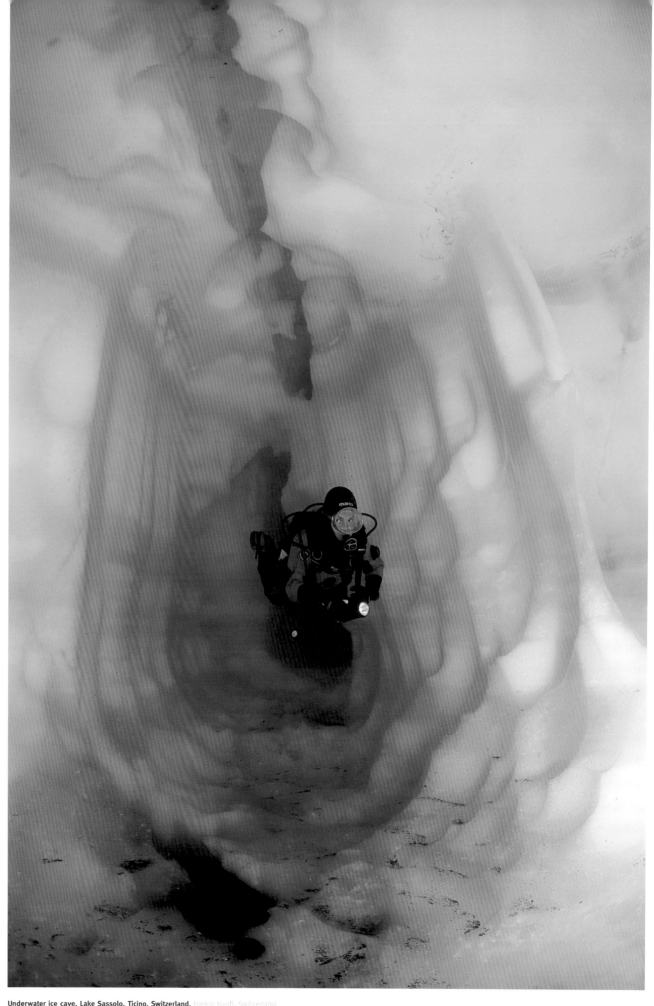

Underwater ice cave, Lake Sassolo, Ticino, Switzerland. Franco Banfi, Switzerland

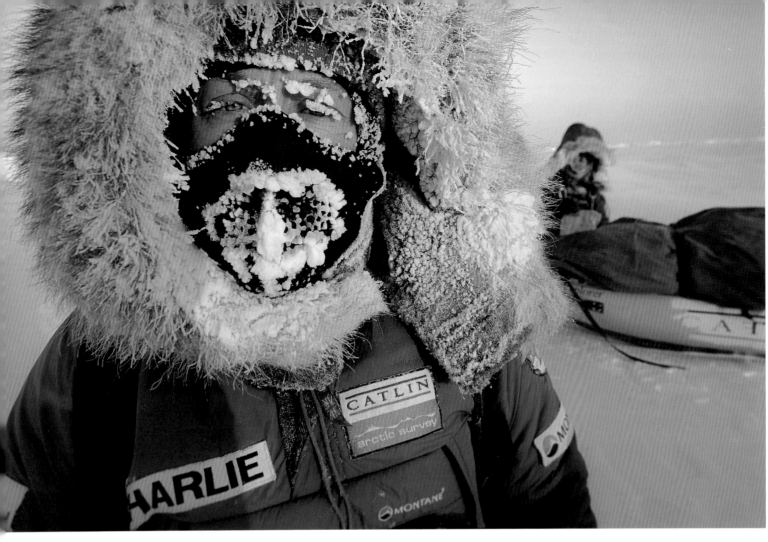

Charlie Paton on Catlin Arctic Survey, Arctic Ocean. Martin Hartley, UK

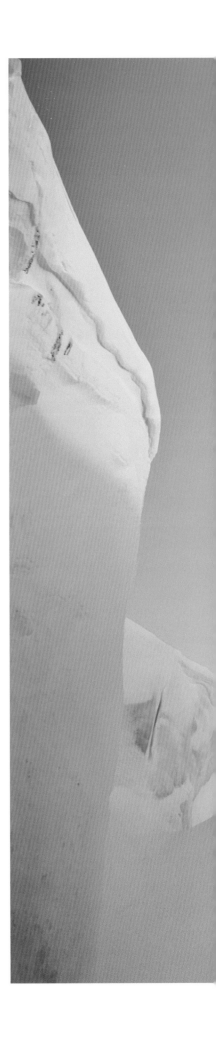

SPIRIT OF ADVENTURE

Martin Hartley UK
Runner Up

Martin's portfolio not only gives a real sense of the harsh Arctic environment confronting the adventurer, but also hints at the sheer scale of the landscape being explored. These images capture a majestic beauty which belies the challenges faced by both explorer and photographer.

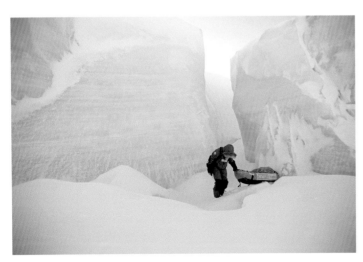

Catlin Arctic Survey, Cornwallis Island, Canada. Martin Hartley, UK

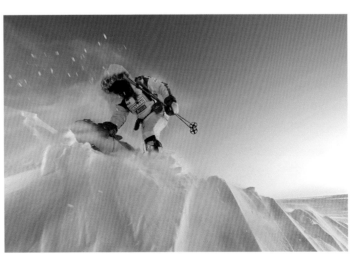

Pen Hadow on Catlin Arctic Survey, Cornwallis Island, Canada. Martin Hartley, UK

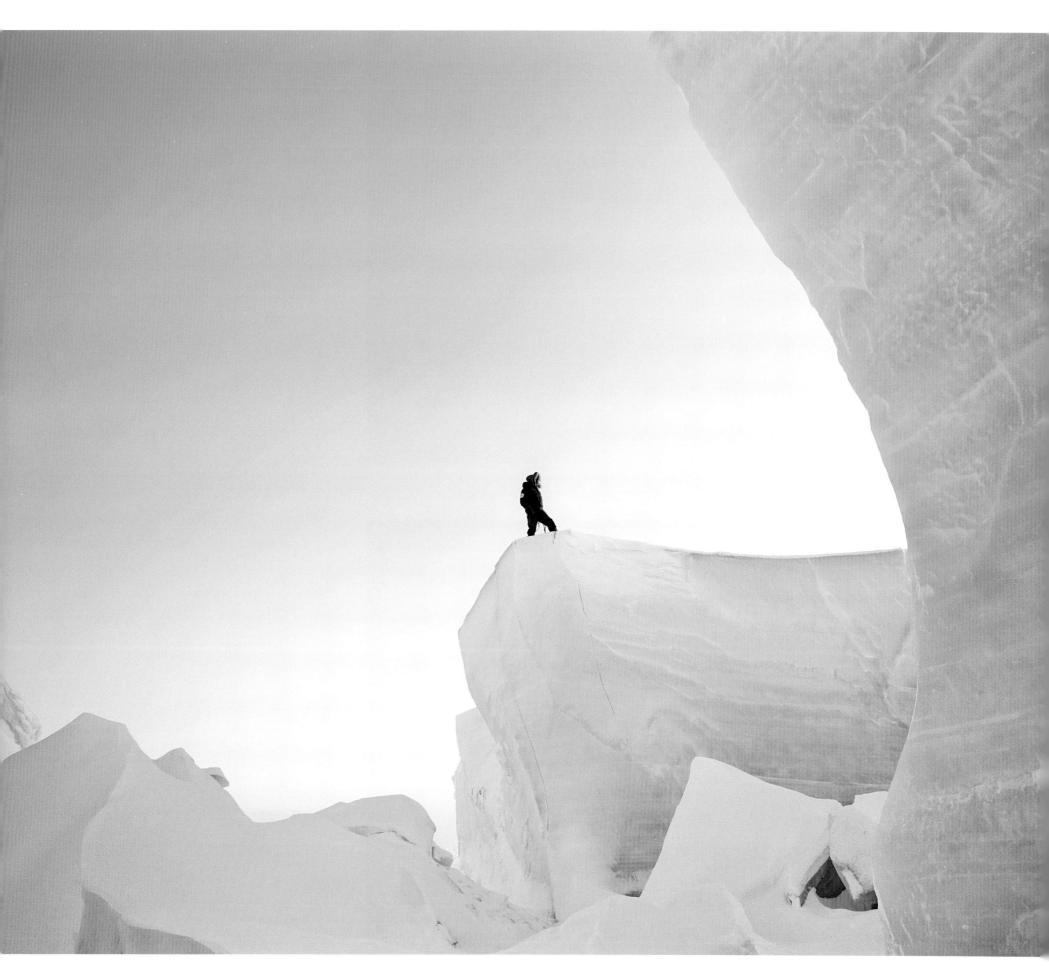

Catlin Arctic Survey, Cornwallis Island, Canada. Martin Hartley, UK

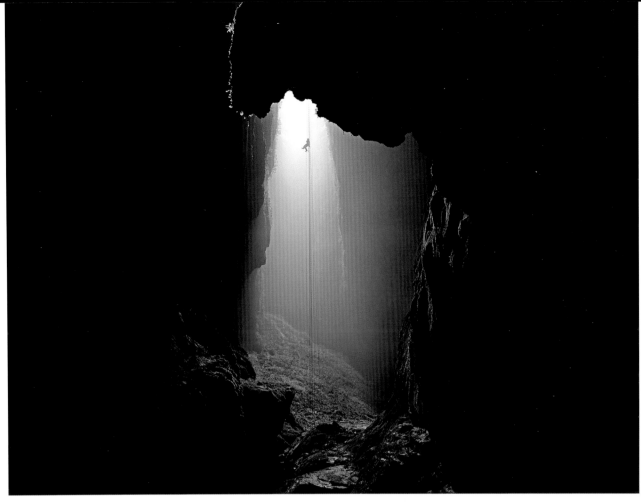

The Lost World, Waitomo Caves, North Island, New Zealand. Chris McLennan, New Zealand

SPIRIT OF ADVENTURE

Chris McLennan New Zealand
Highly Commended

Chris's portfolio explores the solitary challenges which the natural world presents in simple graphic forms, and is enhanced by subtle splashes of colour.

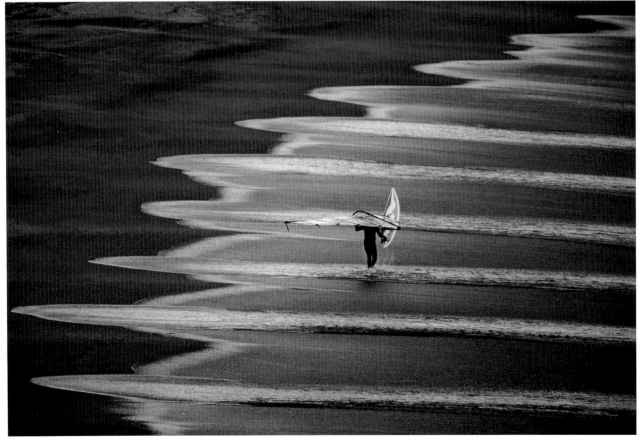

Fortrose, The Catlins, New Zealand. Chris McLennan, New Zealand

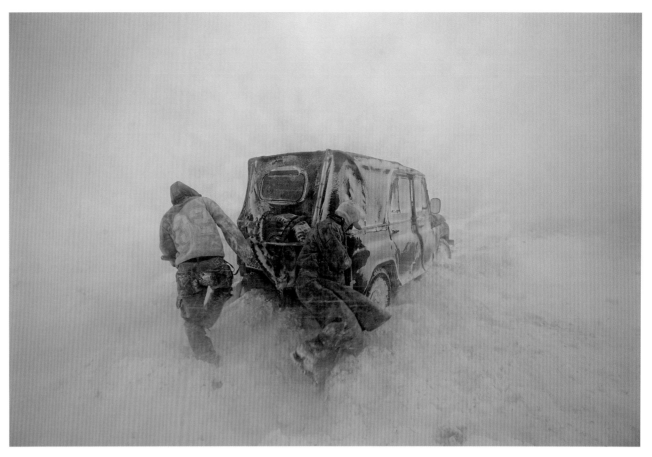

Snow storm in the Altai Mountains, West Mongolia. Edoardo Agresti, Italy

SPIRIT OF ADVENTURE

Edoardo Agresti Italy
Commended

Cold seems to be a common theme in the interpretation of adventure and Edoardo's pictures perfectly capture man's propensity to tackle an apparently impossible and endless terrain with unwavering optimism.

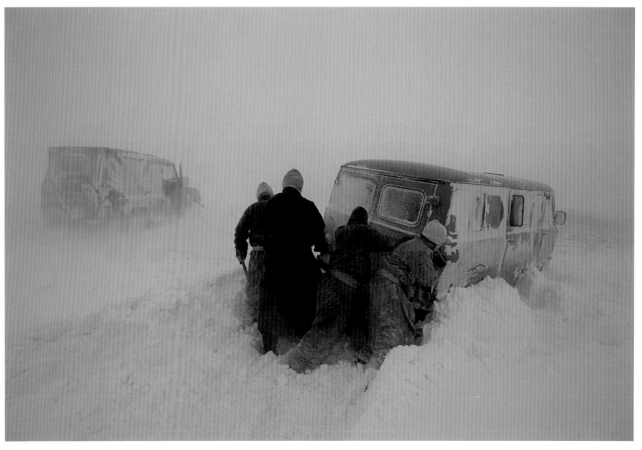

Snow storm in the Altai Mountains, West Mongolia. Edoardo Agresti, Italy

EXOTIC PORTFOLIO 2011

Exotic is in the eye of the beholder. Malgorzata Pioro electrifies the mundane to great effect using vibrant red light. Any inhabitant of London would struggle to find the city they are so familiar with in her pictures, so effectively has she captured exotic beauty in the ordinary.

Sponsors of this award:
Tselana Travel, Adobe, Lexar

Soho, London, UK. Malgorzata Pioro, Poland

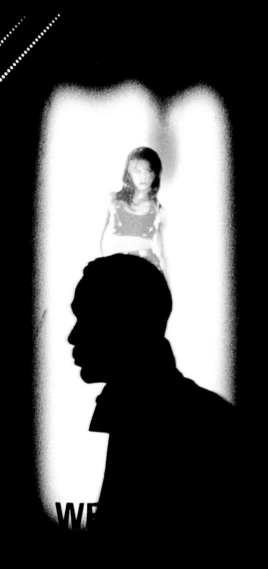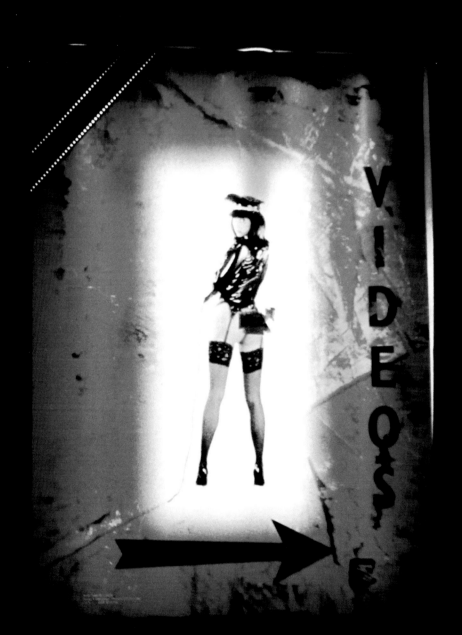

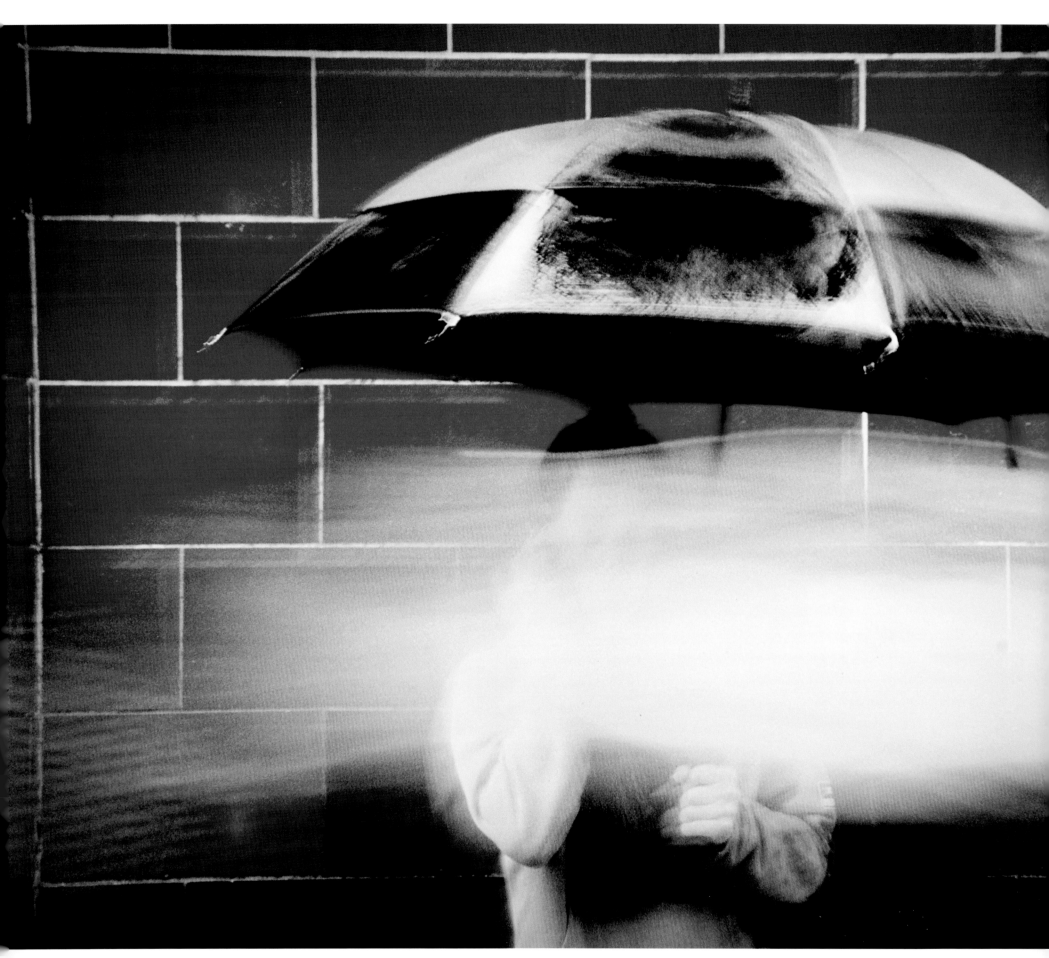

London, UK. Malgorzata Pioro, Poland

EXOTIC

Malgorzata Pioro Poland
Winner

Malgorzata Pioro graduated in pedagogics and sociology from Jagiellonian University in Kracow. Photography became her main occupation after she graduated from the European Academy of Photography in Warsaw. She has worked as a lecturer at the University of Management and Banking as well as at the Academy of Photography and Academy 30+ in Kracow.

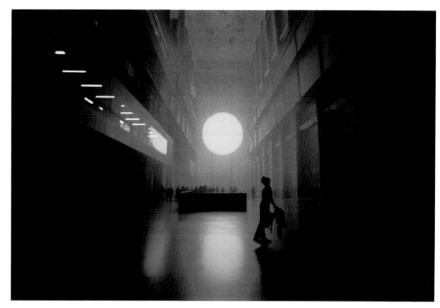

Tate Modern, London, UK. Malgorzata Pioro, Poland

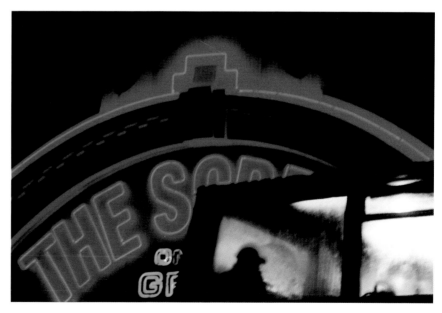

West End, London, UK. Malgorzata Pioro, Poland

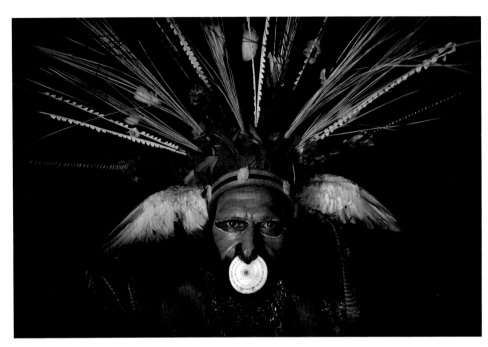

Tribesman in bird-of-paradise feather headdress, Central Highlands, Papua New Guinea. Timothy Allen, UK

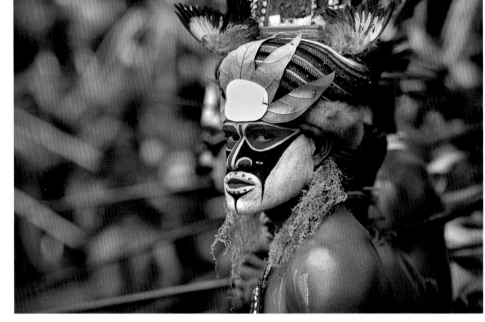

Central Highlands, Papua New Guinea. Timothy Allen, UK

EXOTIC

Timothy Allen UK
Runner Up

These tribal people are certainly exotic, but the elegance with which Timothy has captured them gives a fascinating insight into their character, culture and ceremony.

Courtship ritual, Central Highlands, Papua New Guinea. Timothy Allen, UK

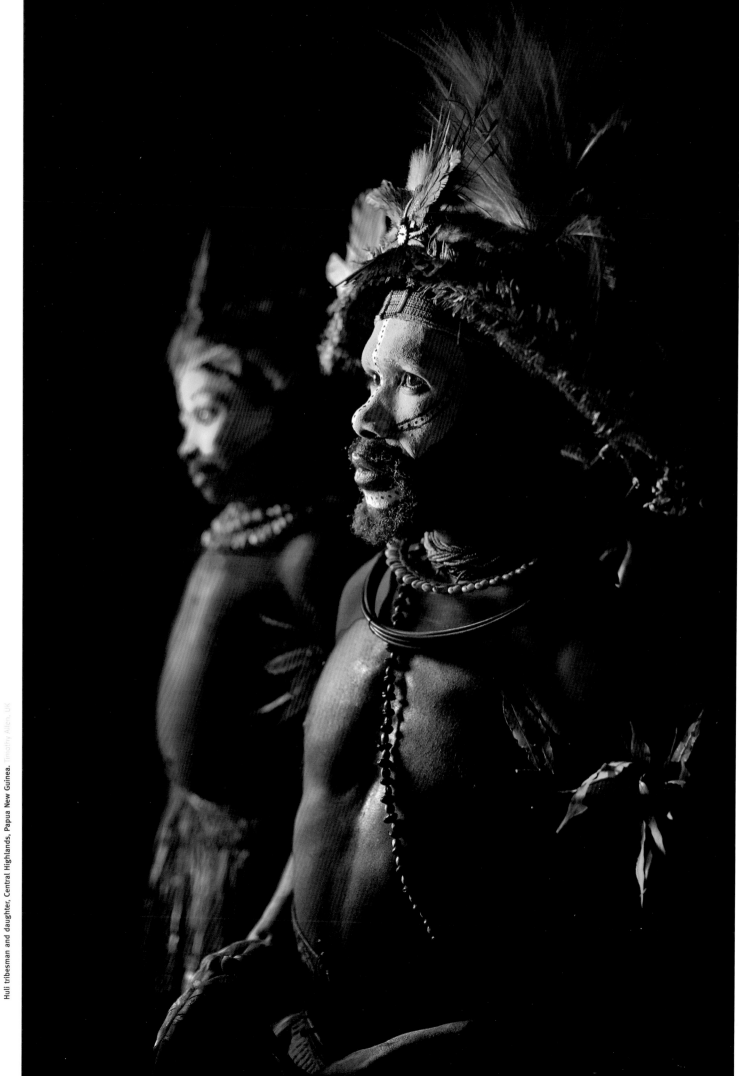

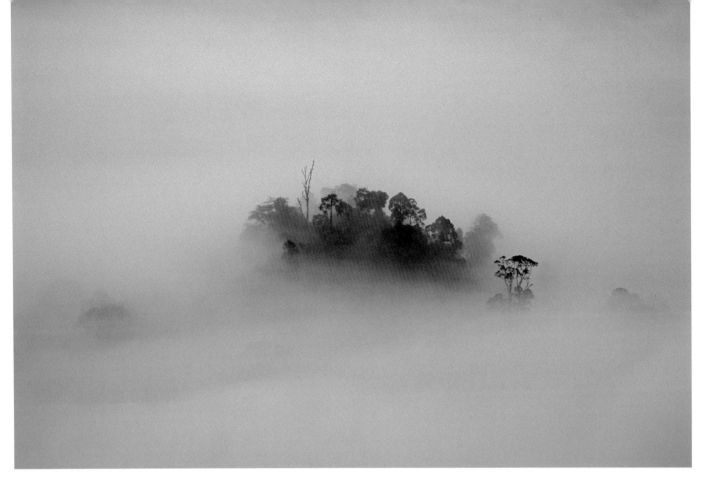

Rainforest canopy, Sabah, Borneo, Malaysia. Thomas Endlein, Germany

EXOTIC

Thomas Endlein Germany
Highly Commended

The gentle beauty of Thomas's images disguises the challenging environment in which he was shooting. Light and shade define the outlines of this jungle, like ink on pastel blue paper.

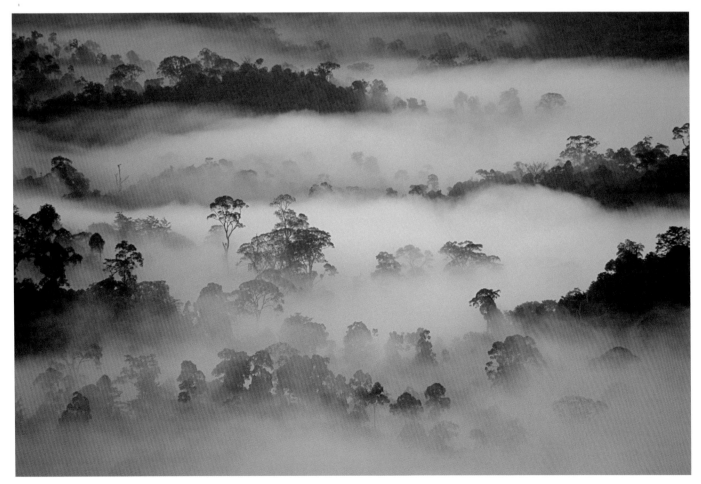

Rainforest canopy, Sabah, Borneo, Malaysia. Thomas Endlein, Germany

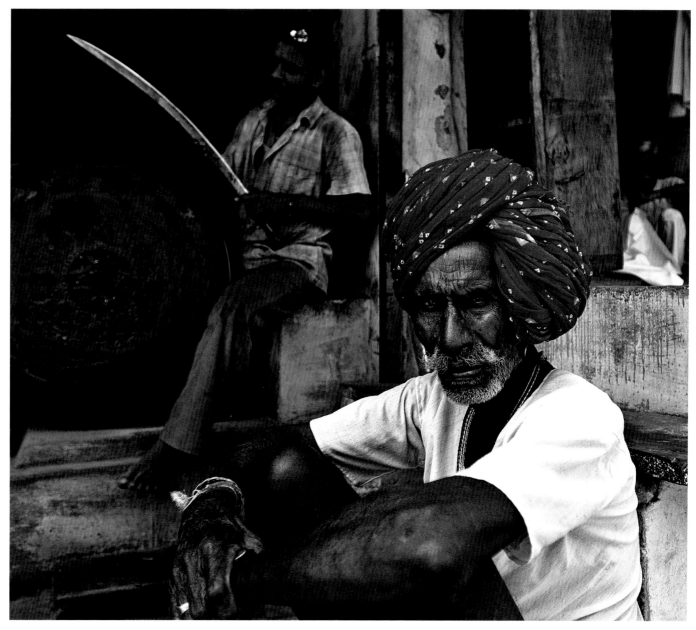

Bundi, Rajasthan, India. Simon Morris, UK

EXOTIC

Simon Morris UK
Commended

The rich hues and soft lighting in Simon's images combine to create exotic, almost painting-like, processing of the photographs.

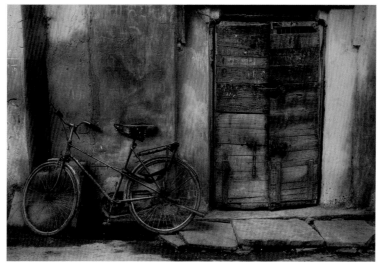

Bundi, Rajasthan, India. Simon Morris, UK

ONE SHOT 2011 — WILD MOMENTS

There were a myriad of interpretations of what a wild moment constitutes, but Stuart Dunn's image captures a truly wild one which borders on insanity! Looking at this image, the word 'why?' just keeps coming to mind, followed by the obvious answer: 'because it's there' – though how either photographer kept their lenses free from water droplets defies an answer.

Sponsors of this award:

Cutty Sark Blended Scotch Whisky, Elephant Family, TPOTY, Adobe, Lexar

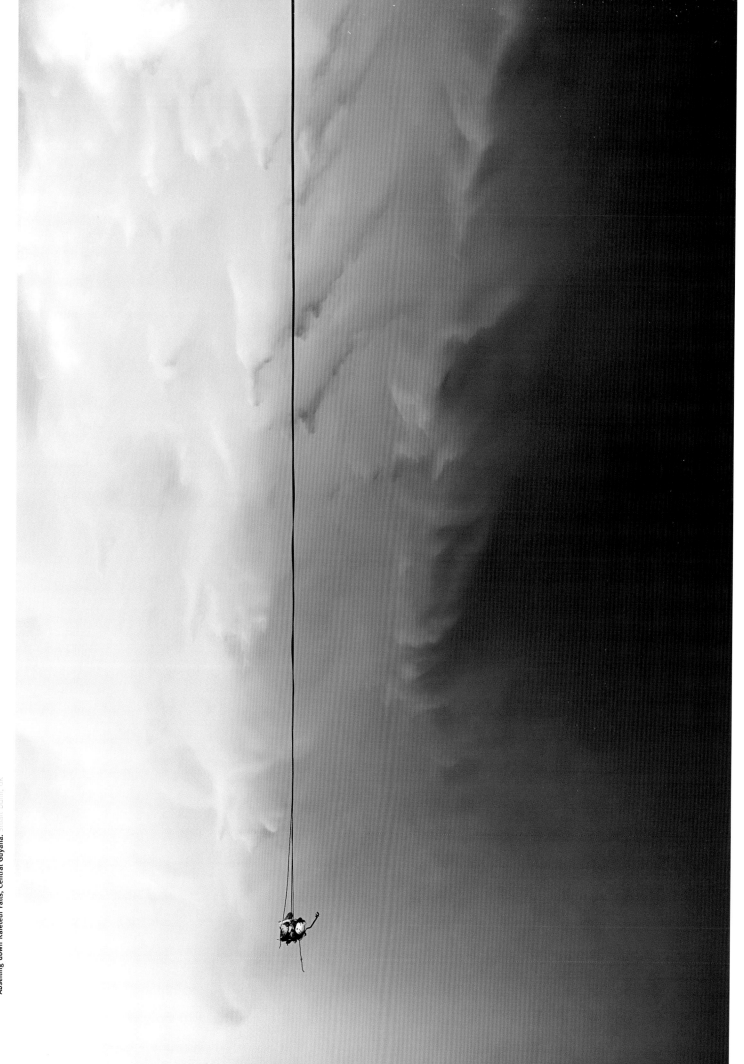

Abseiling down Kaieteur Falls, Central Guyana. Stuart Dunn, UK

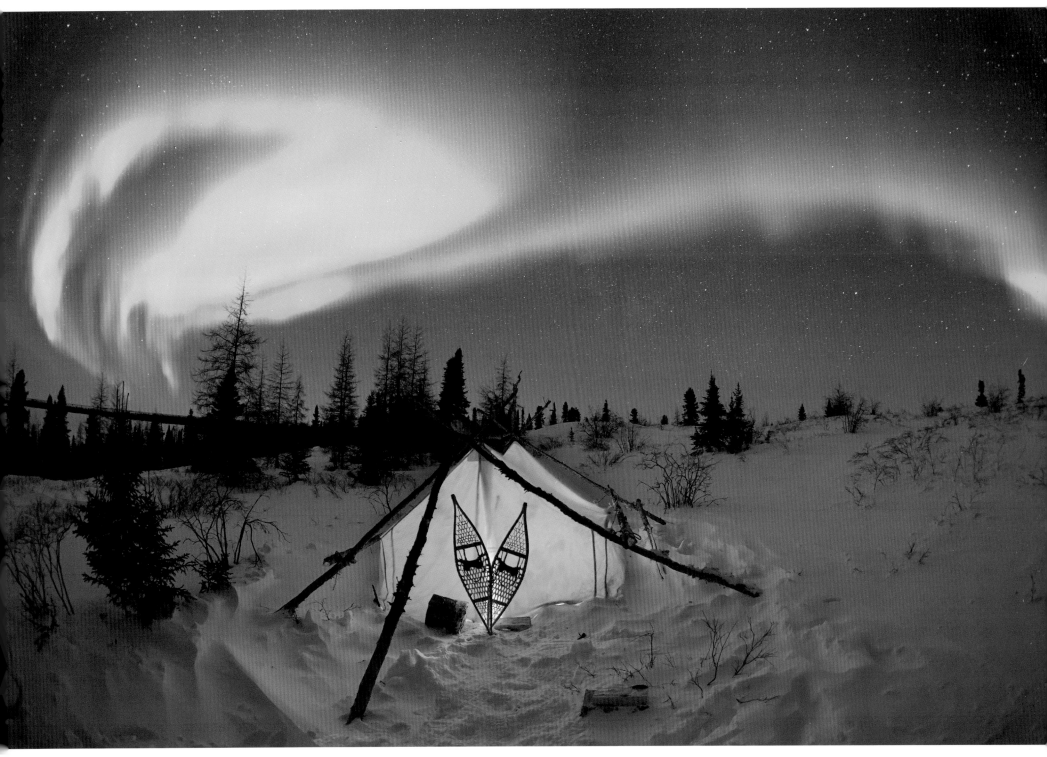

Northern Lights over Hudson Bay, Canada. Thomas Kokta, Germany

WILD MOMENTS

Stuart Dunn UK
Winner

Stuart studied at the Northern Media School and gained a Masters Degree in cinematography. Upon completion, he embarked on his first filming expedition with fellow student and friend Pandula. On a shoestring budget and completely unpaid, they travelled to the Tamil Tiger controlled regions of Northern Sri Lanka in an attempt to tell the story of the civil war that had raged for over 20 years and give a voice to the 500

thousand refugees displaced by the conflict — a baptism by fire to say the least! Since then Stuart has gained an abundance of credits in a variety of publications and TV programmes. He now divides his time between the worlds of photography and cinematography, filming and photographing documentary assignments across the globe in inhospitable environments such as the Amazon jungle, the Arctic and the Himalayas.

WILD MOMENTS

Thomas Kokta Germany
Runner Up

Taking his camera to the technical limits has allowed Thomas to create a graphic, yet dreamlike moment where the vibrant lights in the sky seem to dance above the tent.

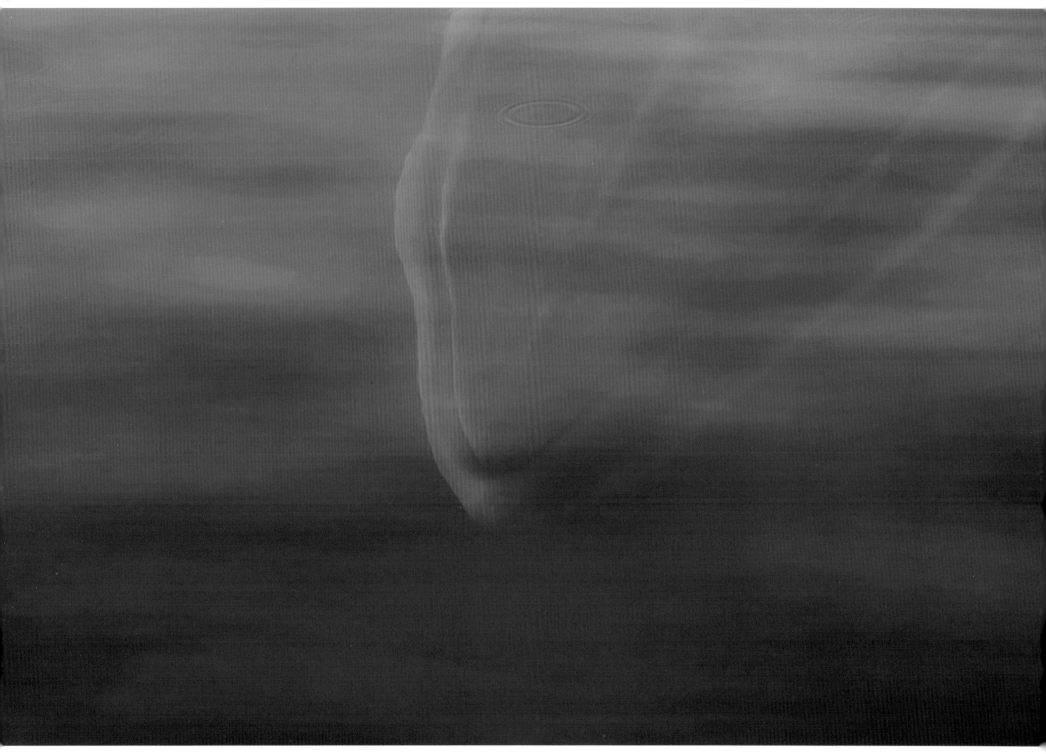

Minke whale, Antarctic Peninsula. Sue Flood, UK

WILD MOMENTS

Sue Flood UK

Highly Commended

Wow! Majestic beauty, gracefully encapsulated in a single ripple on the surface, created by an air bubble escaping from this gentle giant.

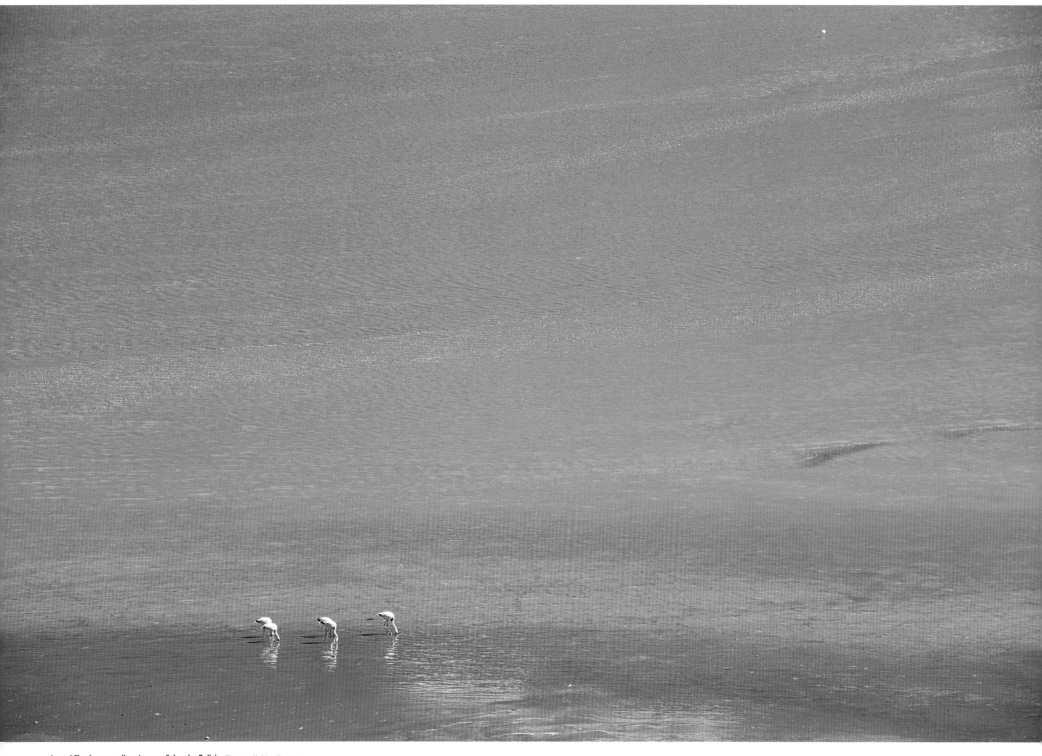

James' Flamingos wading, Laguna Colorada, Bolivia. Thomas Kokta, Germany

WILD MOMENTS

Thomas Kokta Germany
Highly Commended

Simplicity in isolation underlines Thomas's wild moment,
made all the more striking by the vibrant colour.

WILD MOMENTS

Evan McBride New Zealand
Commended

A wild moment and a wild interaction. Evan's image captures the theme perfectly and intimately.

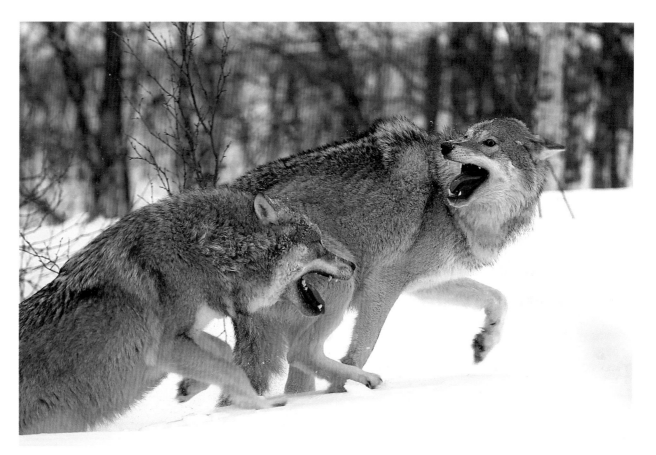

Scandinavian wolves, Norway. Evan McBride, New Zealand

WILD MOMENTS

Franco Banfi Switzerland
Commended

The simple, shimmering beauty of Franco's picture disguises the technical skill required to make this image and make it well.

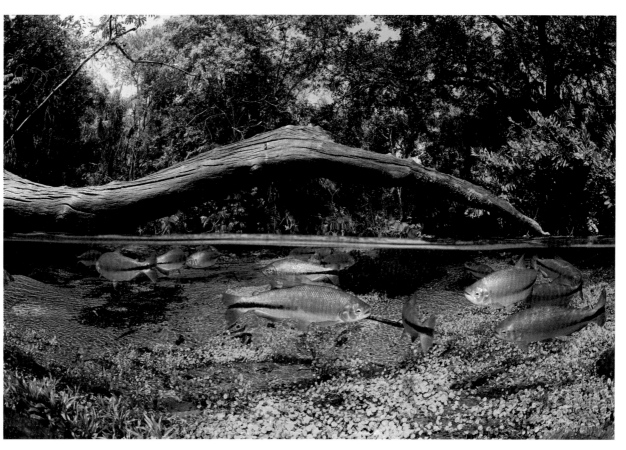

River Sucuri, Mato Grosso do Sul, Brazil. Franco Banfi, Switzerland

NEW TALENT 2011 —
DIARY OF A DESTINATION

The New Talent category encourages and supports aspiring photographers who want to make a career in photography. The photo-journalist skill of storytelling through pictures is a key tool for any professional photographer. In New Talent the judges look for a portfolio of images which show the ability to do this. In Edgard De Bono's portfolio, there is a sense of place and a varied pace to these photographs which give us an insight into his chosen destination, Senegal; capturing detail and movement, as well as the bigger picture.

Sponsors of this award:
Tribes Travel, Adobe, Lexar, Photo Iconic, Plastic Sandwich

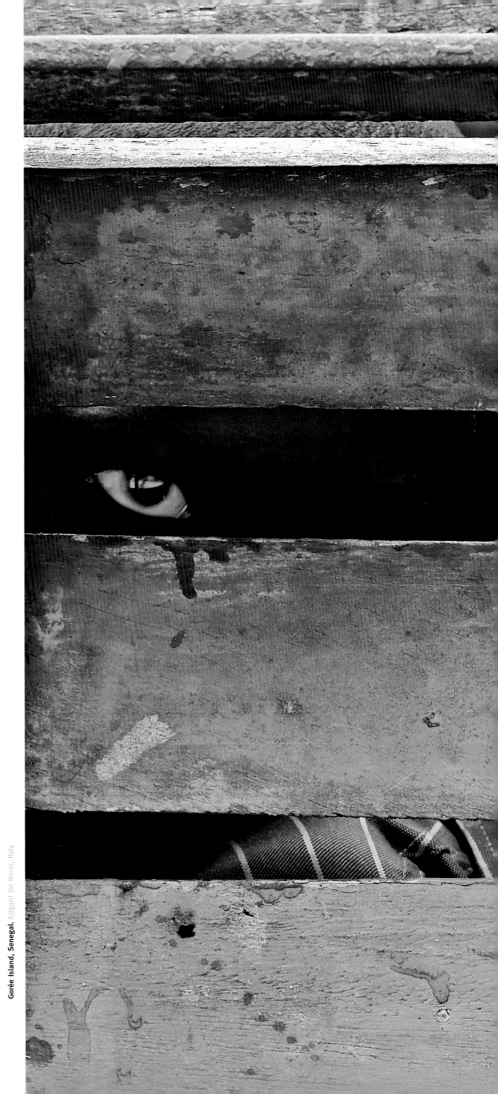

Gorée Island, Senegal. Edgard De Bono, Italy

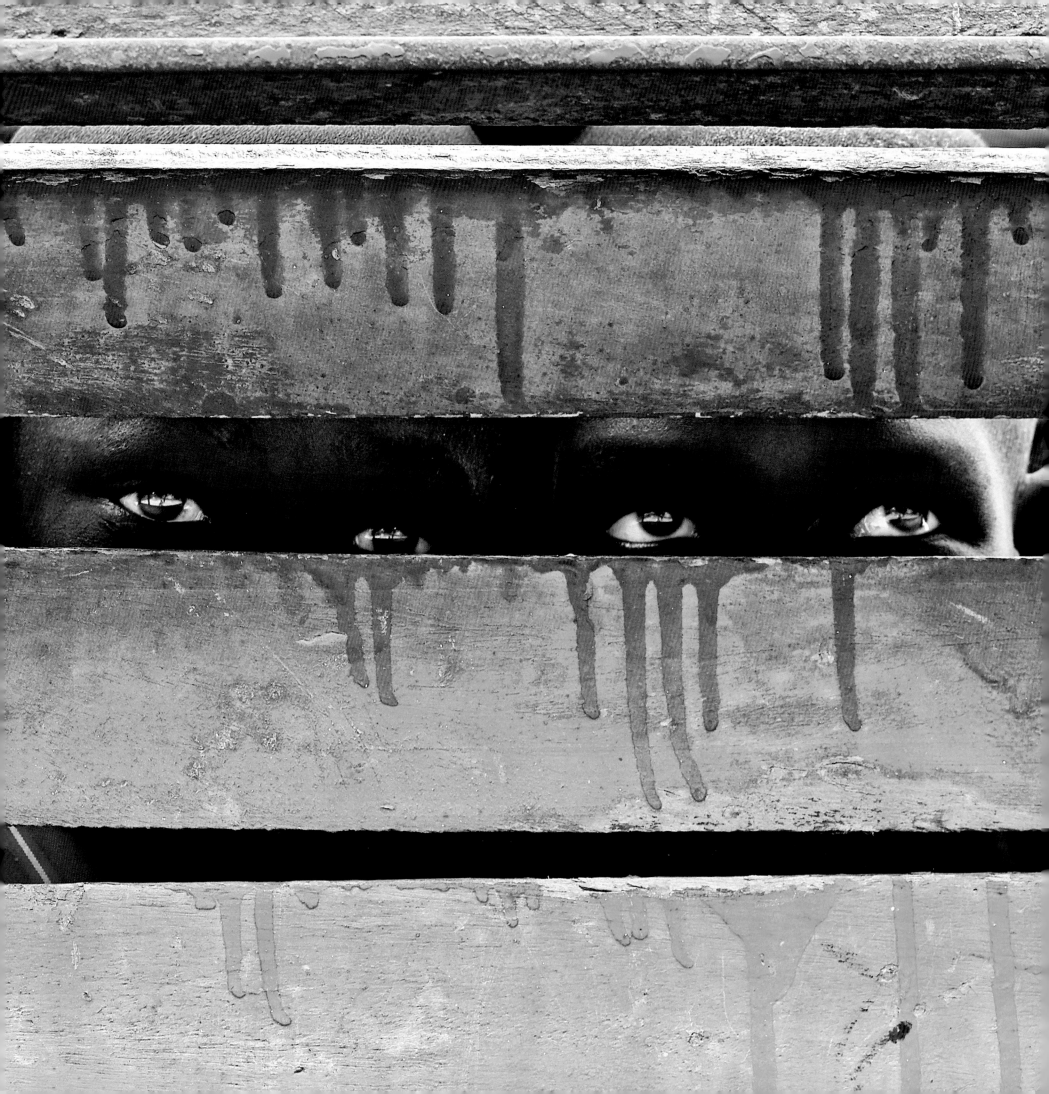

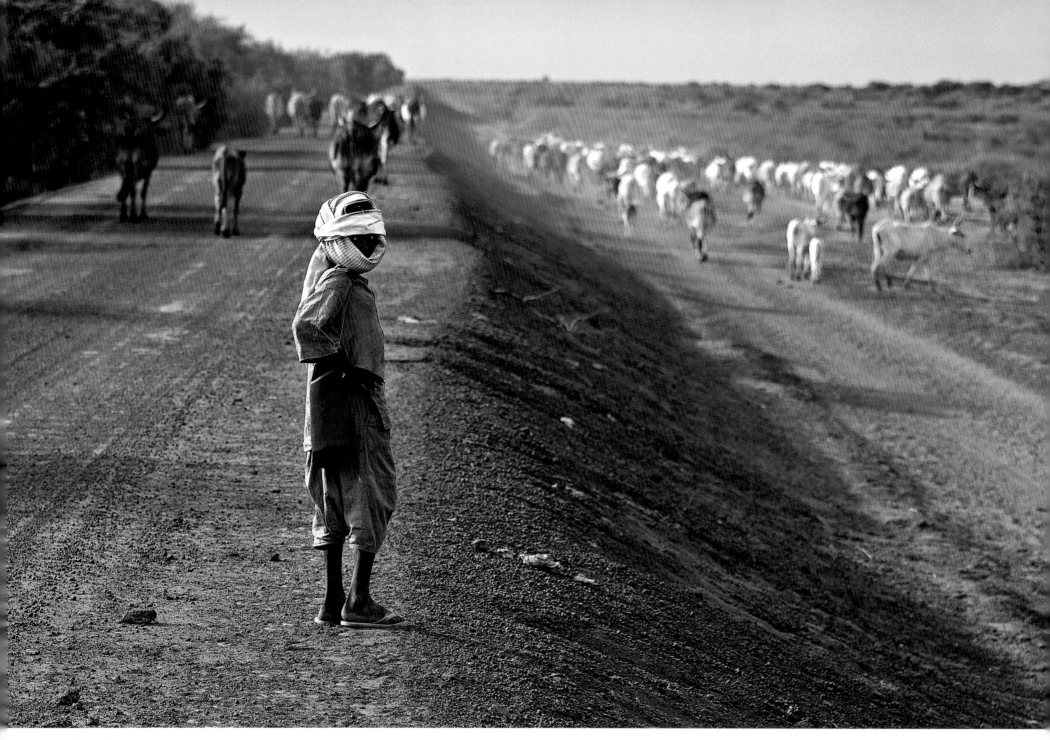

Djoudj, Senegal. Edgard De Bono, Italy

Saint-Louis, Senegal. Edgard De Bono, Italy

NEW TALENT

Edgard De Bono Italy

Winner

Edgard De Bono was born in Udine in 1986, and has had an interest in travel and photography since childhood, admiring and studying the great photographers in Magnum and National Geographic. After graduating as an electronic technician, he attended several photographic workshops in Italy and other countries, travelling to Morocco and Senegal with Vittorio Sciosia. The starting point for his growth as a photographer was a meeting with photographer Edoardo Agresti in Milan, and now he collaborates with different photo studios in his home town. His dream is to work as a freelance photographer for international magazines.

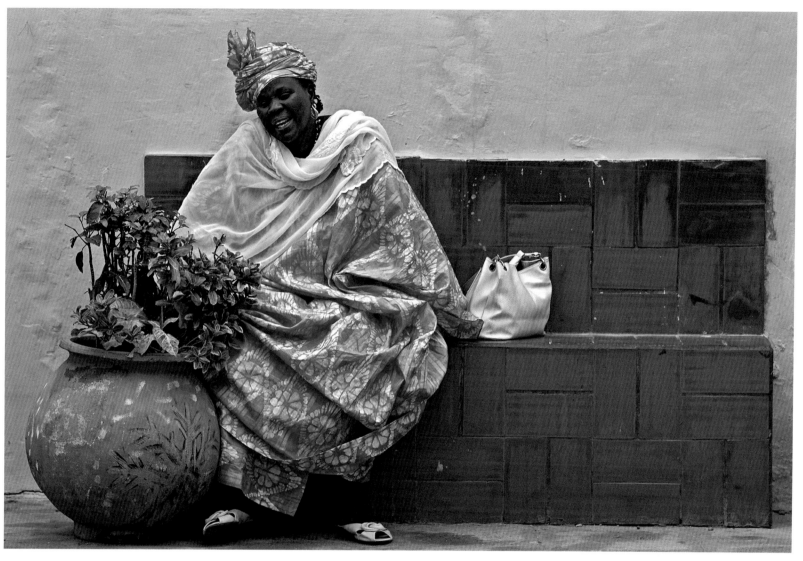

Gorée Island, Senegal. Edgard De Bono, Italy

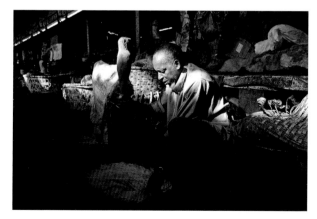

Dakar, Senegal. Edgard De Bono, Italy

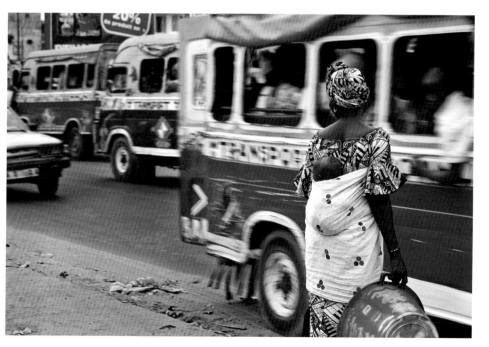

Dakar, Senegal. Edgard De Bono, Italy

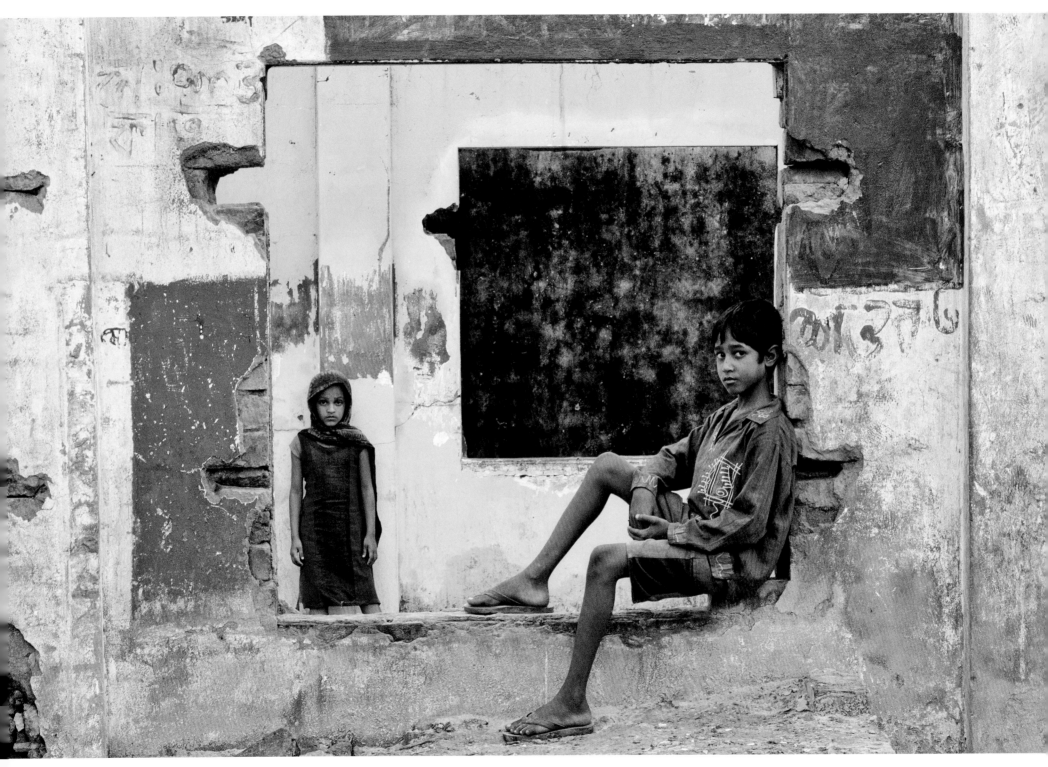

Khulna, Bangladesh. Jonathan Munshi, USA

NEW TALENT

Jonathan Munshi USA
Runner-Up

Jonathan's images transport us into the lives of these Bangladeshi city dwellers, capturing their struggles in poignant yet remarkably beautiful imagery.

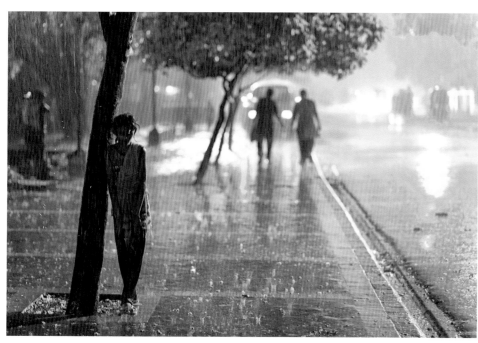

Dhaka City, Bangladesh. Jonathan Munshi, USA

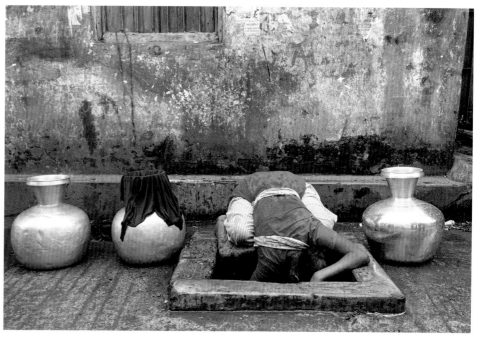

Diving for water, Dhaka City, Bangladesh. Jonathan Munshi, USA

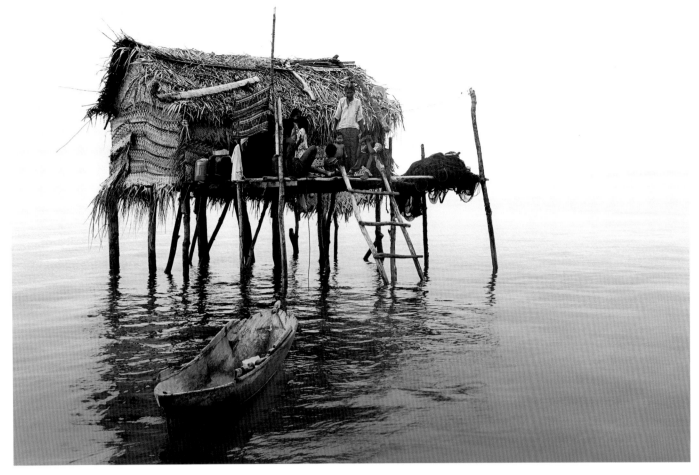

Celebes Sea, Semporna, North Borneo, Malaysia. Ling Cheong, Malaysia

NEW TALENT

Ling Cheong Malaysia
Highly Commended

Ling's softly lit portfolio introduces us to lives of the nomadic Bajau sea gypsies. His use of light, unconventionally shooting into the light gives an unusual yet engaging feel to his images.

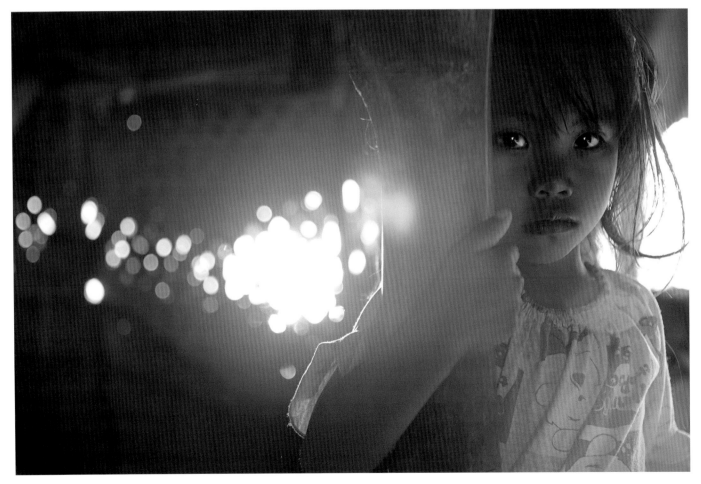

Celebes Sea, Semporna, North Borneo, Malaysia. Ling Cheong, Malaysia

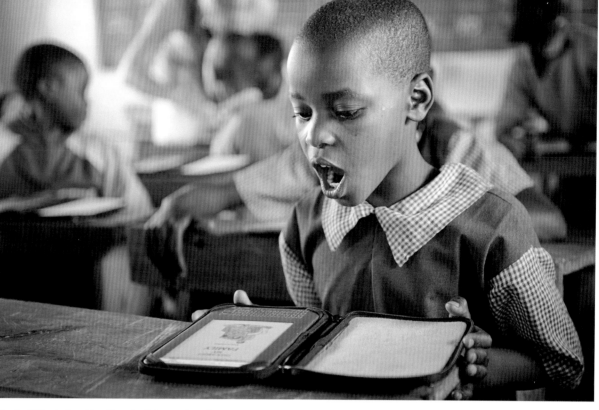

NEW TALENT

Jon McCormack Australia
Commended

Behind Jon's picture is a wonderful story of how his own charity brought Kindles to a rural Kenyan school, transforming the lives of its pupils and having an invigorating effect on their desire to learn.

It's a book! Kilgoris, Trans Mara, Kenya. Jon McCormack, Australia

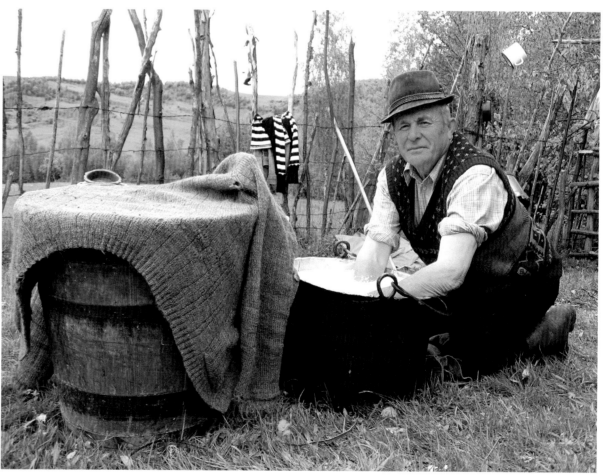

NEW TALENT

Minna Graber UK
Commended

Minna is an inexperienced photographer but has combined her journalistic skills with this new found passion for photography to tell the story of rural life in Romania.

Ardan, Romania. Minna Graber, UK

FIRST SHOT 2011 — WORK, REST, PLAY

The First Shot category is for less experienced, amateur photographers who are still learning their craft. The judges chose the two winners on the basis that their images show great potential and because they feel they will benefit most from the tuition on offer as a prize. Runner up and Commended entries were also chosen.

Sponsors of this award:
Adobe, Photo Iconic

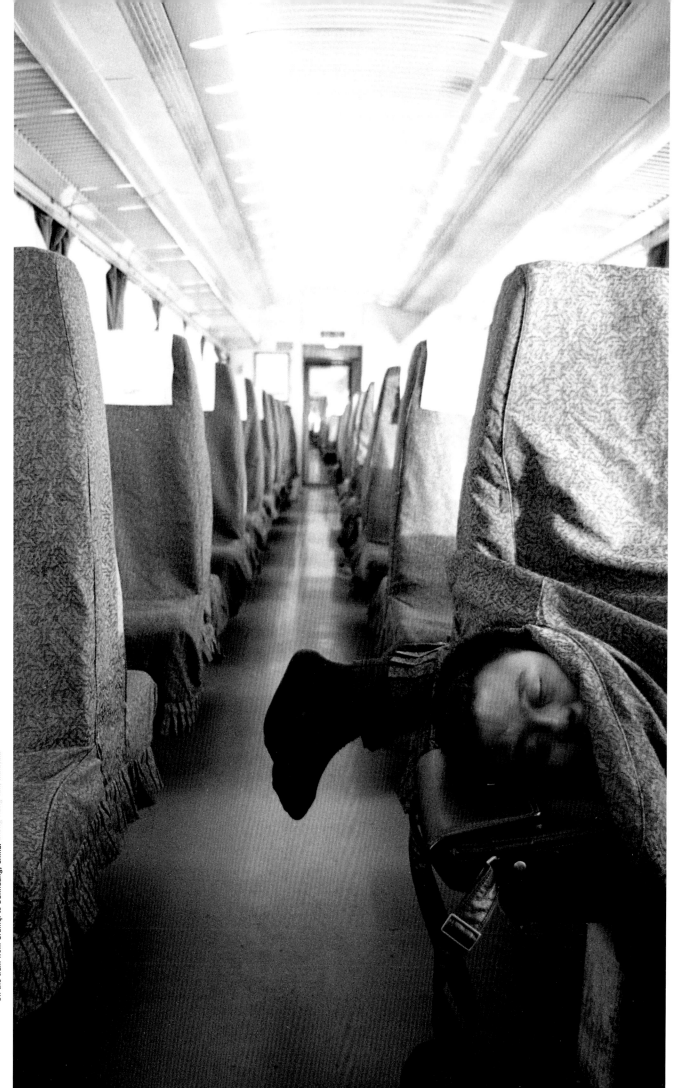

On the train from Urumqi to Dunhuang, China. Sheng Heng Tan, Malaysia

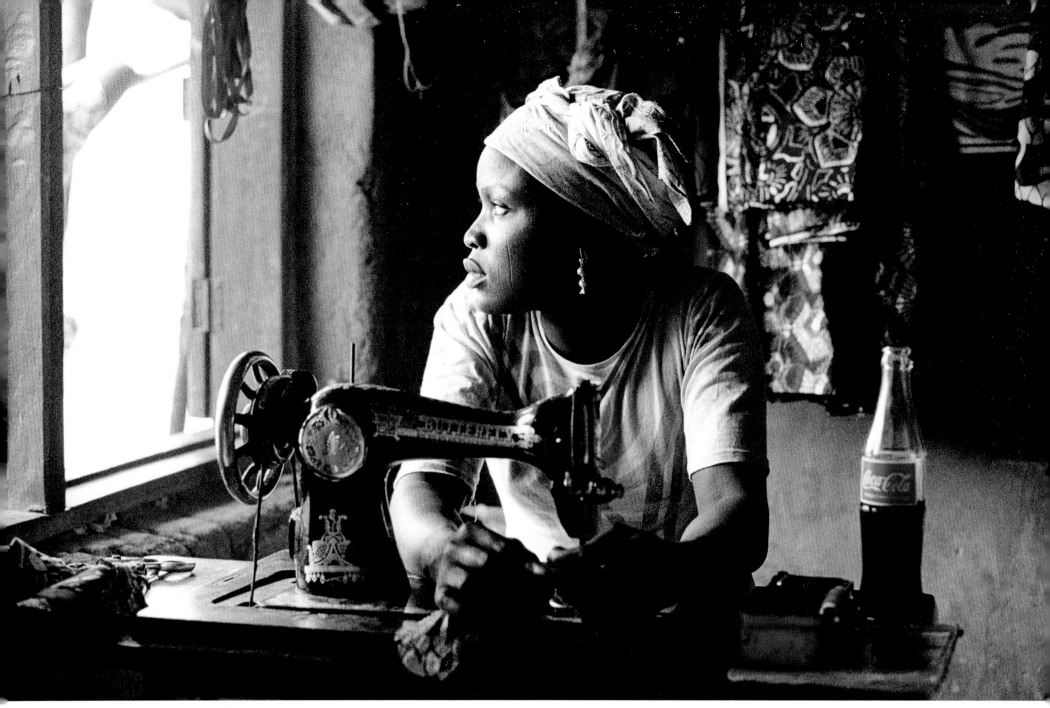

Esu, Northwest Cameroon. Guy Lankester, UK

FIRST SHOT

Guy Lankester UK
Winner

I'm working, but I'd rather be playing! Guy has captured a
wistful moment which we can all identify with.

FIRST SHOT

Sheng Hong Tan Malaysia
Winner

The wonderful humour in Sheng's whimsical image makes
you look again and again as you try to fathom it out.

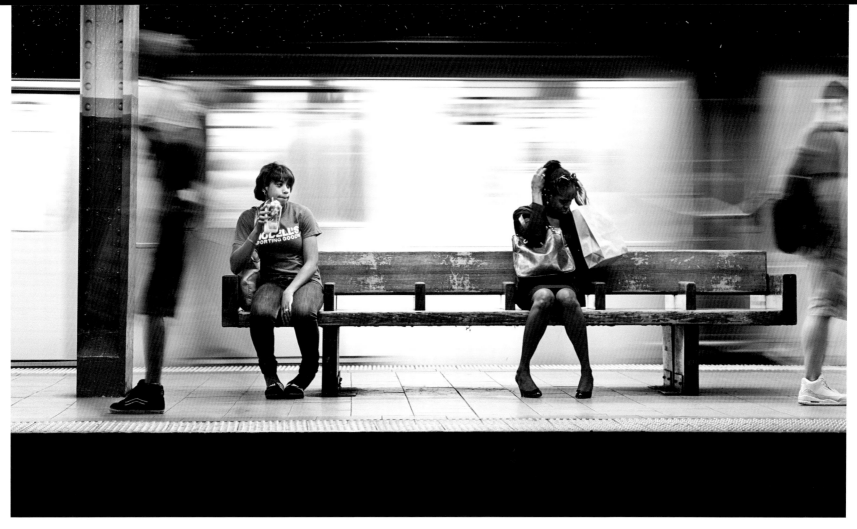

Subway, New York, USA. Renny Whitehead, UK

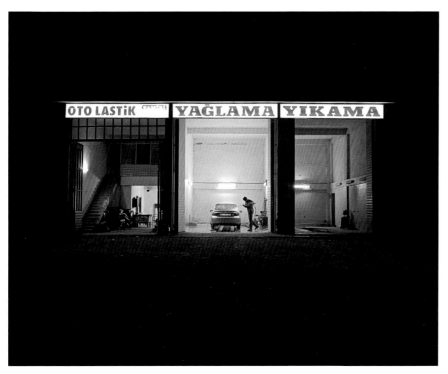

Isolated garage between Kars, Turkey and Tbilisi, Georgia. Damian Levingston UK

FIRST SHOT

Renny Whitehead UK
Runner Up

Renny's picture (above) sets the mundane process of waiting to travel against the sheer speed of the journey.

FIRST SHOT

Damian Levingston UK
Runner Up

A brief glimpse into another world leaves Damian's image posing more questions than it answers.

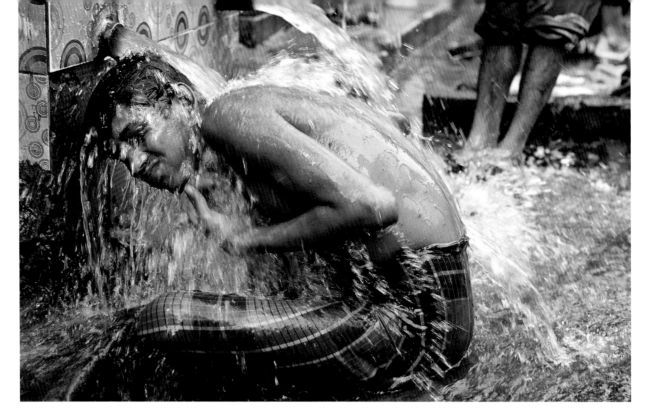

FIRST SHOT

Sumit Dua, USA
Commended

Kolkata (Calcutta), India. Sumit Dua, USA

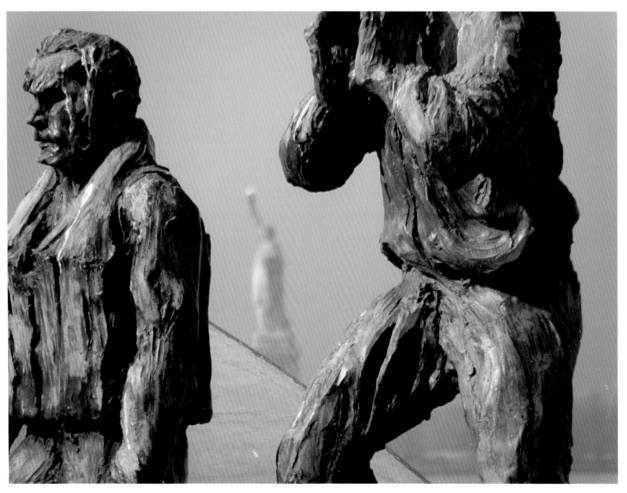

FIRST SHOT

Maria Filippidou Greece
Commended

American Merchant Mariners' Memorial, New York, USA. Maria Filippidou, Greece

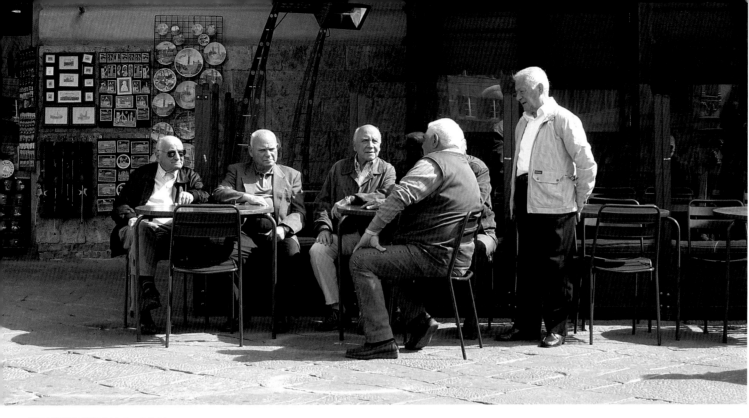

Siena, Tuscany, Italy. Kelvin Lee, Singapore

FIRST SHOT

Kelvin Lee Singapore
Commended

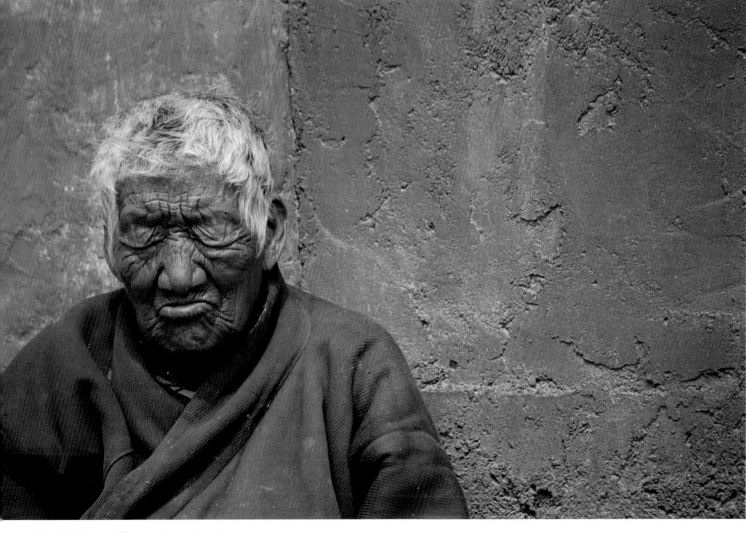

Yushu, Qinghai Province, China. Emil Mikkelsen, Denmark

FIRST SHOT

Emil Mikkelsen Denmark
Commended

BEST SINGLE IMAGE
IN PORTFOLIO 2011

Each year there are many portfolio entries which don't win prizes, but which contain outstanding individual images. In 2011 such images were chosen by the judging panel from all four portfolio categories, with further images of note awarded special mentions.

Sponsors of this award:

TPOTY, Genesis Imaging, Royal Geographical Society (with IBG)

Tongi, northern border of Dhaka, Bangladesh. Yeow Kwang Yeo, Singapore

Tattered prayer flag, Chele La pass, Bhutan. Richard Murai, USA

NATURAL ELEMENTS

Richard Murai USA
Winner

Eerie and spiritual.

EXOTIC

Yeow Kwang Yeo Singapore
Winner

A delightfully engaging image that takes rail travel to new
heights of popularity!

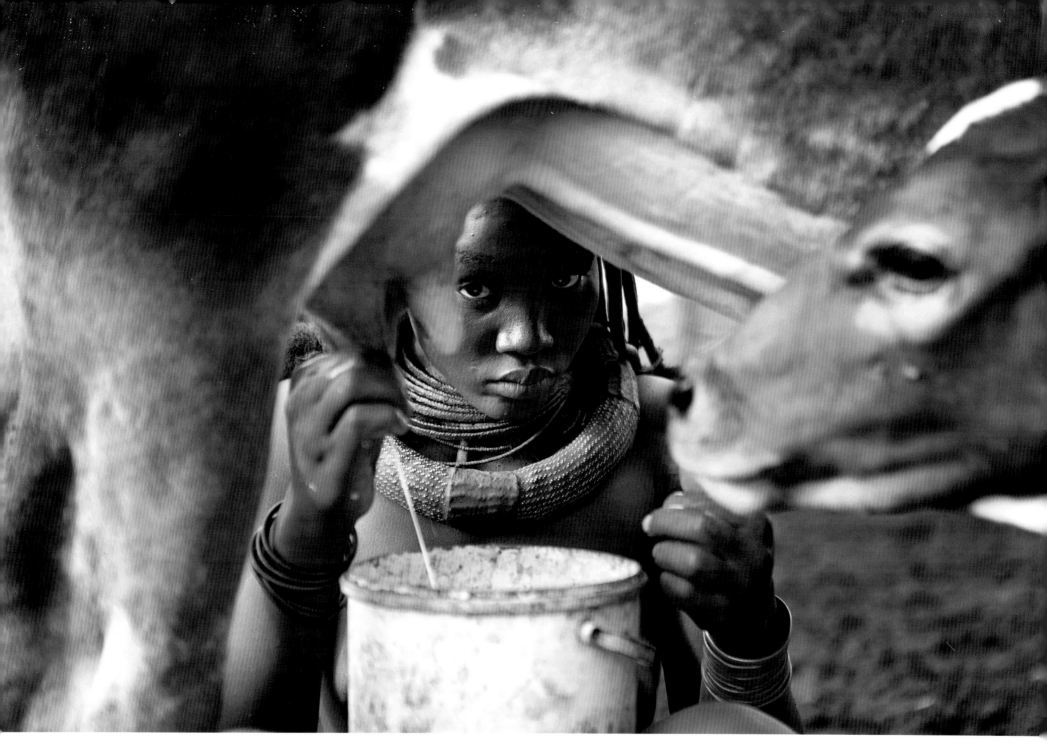

Ohamaremba, Opuwo, Namibia. Malin Palm, Sweden

CULTURES AND TRADITIONS

Malin Palm Sweden
Special Mention

Who's watching who?

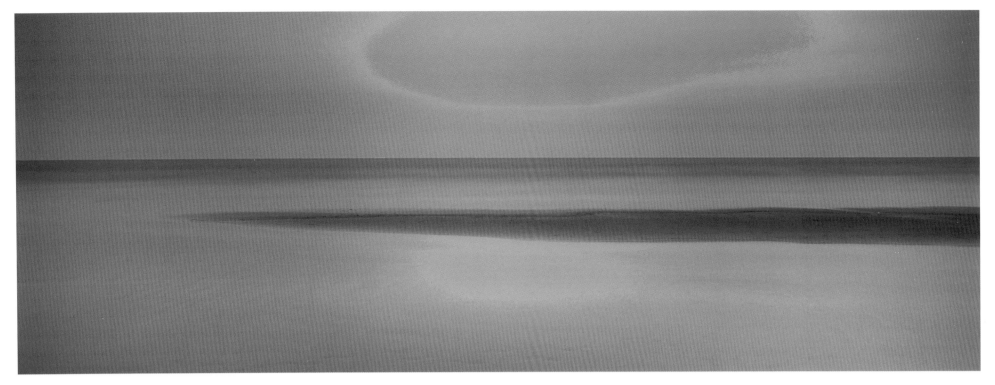

Arambol, Goa, India. Ben Pipe, UK

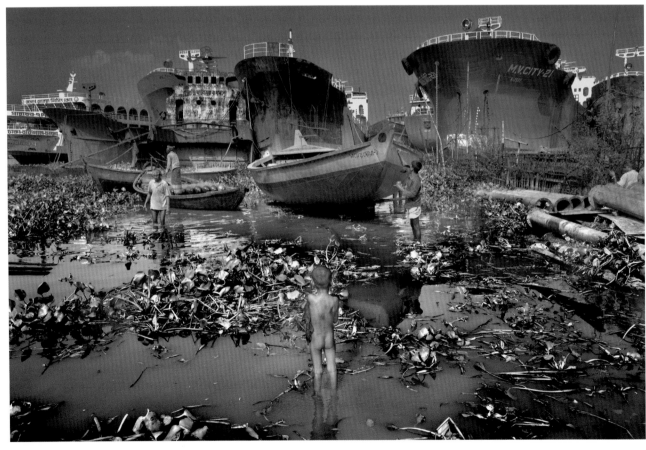

Buriganga River, Dhaka, Bangladesh. Larry Louie, Canada

NATURAL ELEMENTS

Larry Louie Canada
Special Mention

What are we doing to our amazing planet?

NATURAL ELEMENTS

Ben Pipe UK
Special Mention

Ethereal in its simplicity.

CULTURES AND TRADITIONS

Philip Lee Harvey UK
Winner

Light on a canvas in gently contrasting colours makes this
image a captivating glimpse into a mysterious culture.

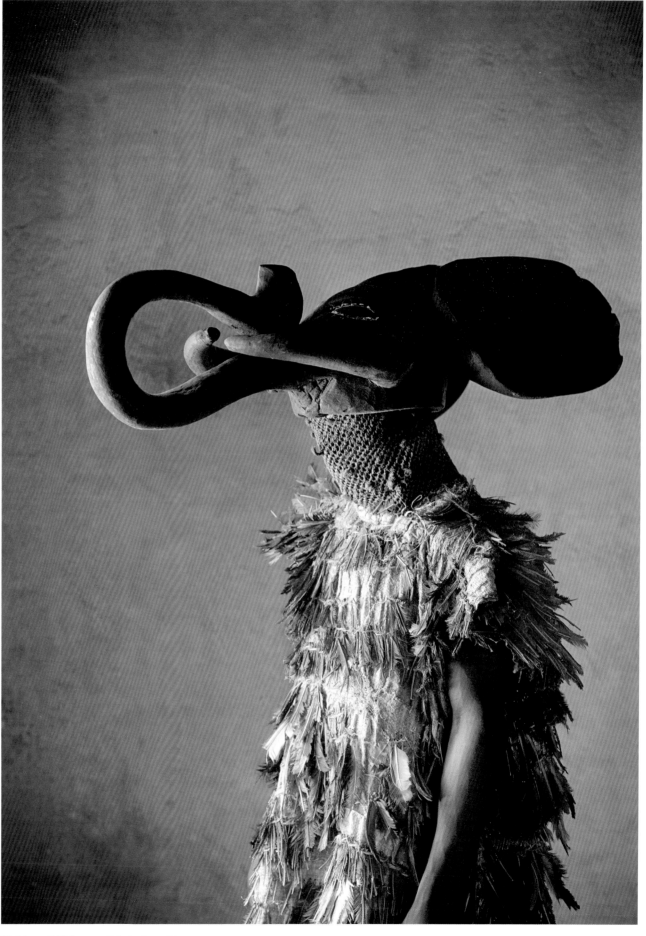

Tribal dancer, Bafut, Cameroon. Philip Lee Harvey, UK

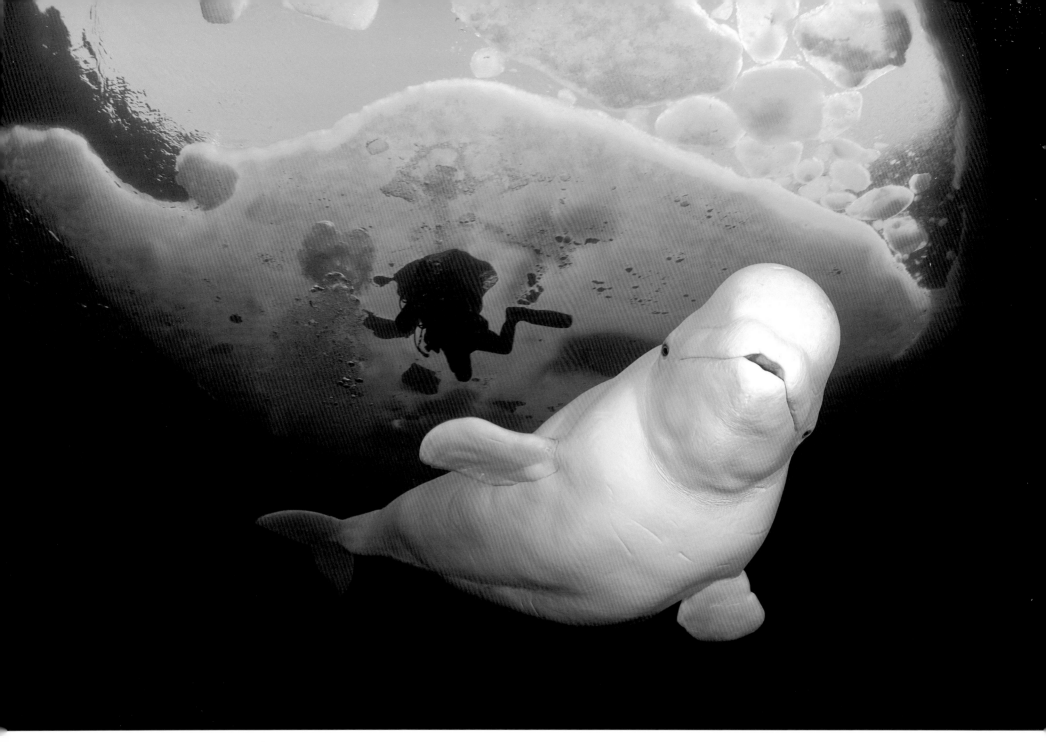

Playful beluga whale, White Sea, Karelia Region, Northern Russia. Franco Banfi, Switzerland

SPIRIT OF ADVENTURE

Franco Banfi Switzerland
Winner

A truly magical moment -- a privilege to share.

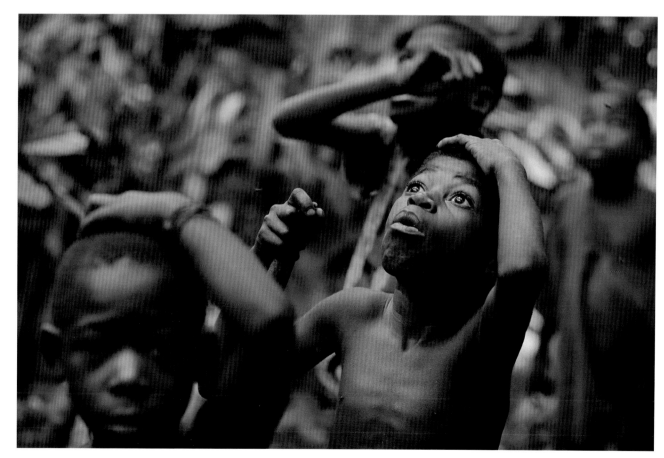

NATURAL ELEMENTS

Doran Talmi Israel
Special Mention

An intense icy chill, vivid colour and impressive geometry.

Ice chunks from glacier, Jökulsárlón, Iceland. Doran Talmi, Israel

CULTURES AND TRADITIONS

Timothy Allen UK
Special Mention

Watching the honey gatherer – full of awe and expectation!

Bayaka children, Congo Basin, Central African Republic. Timothy Allen, UK

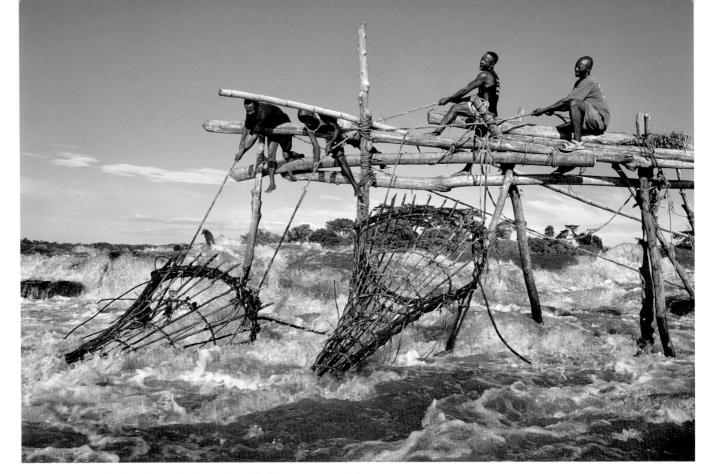

SPIRIT OF ADVENTURE

Johnny Haglund Norway
Special Mention

You can bet the fish tasted good after all this effort!

Fishermen checking traps for fish, Tshopo Province, Democratic Republic of Congo. Johnny Haglund, Norway

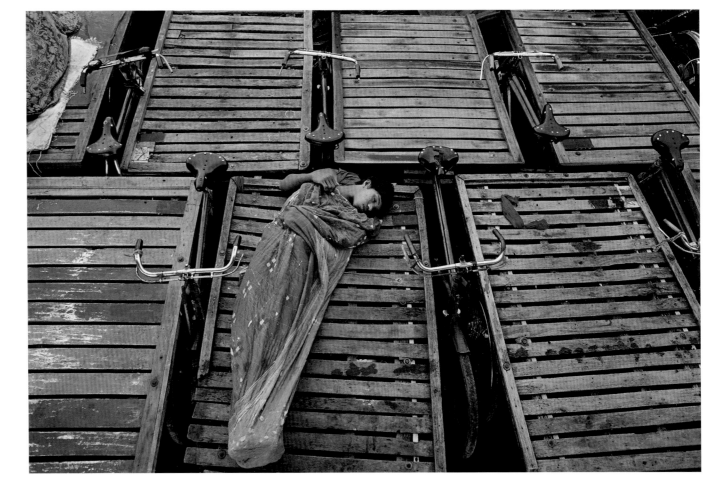

EXOTIC

GMB Akash Bangladesh
Special Mention

A quiet, well-observed moment between rush hours.

Dhaka, Bangladesh. GMB Akash, Bangladesh

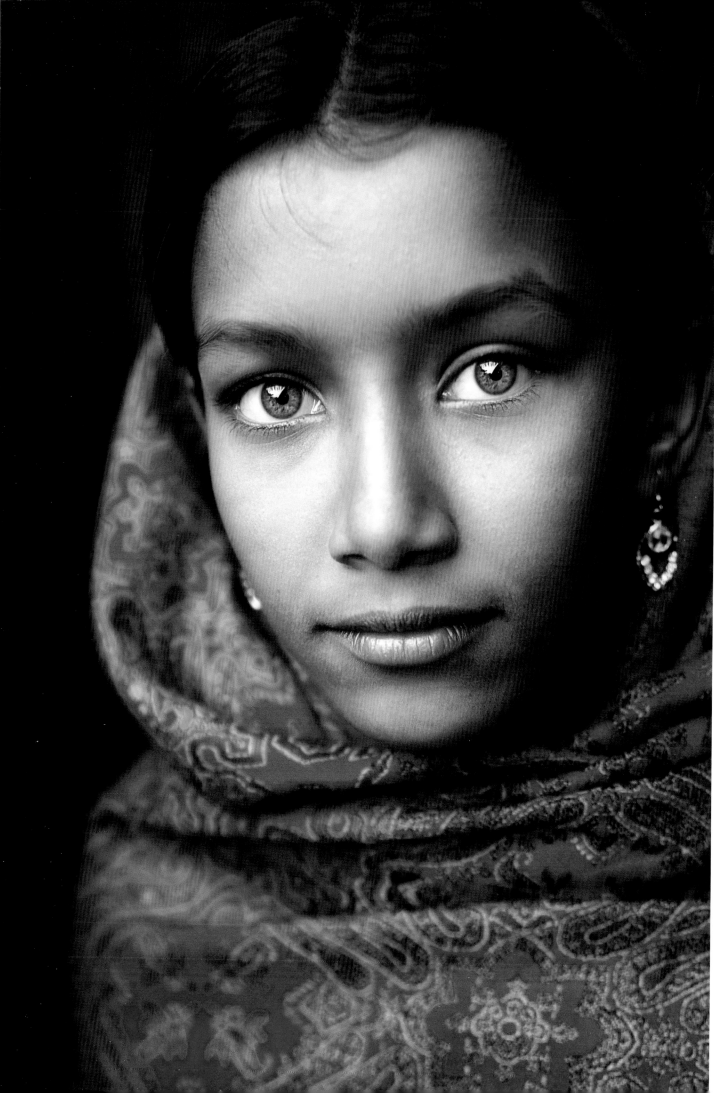

Putia, Bangladesh. David Lazar, Australia

EXOTIC

David Lazar Australia
Special Mention

An intensely beautiful young woman and image.

TRAVEL PHOTOGRAPHER OF THE YEAR 2010

Larry Louie's photographs draw the viewer in to share their intricate, and sometimes humorous, detail. Their beautiful and often precise composition creates images which not only have an immediate impact, but also linger. A joyous celebration of life and light which intrigues and illuminates.

Sponsors of this award:

Intrepid Travel, Adobe, Lexar, Plastic Sandwich

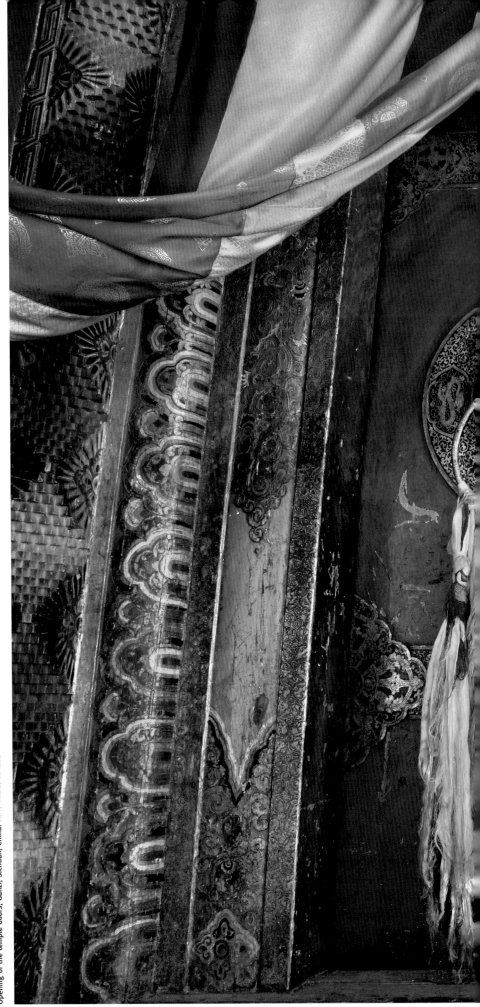

Opening of the temple doors, Ganzi, Sichuan, China. Larry Louie, Canada

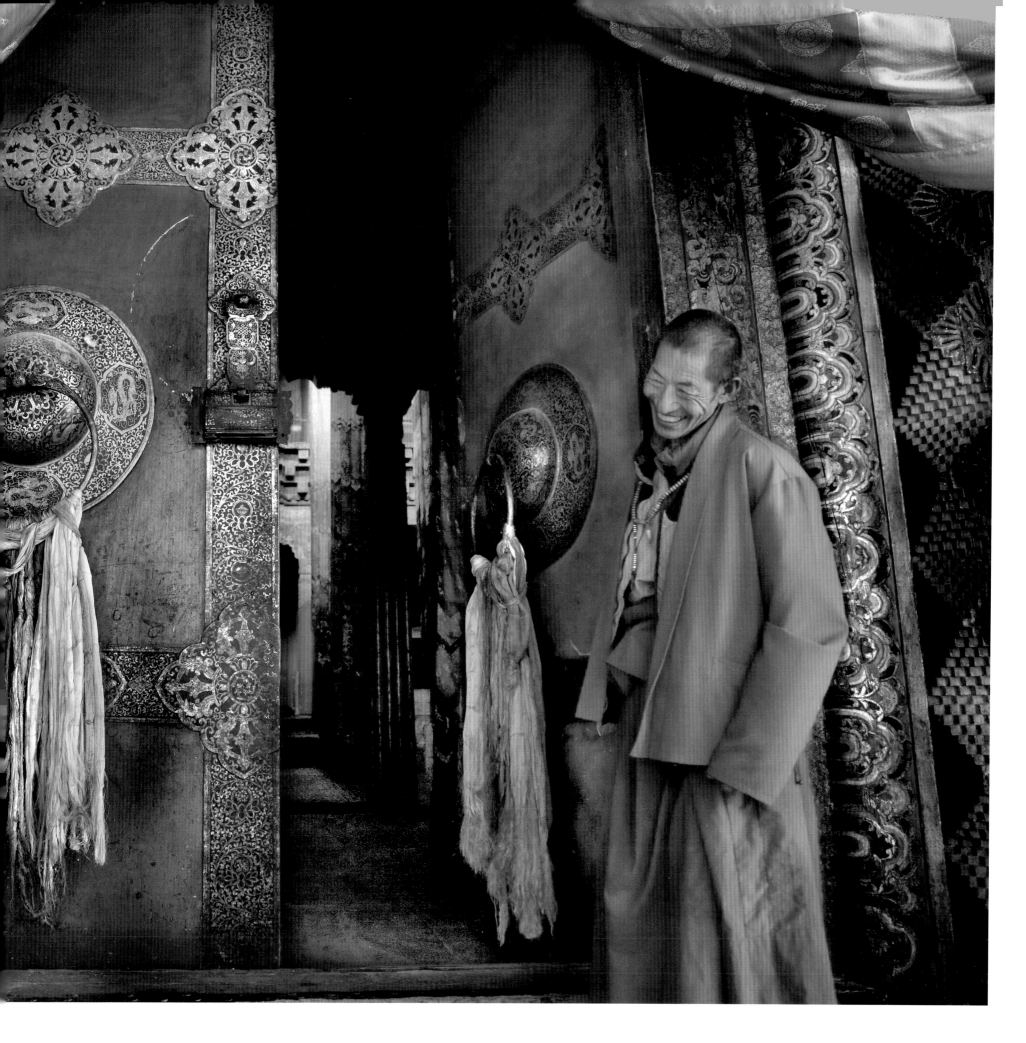

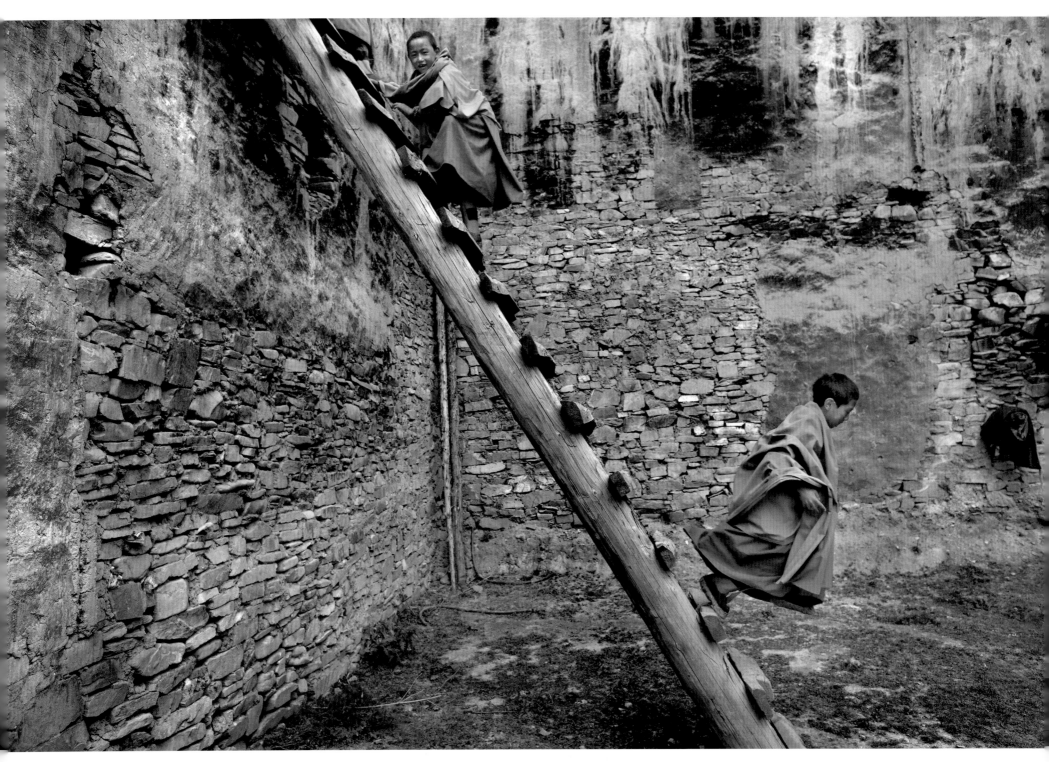

Defying gravity, Ganzi, Sichuan, China. Larry Louie, Canada

TRAVEL PHOTOGRAPHER
OF THE YEAR 2010

Larry Louie Canada
Winner

Larry Louie leads a dual career. In his optometry clinic, he is Dr. Larry Louie, working to enhance the vision of people from all walks of life in the urban core of a North American city. On his travels, he is a humanitarian documentary photographer, exploring the lives of remote indigenous people, and documenting social issues around the world. As an optometrist, Larry adjusts people's visual perception. As a photographer, he seeks to adjust people's view of the world. Either way, he is interested in things that exist outside the regular field of vision.

Over the last few years, he has used his photography as a platform to highlight the work of Seva Canada and its partners, along with other social issues and challenges people are encountering in a world facing rapid urbanization and globalization. He wants to engage people in inspiring stories of perseverance and strength, not only of those who have found themselves caught in such a plight, but also amazing individuals and organizations that are lending a helping hand. From Seva Canada's Vision 20/20 Goal the global initiative for the elimination of preventable and avoidable blindness in the world by year 2020, to the United Nations Development Program's Millennium Development Goals to End Poverty, he hopes his photographs will be able to tell the stories and make a difference, and to reveal light that is found in the darkest of places.

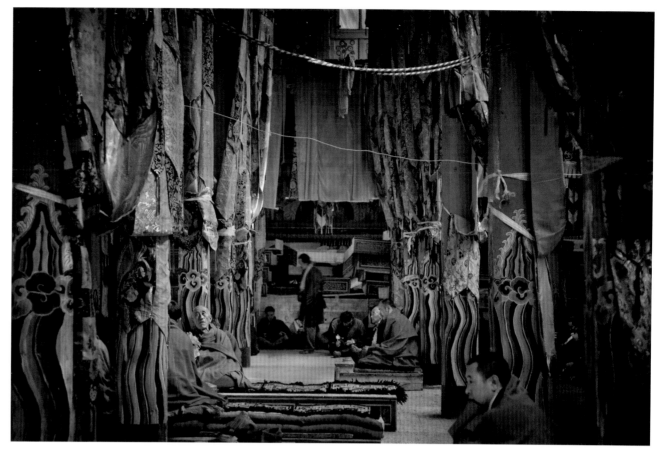

Tibetan monastery, Ganzi, Sichuan, China. Larry Louie, Canada

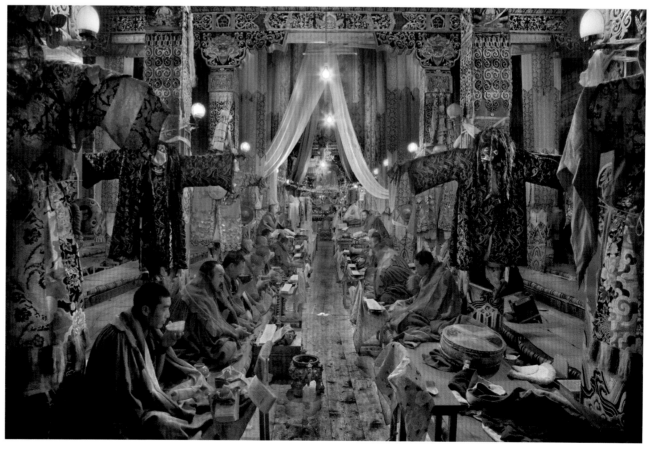

Tibetan monastery, Ganzi, Sichuan, China. Larry Louie, Canada

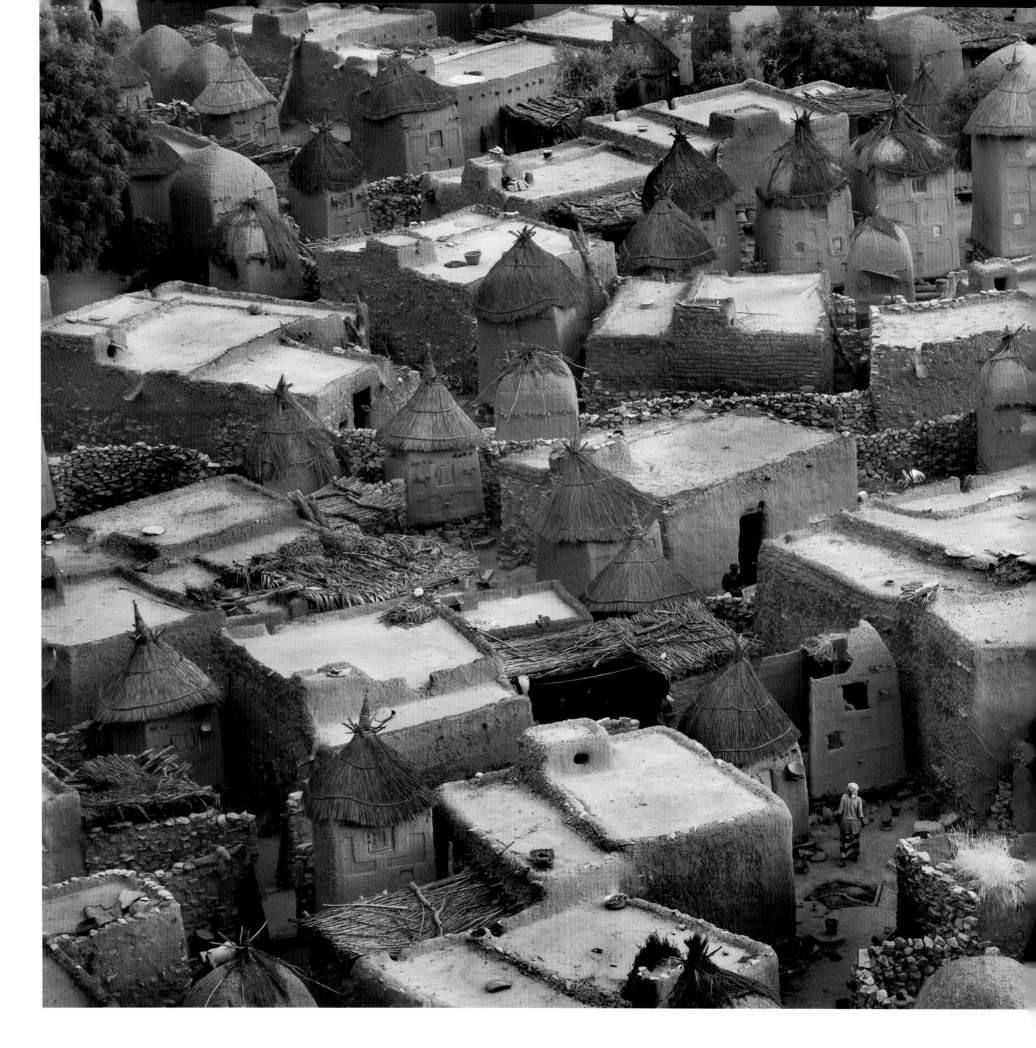

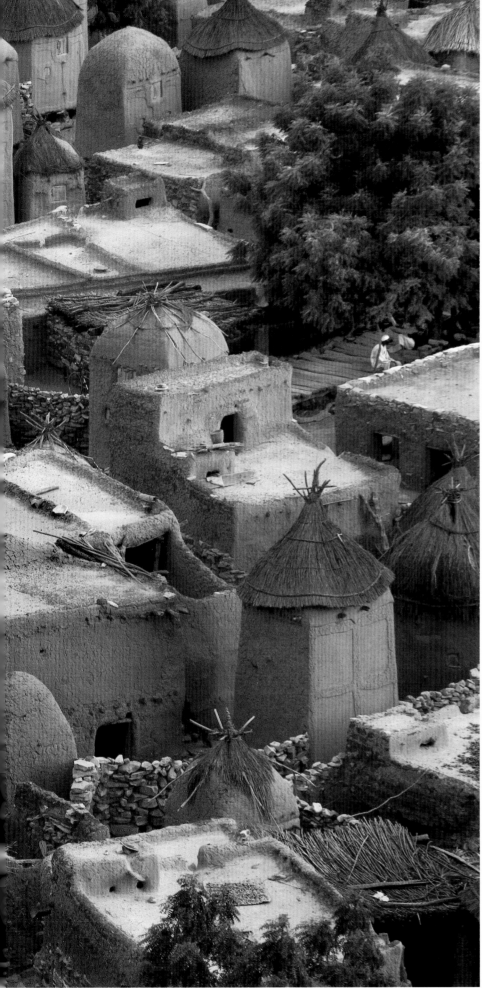

Dogon village, Djenné, Mali. Larry Louie, Canada

Morning market, Djenné, Mali. Larry Louie, Canada

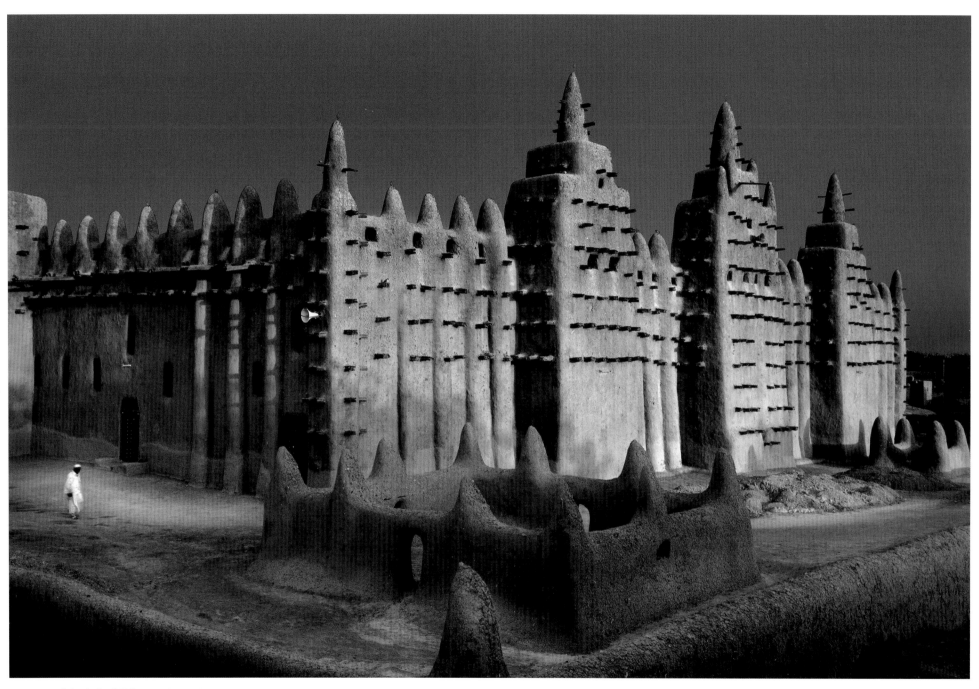

Great Mosque of Djenné, Djenné, Mali. Larry Louie, Canada

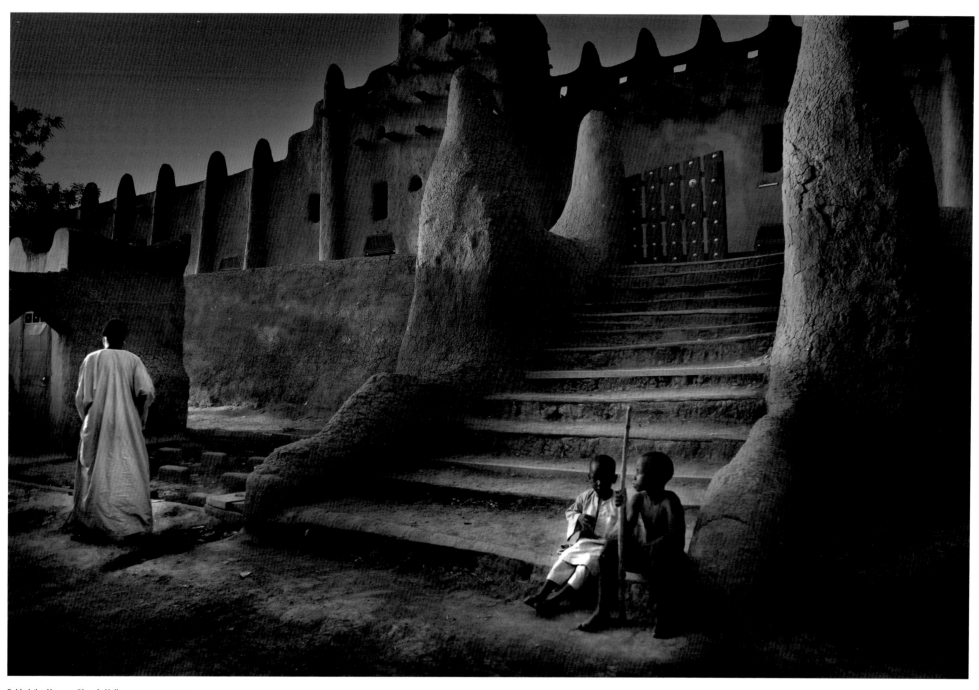

Behind the Mosque, Djenné, Mali. Larry Louie, Canada

YOUNG TRAVEL PHOTOGRAPHER OF THE YEAR 2010

Big World Small World: Seventeen-year-old Kat Waters interpreted the theme through a series of images linking places situated along London's Hammersmith and City underground line. Her approach to her portfolio is considered and inventive. The observed moments which she captured tell a story of daily life and the cosmopolitan nature of the capital.

Sponsors of this award:

Adobe, Wacom, Lexar, Photo Iconic, Young Photographers' Alliance

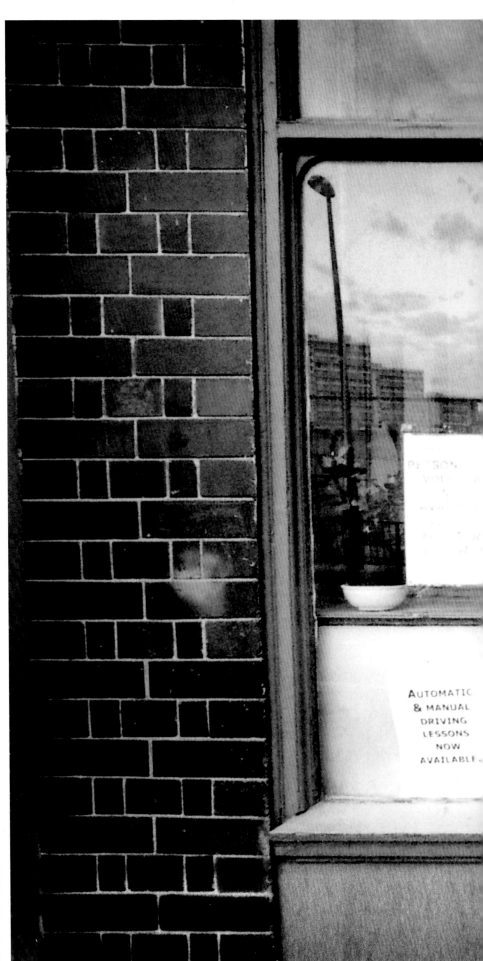

Westbourne Park, London, UK. Kat Waters, UK

WILL BE BACK IN
10 MINUTES
SORRY FOR THE
INCONVENIENCE

CUSTOMERS ENQUIRIES
DRIVING INSTRUCTORS
ENTRANCE

NO SMOKING.

Farringdon, London, UK. Kat Waters, UK

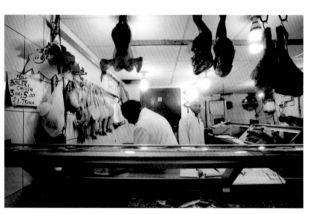

Shepherd's Bush Market, London, UK. Kat Waters, UK

YOUNG TRAVEL PHOTOGRAPHER OF THE YEAR 2010

Kat Waters UK
Winner
Joint Winner of the Young Photographers'
Alliance Emerging Talent Award

Kat Waters has been photographing the world since before she can remember. Her father, a professional studio photographer, bought her her first camera at the age of five, and she barely went anywhere without it. In 2000, aged seven, she had her photographs exhibited in London for the first time, in the BBC London Photographic Awards. In 2004, she won the very same competition in the under-18s category, aged 10. Things got quieter when she went to secondary school, but this changed in 2007 when an earlier YTPOTY portfolio was awarded 'commended finalist', and after that she began to enter more international competitions. In 2009, she won Young Garden Photographer of the Year.

In early 2010, Kat began to develop a love for using black-and-white film with her dad's old camera and her mum's old wide-angle lens; this passion grew into an obsession after she won the under-25s Black and White Photographer of the Year 2010. She doesn't know where the future will take her, but she knows she'll always be a photographer.

YOUNG TRAVEL PHOTOGRAPHER OF THE YEAR 2010

Chase Guttman (age 13) USA
Winner — Under 14 age group

Already an intrepid young adventurer and world traveller, Chase Guttman's photographic endeavours have taken him to more than 40 countries. The son of a travel photographer, Chase was exposed to the techniques, display and evaluation of photography before he could even speak. Since then his passion for the visual arts and the beauty of the planet has only grown stronger. Although still a teenager, he already has a popular photography tips and guide blog and has undertaken assignments for publications.

As with all young photographers, Chase is still developing a style, but his willingness and enthusiasm to experiment with viewpoint and to engage with the subjects is already evident in his pictures.

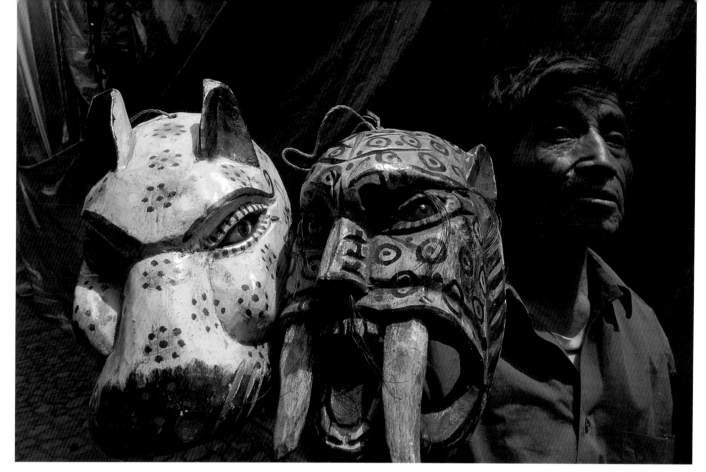

Chichicastenango, Guatemala. Chase Guttman, USA

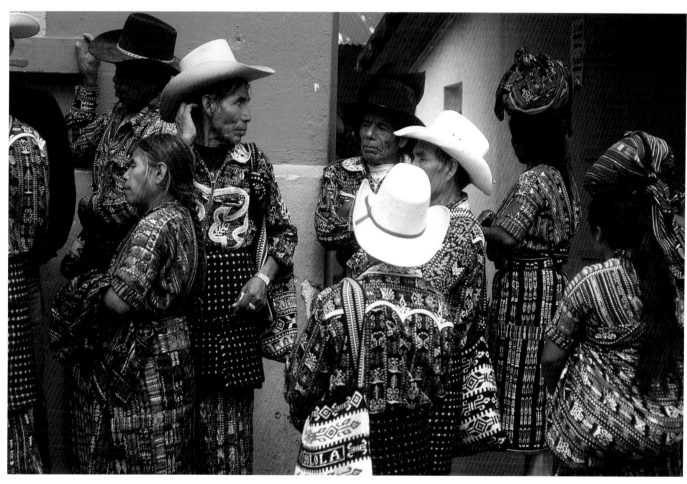

Solola, Guatemala. Chase Guttman, USA

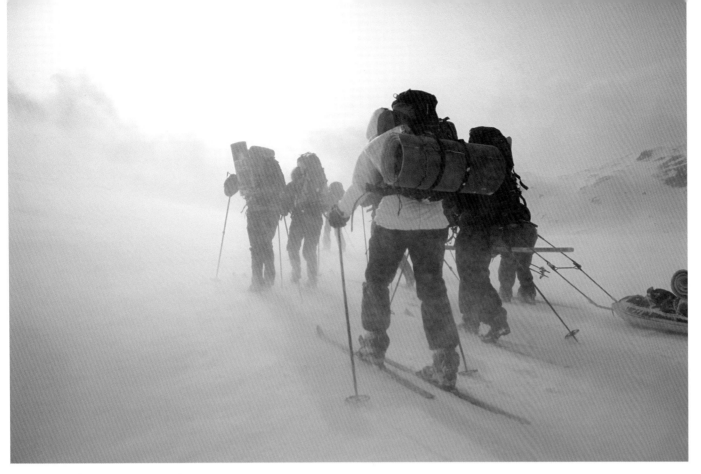

Snowstorm, Skarvheimen, Norway. Ivar August Bull, Norway

YOUNG TRAVEL PHOTOGRAPHER OF THE YEAR 2010

Ivar August Bull (age 18) Norway
Winner — 15–18 age group
Joint Winner of the Young Photographers'
Alliance Emerging Talent Award

Ivar August Bull is from the western part of Norway, known for its fjords, mountains and glaciers. He has been attending high school in the wilderness. He has a love of outdoor life, hiking, skiing, whitewater rafting, fishing, hunting and climbing, and his interest in photography started three years ago. Six months later he got his first SLR camera, and one of his teachers, a gifted photographer, inspired him.

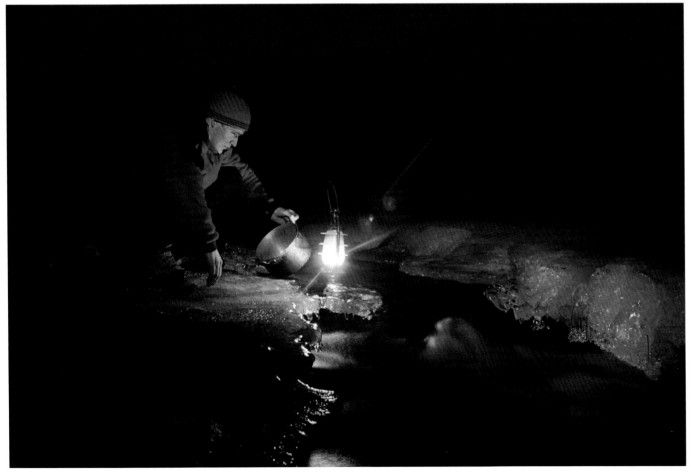

Brekkedalen, Voss, Norway. Ivar August Bull, Norway

The Emerging Talent Award is about nurturing talent and potential. Two photographers shared this award in 2010: Kat Waters (see pages 90 — 93) and Ivar August Bull. Ivar's photography already shows promise in managing to capture balanced detail in challenging light conditions through careful control of exposure. His portfolio was shot in his homeland, Norway, in freezing conditions and shows the beginnings of an important ability to tell a story through his images.

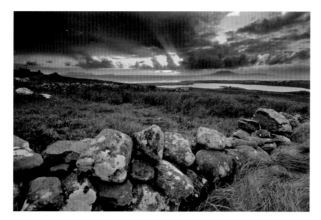
County Mayo, west coast of Ireland. Freddie Reed, UK

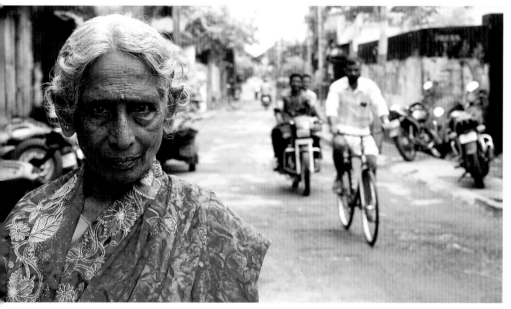
Kochi (Cochin), India. Gali Lucas, UK

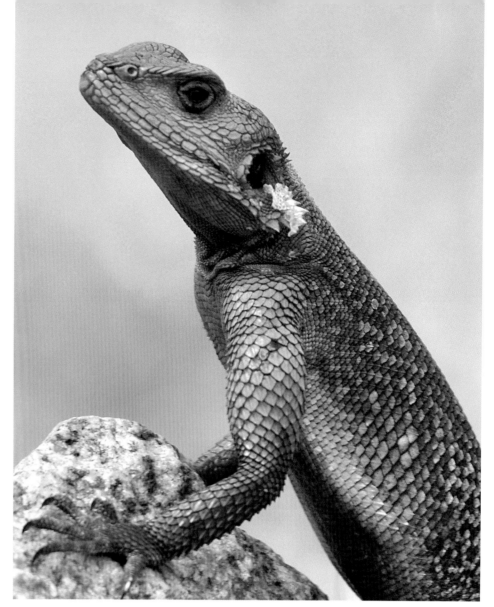
Agama lizard, Tanzania. Sam Baylis, UK

YOUNG TRAVEL PHOTOGRAPHER OF THE YEAR 2010

Freddie Reed (age 18) UK
Commended — Landscape, 15–18 age group

Gali Lucas (age 18) UK
Runner Up — People, 15–18 age group

Sam Baylis (age 14) UK
Runner Up — Under 14 age group

Haoqing Cheng (age 15) China
Commended — Landscape, 15–18 age group

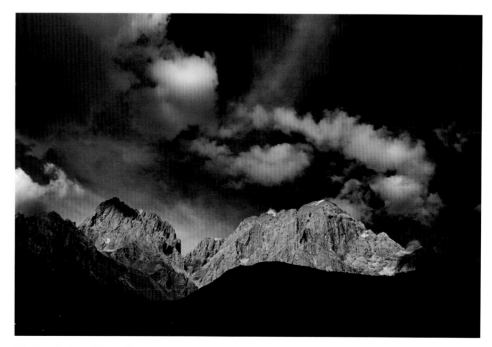
Saint Mountain, Garze, Sichuan, China. Haoqing Cheng, China

AMAZING PLACES
PORTFOLIO 2010

Shot with a fairly basic camera while on a challenging expedition in Greenland, Quintin Lake's minimalist images of a vast and empty landscape are magnificent in their simplicity. What appear at first glance to be small snow dunes are in fact huge mountains, serving only to enhance the grandeur of this fragile wilderness.

Sponsors of this award:

Adobe, Wacom, Lexar, Lee Filters, Photo Iconic

Knud Rasmussen Land, East Greenland, Arctic. Quintin Lake, UK

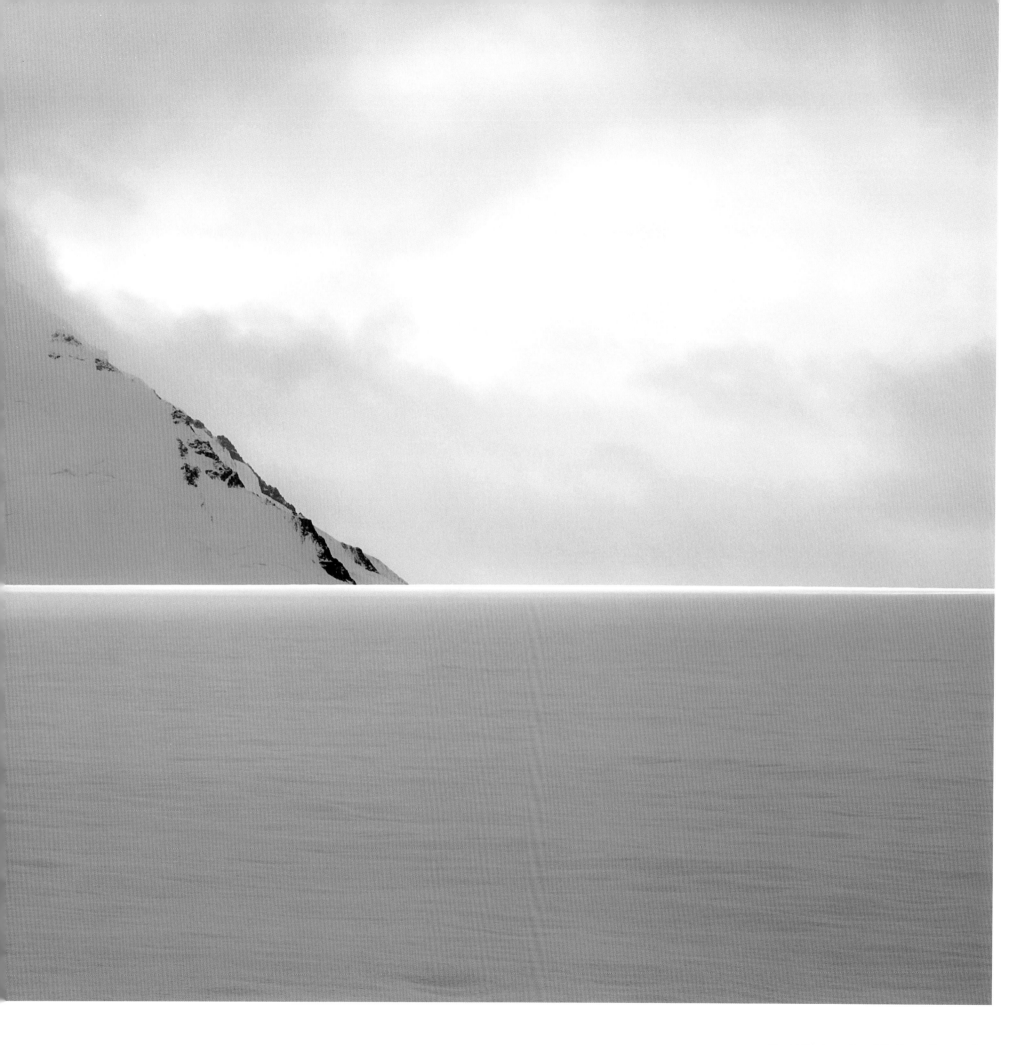

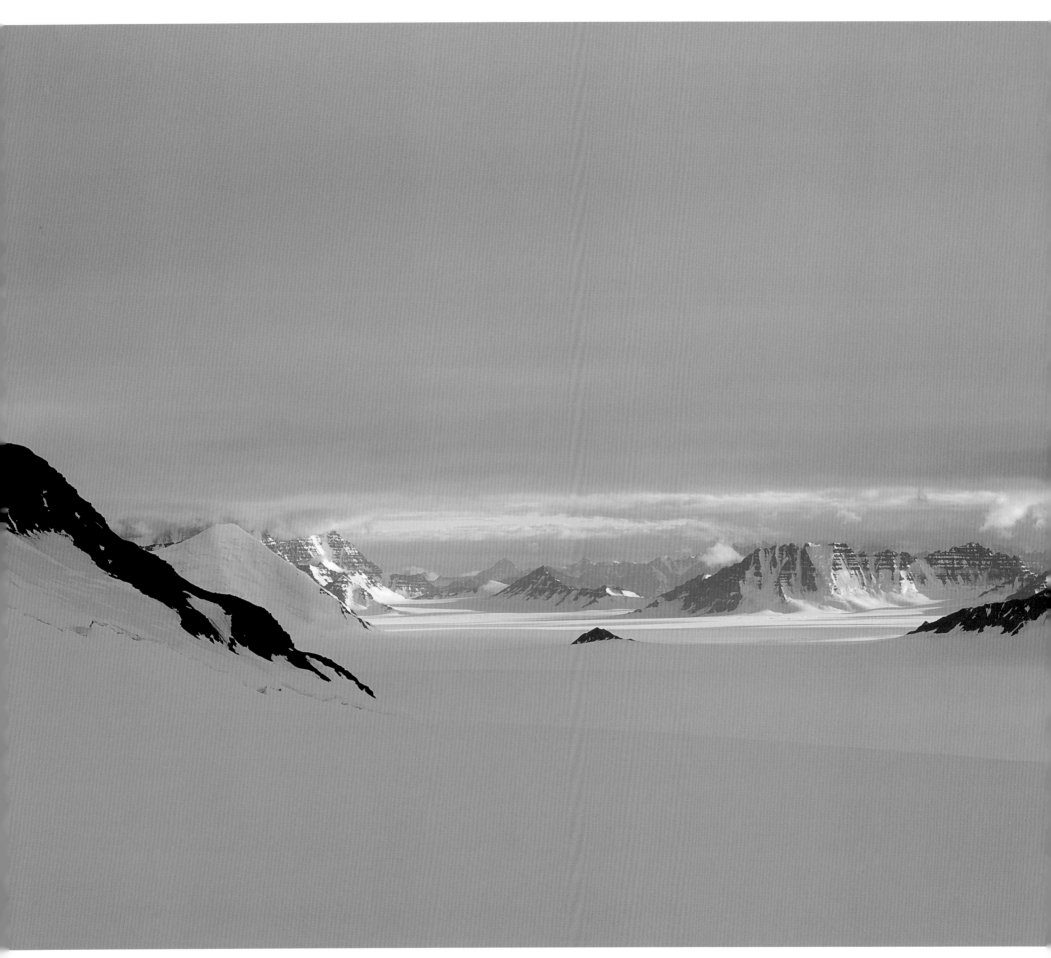

Knud Rasmussen Land, East Greenland, Arctic. Quintin Lake, UK

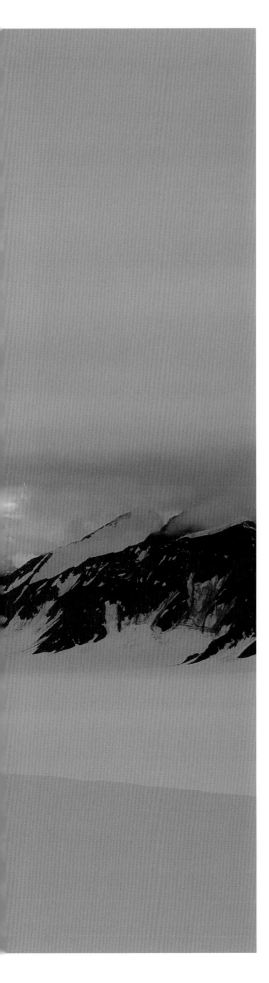

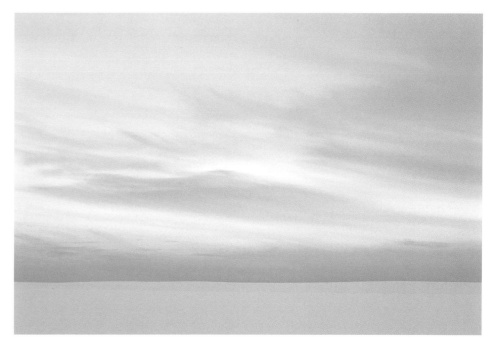

Knud Rasmussen Land, East Greenland, Arctic. Quintin Lake, UK

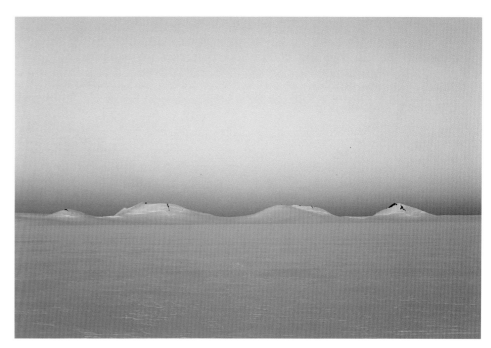

Knud Rasmussen Land, East Greenland, Arctic. Quintin Lake, UK

AMAZING PLACES

Quintin Lake UK
Winner

Quintin Lake is a fine art and commercial architectural photographer who draws his inspiration from exploration and architecture. He originally trained as an architect, which developed in him an interest in place, form and graphic structure which informs all his photographic work. He has photographed in over 60 countries and participated in nine major expeditions, including the Lesotho Rock Art Survey 2000, Anglo-Scottish East Greenland Expedition 2006, a solo winter walk from Land's End to John o'Groats, and an Oxford University expedition which found new species of Peruvian orchid in 2008. His first book 'Drawing Parallels: Architecture Observed', which is a source of architectural inspiration from around the world, was published in 2009.

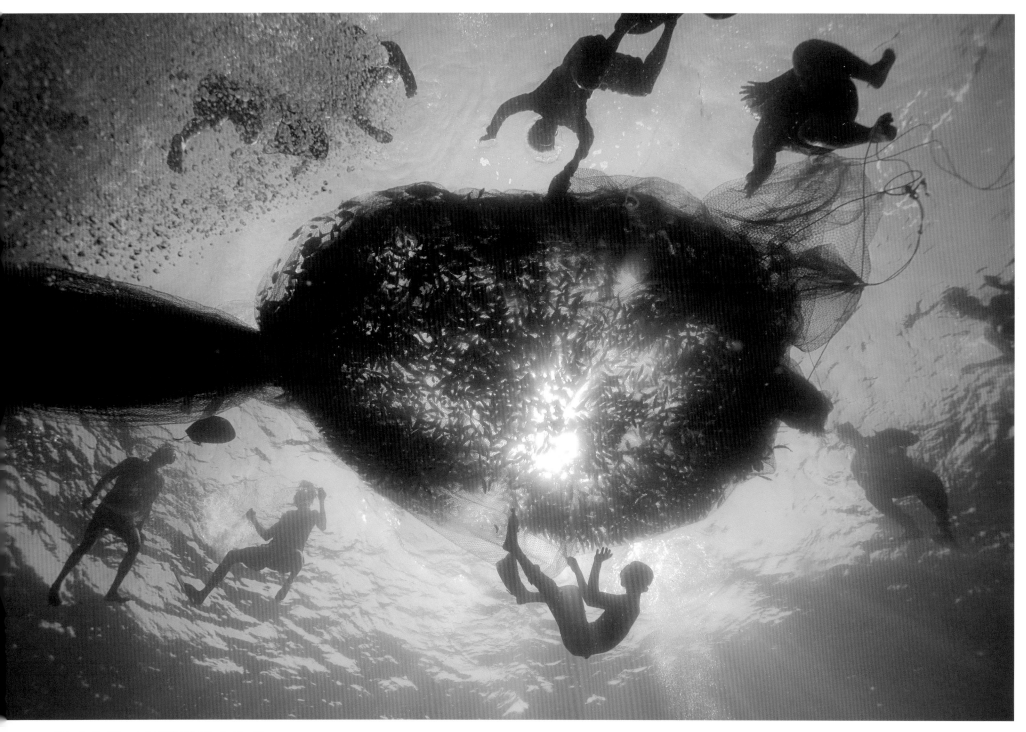

Filipino Pa-aling fishermen, South China Sea. Timothy Allen, UK

AMAZING PLACES

Timothy Allen UK
Runner Up

A dangerous, and at times life-threatening, way of fishing is
captured in all its balletic gracefulness in Timothy's pictures.
The divers work with minimal, often homemade equipment,
using pressurised air lines which frequently result in the bends.

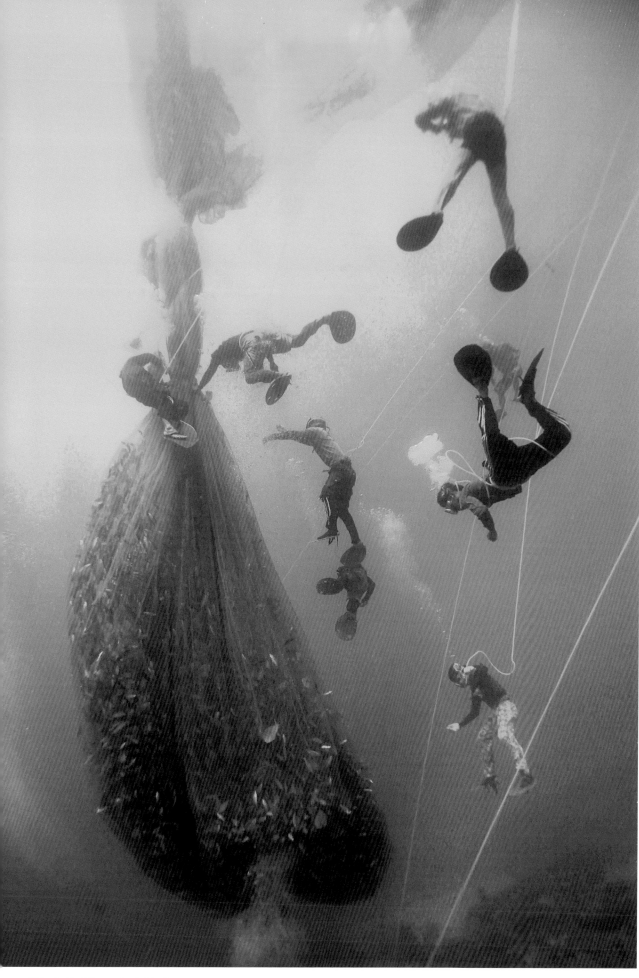

Filipino Pa-aling fishermen, South China Sea. Timothy Allen, UK

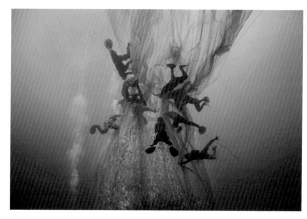

Filipino Pa-aling fishermen, South China Sea. Timothy Allen, UK

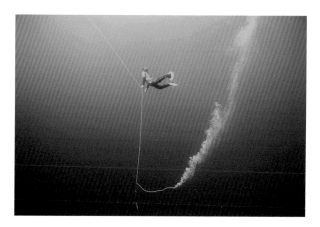

Filipino Pa-aling fishermen, South China Sea. Timothy Allen, UK

Museum, Kolkata (Calcutta), India. David Pinzer, Germany

AMAZING PLACES

David Pinzer Germany
Highly Commended

David's atmospheric photographs of the Natural History Museum in Calcutta have a haunting quality which capture an institution caught in a bygone era.

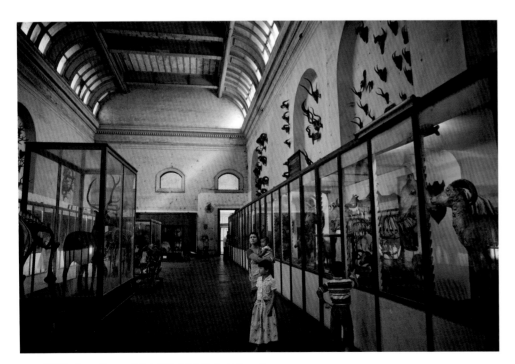

Fauna Exhibition Room, Museum, Kolkata (Calcutta), India. David Pinzer, Germany

AMAZING PLACES

Richard Murai USA
Commended

Use of a Lensbaby lends these images of Laos has given them a gentle, unearthly quality.

Luke Duggleby UK
Commended

Luke has captured the scale of this spectacular occasion by using symmetry and precision to wonderful effect.

Mekong River, Northern Laos. Richard Murai, USA

Luang Prabang, Northern Laos. Richard Murai, USA

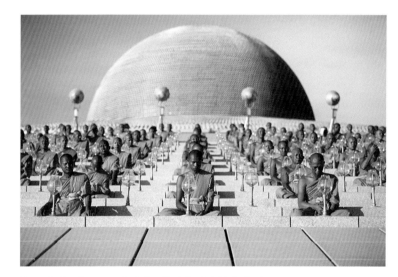

Mass ordination of 34,000 monks, Pathum Thani, Bangkok, Thailand. Luke Duggleby, UK

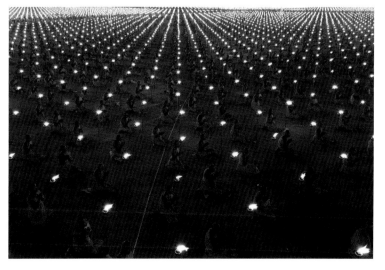

Mass ordination of 34,000 monks, Pathum Thani, Bangkok, Thailand. Luke Duggleby, UK

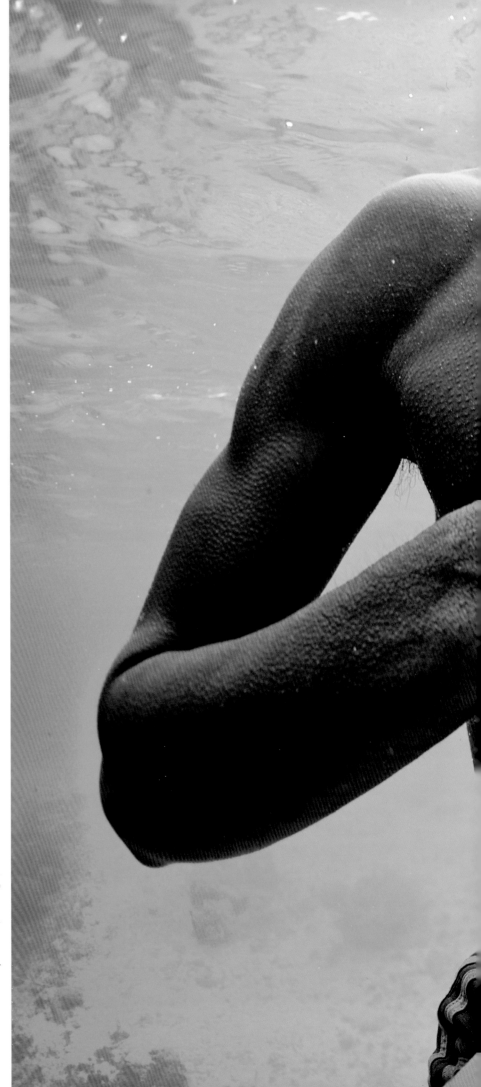

ENCOUNTERS
PORTFOLIO 2010

James Morgan's portfolio takes us beneath the surface to show two very different human encounters with sea life: one as a companion, the other as a hunter. The former is portrayed through playfulness, the latter via the threatening image of a fisherman clutching his prey as if to squeeze the life from it.

Sponsors of this award:

Adobe, Wacom, Lexar, Lee Filters, Photo Iconic

Sulawesi, Indonesia. James Morgan, UK

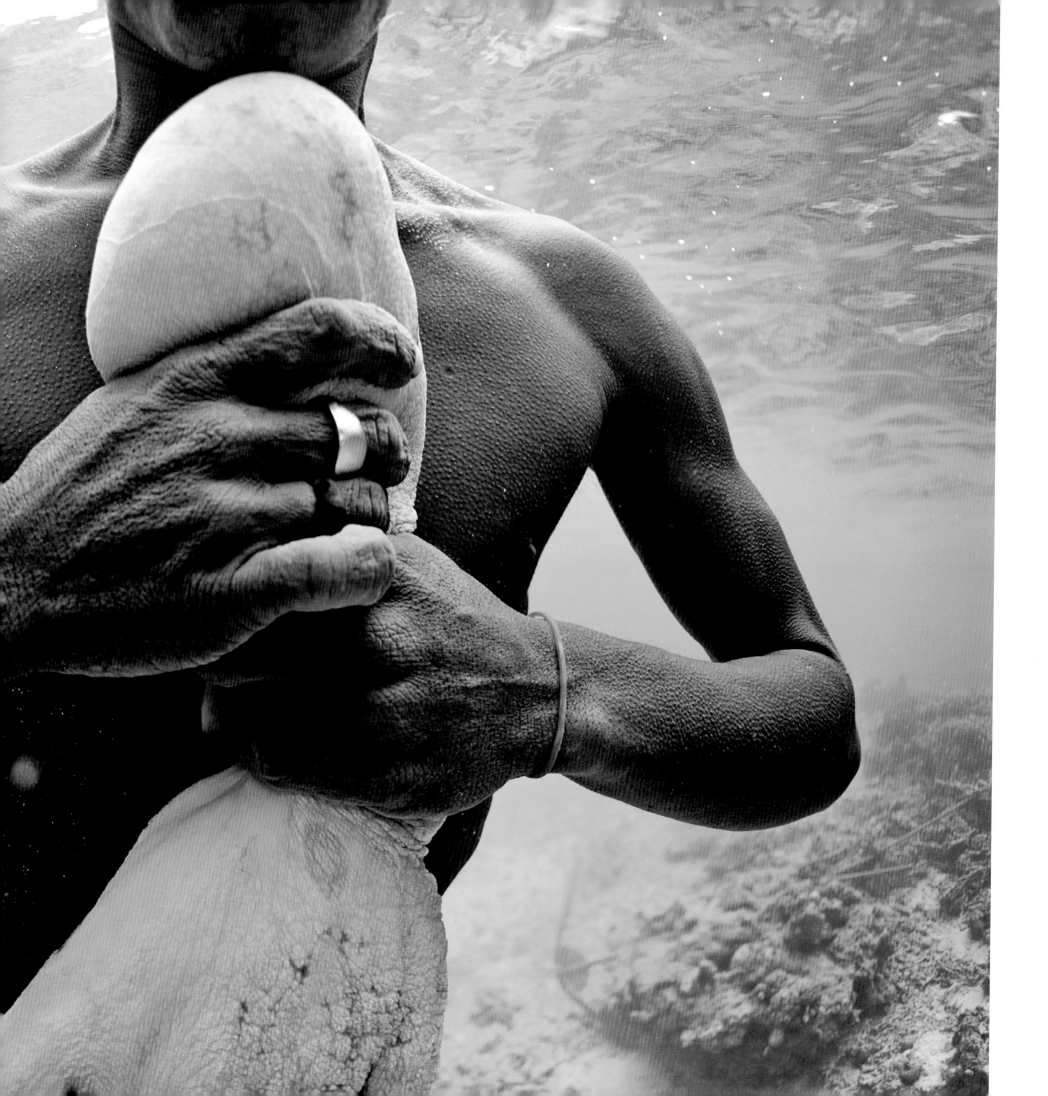

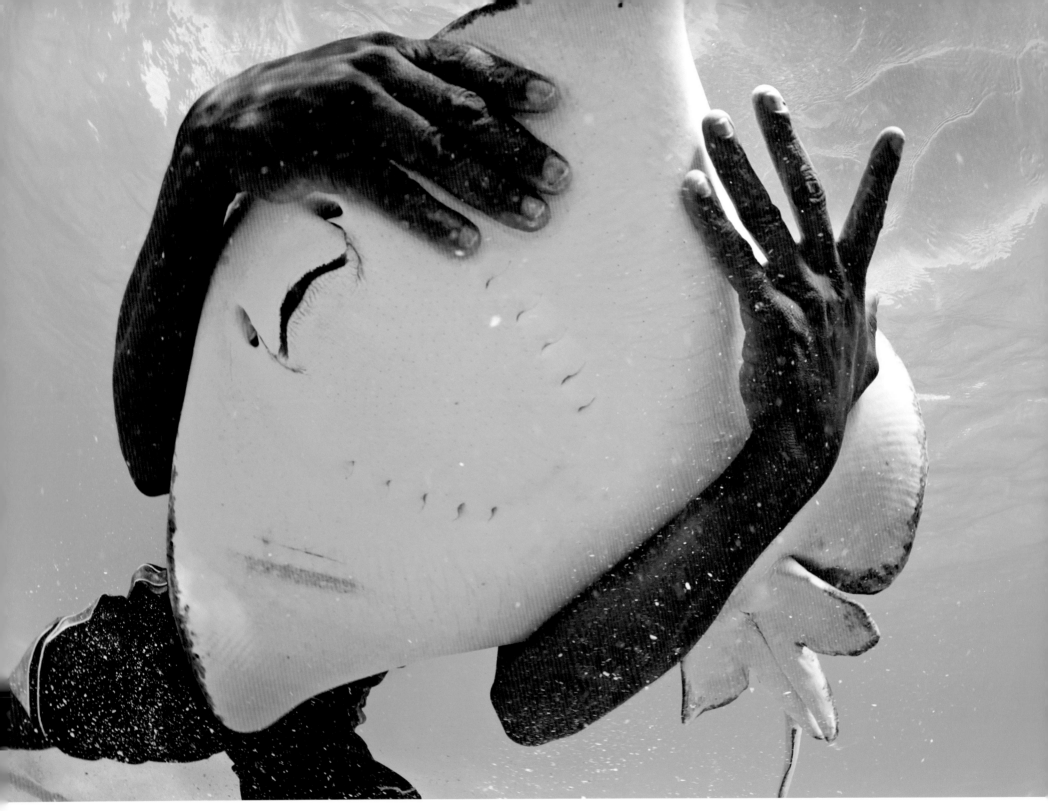

Antigua. James Morgan, UK

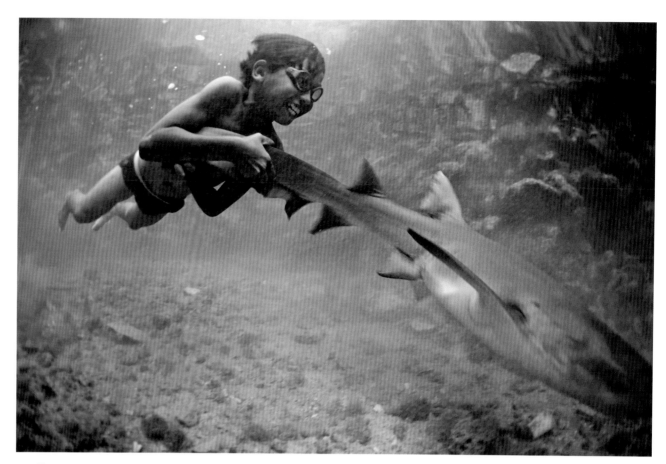

Boy with pet shark, Sulawesi, Indonesia. James Morgan, UK

ENCOUNTERS

James Morgan UK
Winner

James Morgan is a freelance photographer and visual storyteller. His work takes him all over the world, has won him numerous awards and been published in some of the most well-respected magazines and newspapers in Europe, Asia and the Americas. James merges a fine art aesthetic with a rigorously ethnographic methodology, stressing intimacy with his subject matter and working out of compassion, respect and understanding for the people and issues he is fortunate enough to photograph. It is this approach that enables James to capture unique and stunning images from some of the most remote places in the world. James understands the power of imagery and believes passionately in the ethical application of photography. Accordingly, he does his best to ensure that he only works with very nice people!

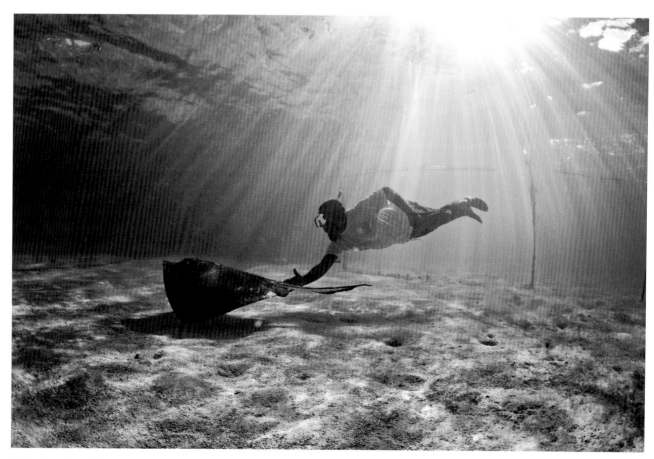

Antigua. James Morgan, UK

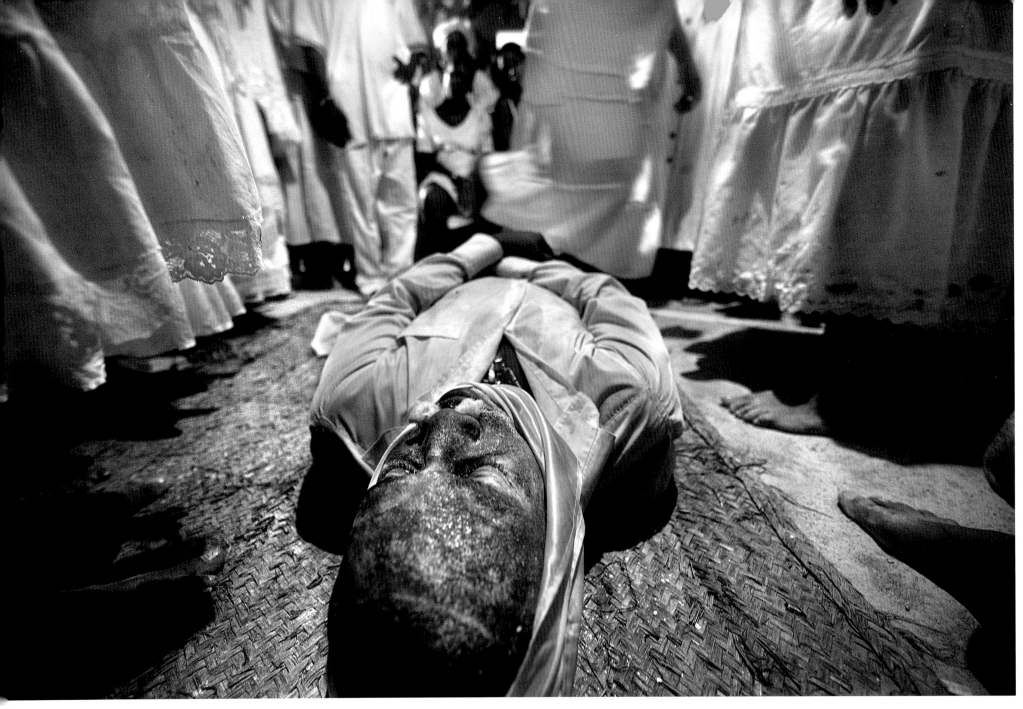

Fete Gede (Feast of the Dead), Port-au-Prince, Haiti. Jordi Cohen Colldeforns, Spain

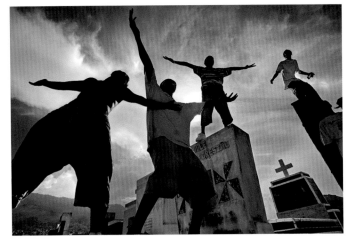

Fete Gede (Feast of the Dead), Port-au-Prince, Haiti. Jordi Cohen Colldeforns, Spain

ENCOUNTERS

Jordi Cohen Colldeforns Spain
Runner Up

Attitudes to death vary from culture to culture, but many celebrate the dead. The images in Jordi's gritty and thought-provoking portfolio covering the Day of the Dead festivities are somewhat macabre and disturbing, but full of emotion too.

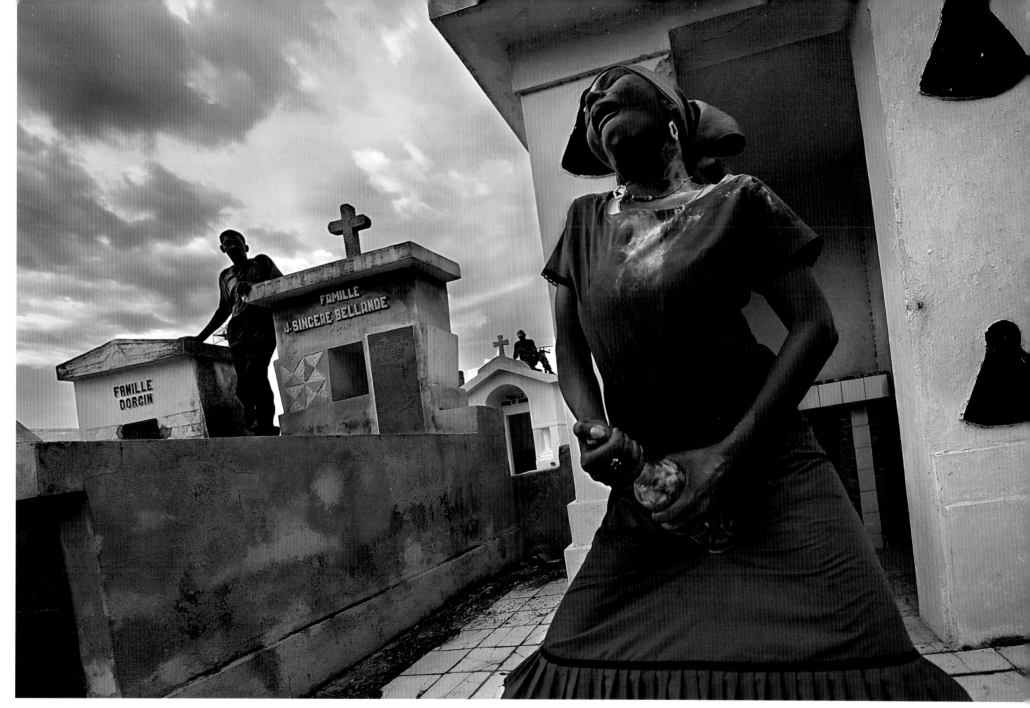

Fete Gede (Feast of the Dead), Port-au-Prince, Haiti. Jordi Cohen Colldeforns, Spain

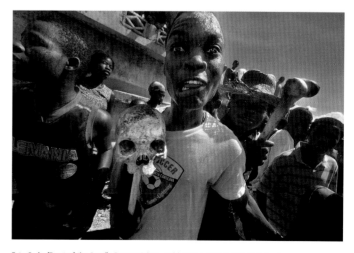

Fete Gede (Feast of the Dead), Port-au-Prince, Haiti. Jordi Cohen Colldeforns, Spain

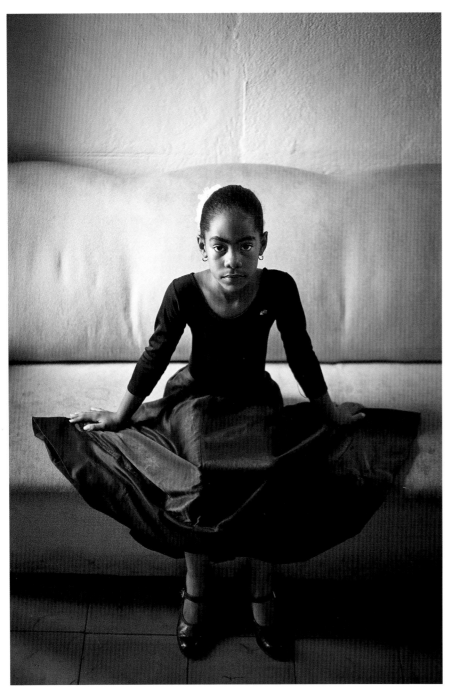

Holguin, Cuba. Guylain Doyle, Canada

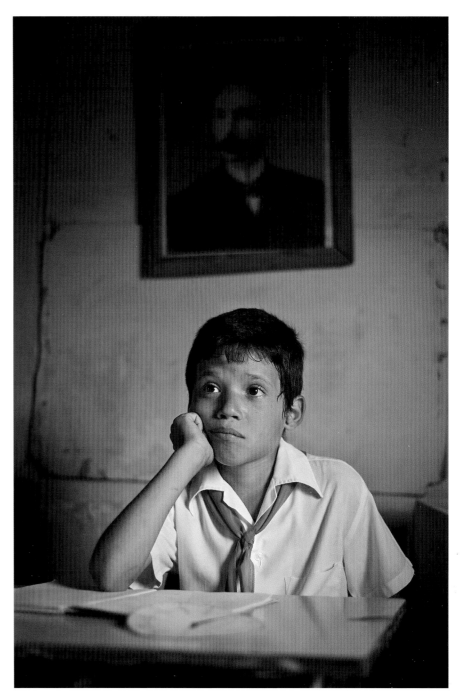

Holguin, Cuba. Guylain Doyle, Canada

ENCOUNTERS

Guylain Doyle Canada
Highly Commended

Beautifully shot, Guylain's portraits of Cuban children capture
key aspects of life in the country.

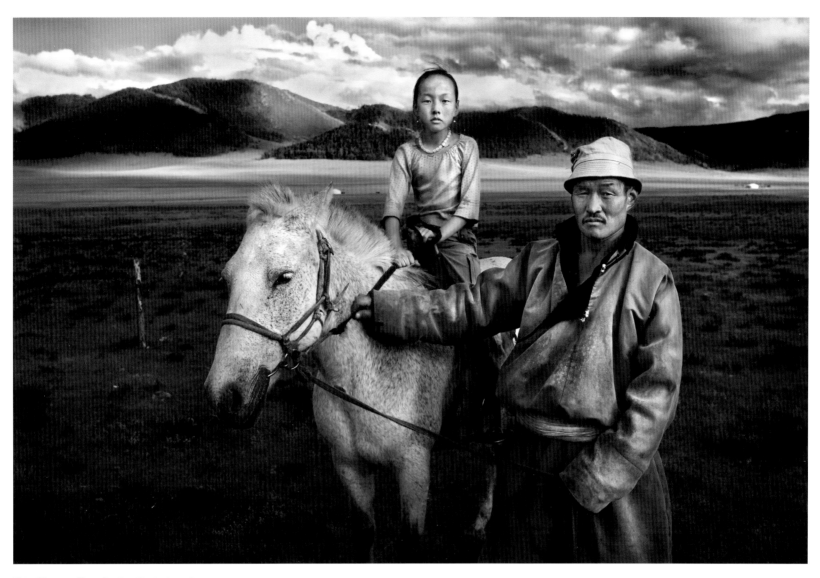

Shine-Ider area, Mongolia. Kym Morris, Australia

ENCOUNTERS

Kym Morris Australia
Commended

Kym has portrayed her encounter in a series of serene family orientated portraits of everyday life in Mongolia.

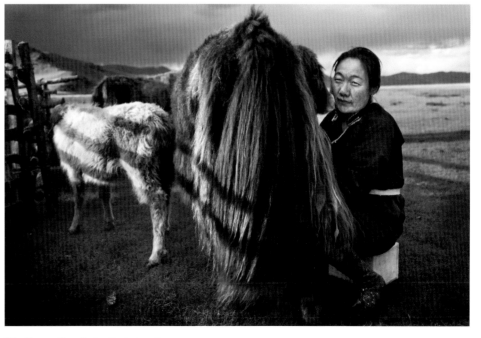

Shine-Ider area, Mongolia. Kym Morris, Australia

WORLD IN MOTION
PORTFOLIO 2010

Richard Murai has elegantly and cleverly interpreted a world in motion through engaging monochrome imagery, capturing elements of Bhutanese culture, religion and celebration. The images have a calm, antique quality which hints at a culture that is proud of its ancient traditions. The use of fabrics to convey movement of air is especially evocative.

Sponsors of this award:
Adobe, Wacom, Lexar, Lee Filters, Photo Iconic

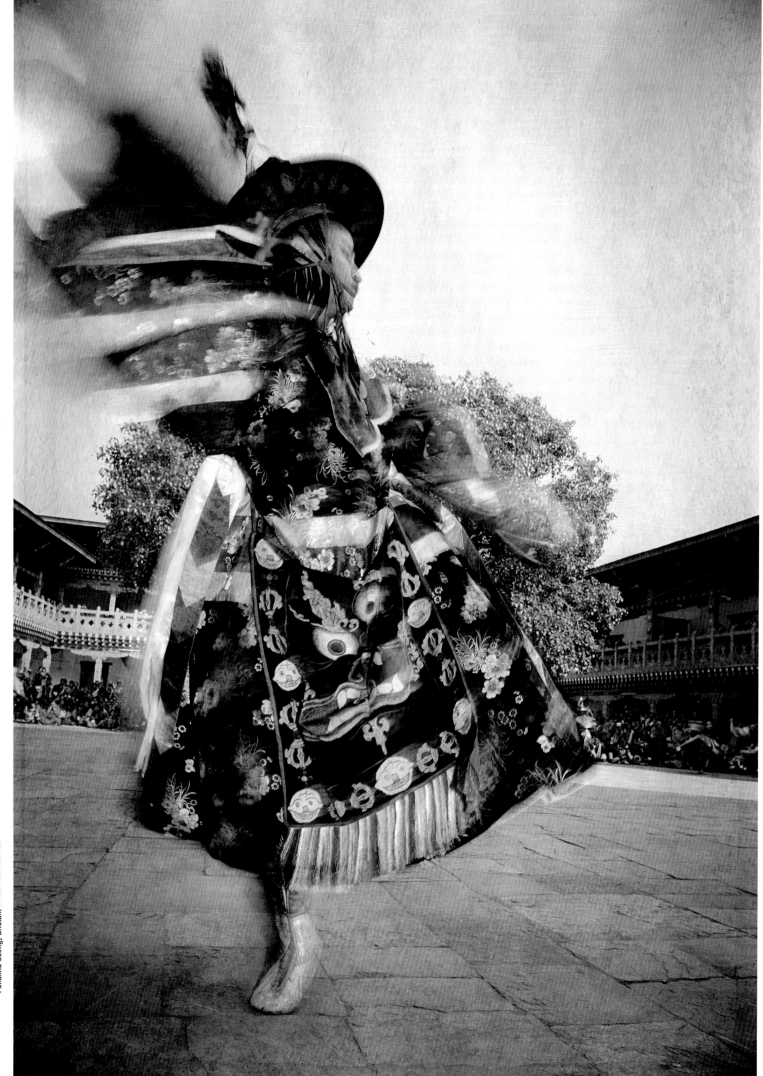

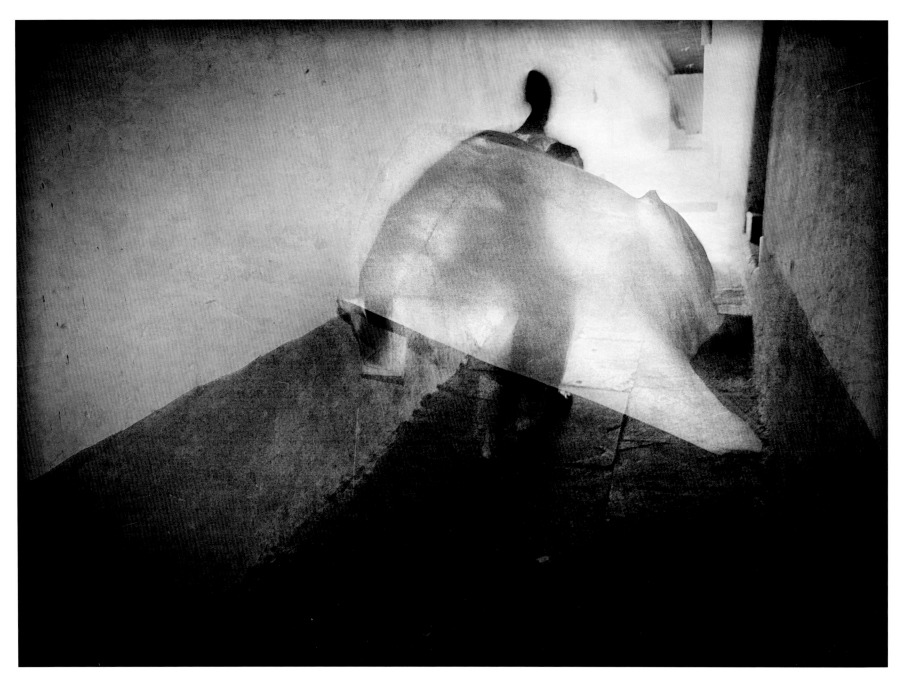

Punakha Dzong, Bhutan. Richard Murai, USA

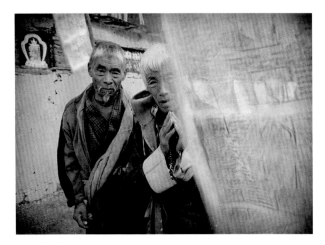

Chendebjee Stupa, Bhutan. Richard Murai, USA

WORLD IN MOTION

Richard Murai USA
Winner

Born, raised and educated in the San Francisco Bay Area, Richard Murai now teaches creative photography in northern California (USA). His ongoing fascination with documenting sacred sites of the world has generated travel to locations within India, South America, the Middle East, Russia, Asia, Europe, Polynesia and the United States. Richard's recent work from Bhutan and Laos reflects a voyage of discovery and creative exploration that documents intense spiritual devotion and religious fervor within unique and distinctive cultures. His work is widely exhibited and collected.

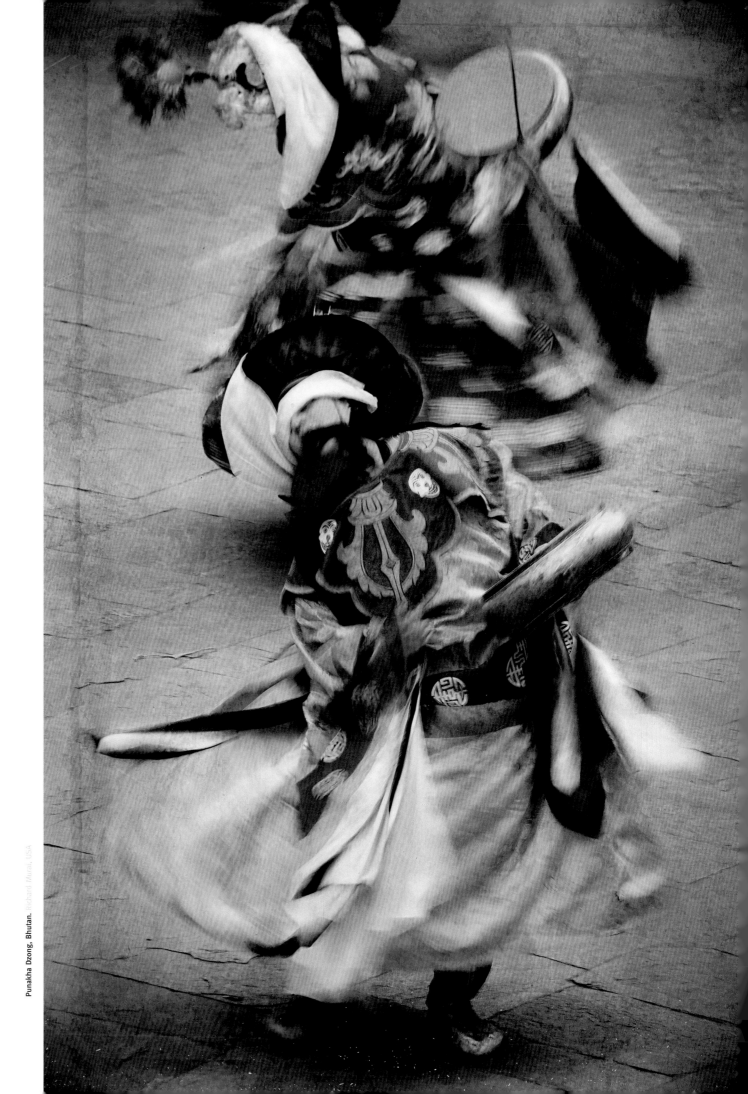

Punakha Dzong, Bhutan. Richard Murai, USA.

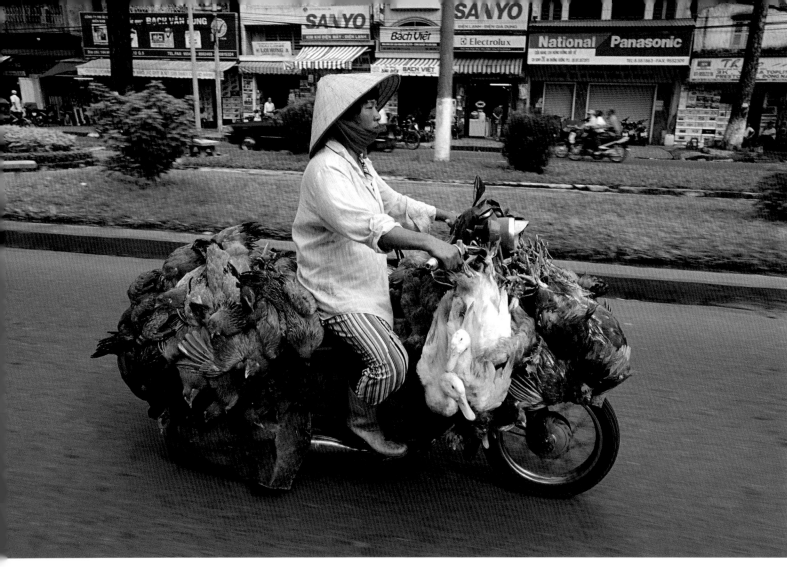

Ho Chi Minh City, Vietnam. Hans Kemp, Netherlands

WORLD IN MOTION

Hans Kemp Netherlands
Runner Up

In postcard-like pictures, Hans has provided us with a quirky glimpse into how the motorbike has become an essential means of transport throughout Asia — for everything, and anything, it seems!

Hanoi, Vietnam. Hans Kemp, Netherlands

Ho Chi Minh City, Vietnam. Hans Kemp, Netherlands

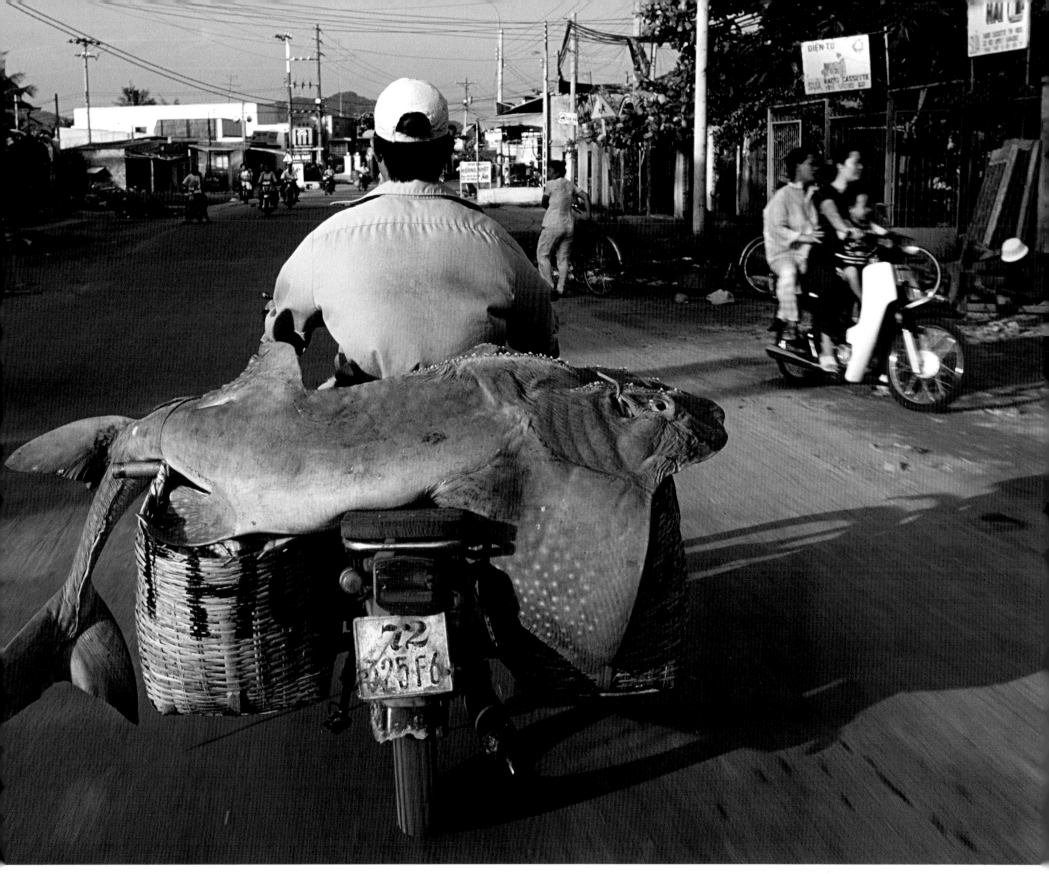

Ba Ria, Vietnam. Hans Kemp, Netherlands

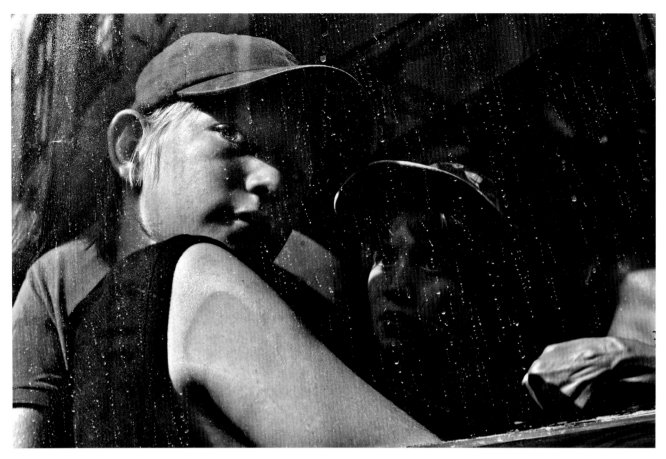

Lisbon, Portugal. Dougie Wallace, UK

WORLD IN MOTION

Dougie Wallace UK
Highly Commended

For many, the bus is the most readily available and affordable form of public transport. Here, thanks to Dougie's gritty images, we look back into the passengers' window but also, through the reflection, glimpse their view of the world .

Lviv, Ukraine. Dougie Wallace, UK

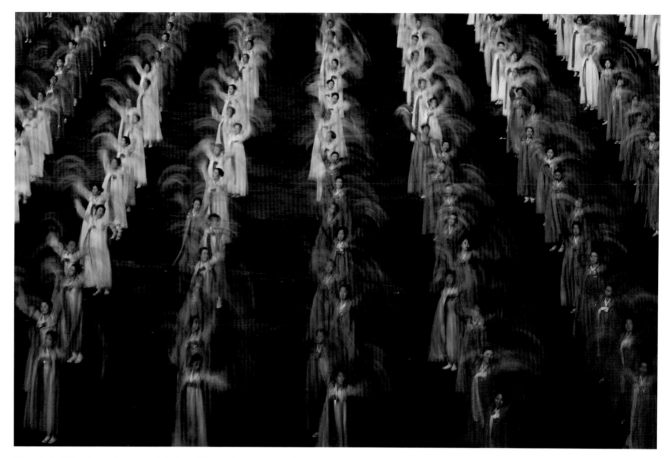

Arirang Festival Mass Games, Pyongyang, North Korea. Simon Hathaway, UK

WORLD IN MOTION

Simon Hathaway UK
Commended

As North Korea slowly opens its doors to travellers, the grand scale of its Mass Games provides an awe-inspiring display of a world in choreographed motion.

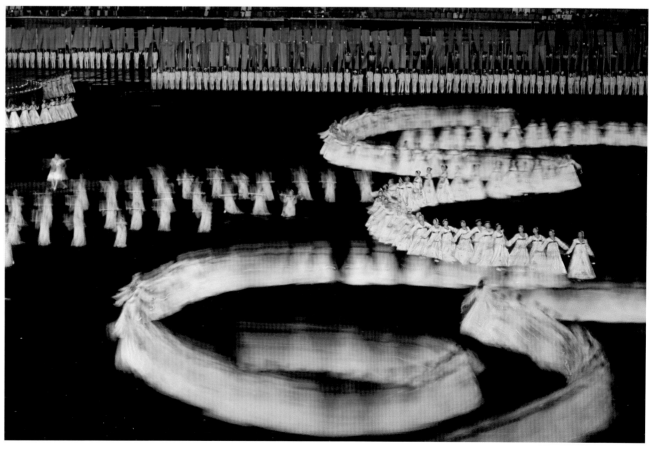

Arirang Festival Mass Games, Pyongyang, North Korea. Simon Hathaway, UK

ONE SHOT 2010 — ADVENTURES

Adventures take many forms, but all of them take us to an unfamiliar place – either physically, mentally or emotionally. In Maja Flink's image, the juxtaposition of technology and tradition creates a surprising and memorable image.

Sponsors of this award:
Intrepid Travel, Adobe, Lexar, Photo Iconic

Preparing to view solar eclipse, Bemri mountain, Bhutan. Maja Flink, Sweden

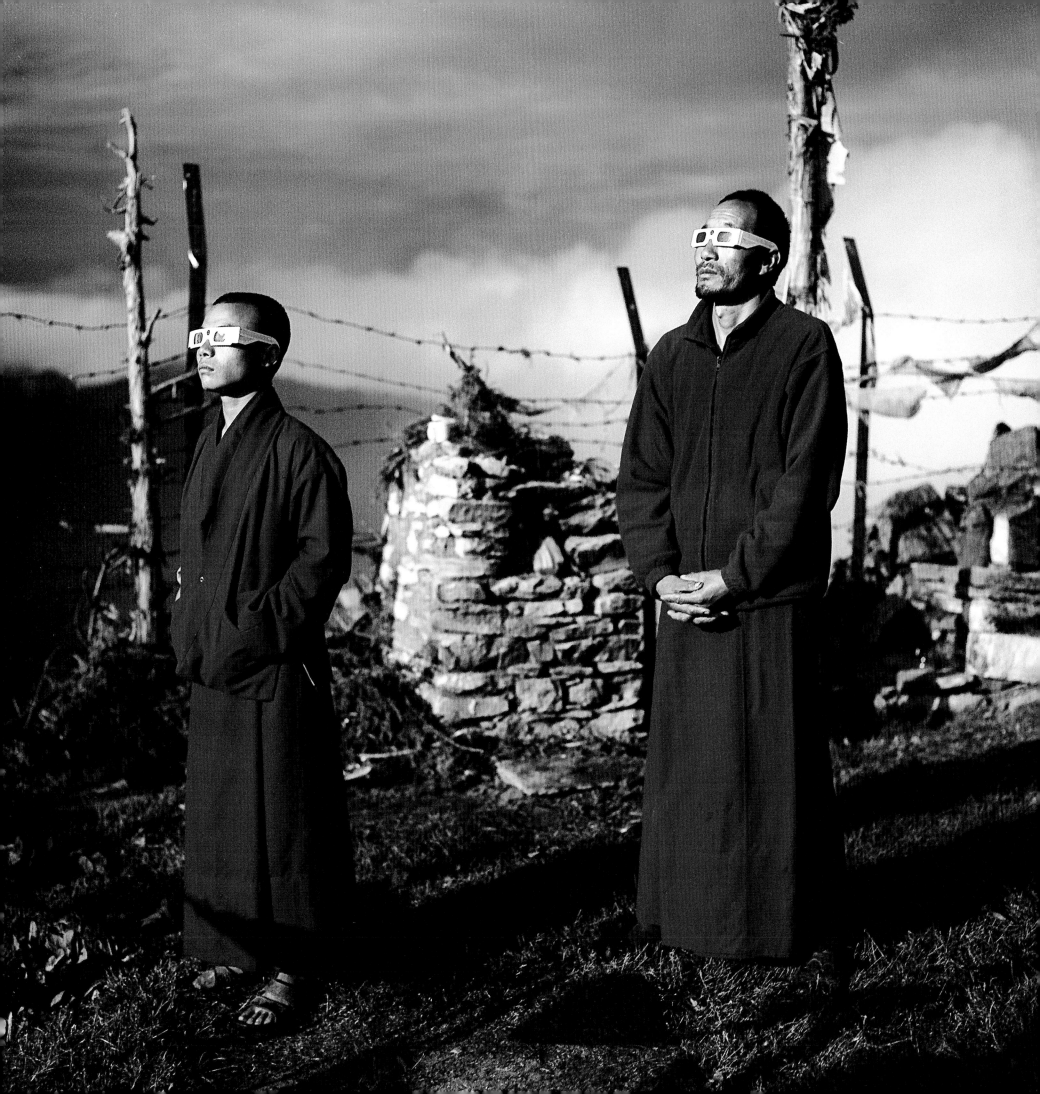

Yarra Valley, Australia. Tim Barker, Australia

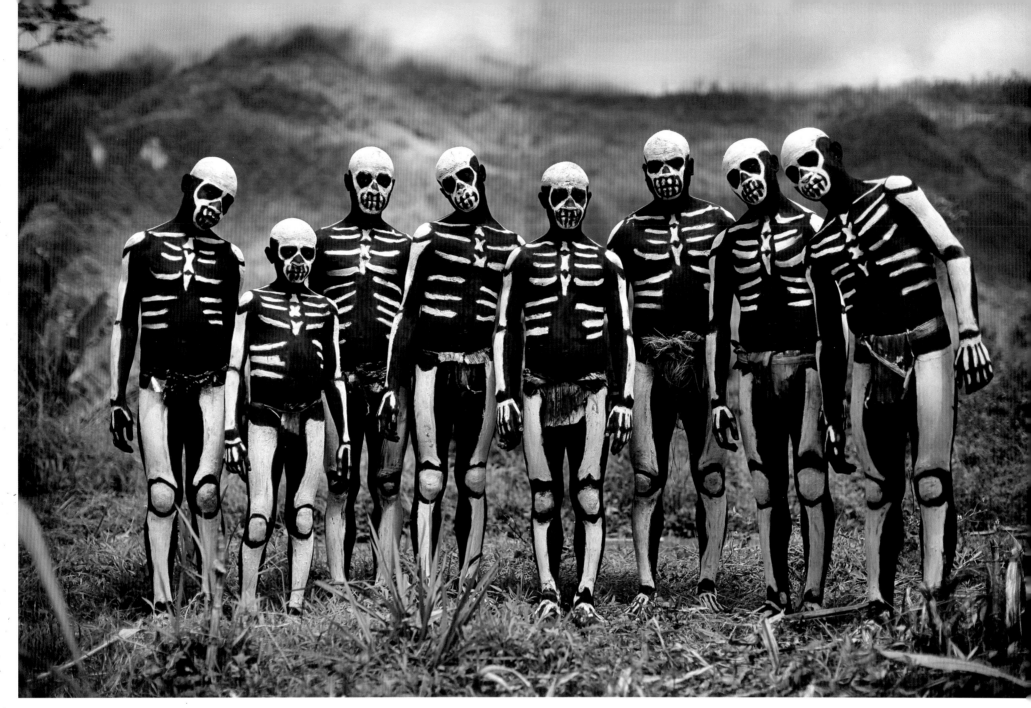

Western Highlands, Papua New Guinea. Timothy Allen, UK

ONE SHOT

Tim Barker Australia
Runner Up

The familiar seen from a different perspective makes for a simple, yet effective, image.

ONE SHOT

Timothy Allen UK
Highly Commended

This image is one of those which quizzically begs an explanation and just makes you smile!

ONE SHOT

Maja Flink Sweden
Winner

Maja Flink started working as a photographer in 2007 after studying photography at London College of Communication. Since then she has been working as a portrait photographer for various magazines such as Monocle, The Telegraph, The Independent, Architects Journal, Icon & Paper magazine. Maja's passion for portraiture also shows in her personal work, which is often focused around universal subjects we all can relate to, such as identity, gender and family relations. She approaches her subjects with great simplicity and gentleness. Her aim is to involve the subjects in what she is doing, and making them feel comfortable, brings a calm and very specific atmosphere to her photographs.

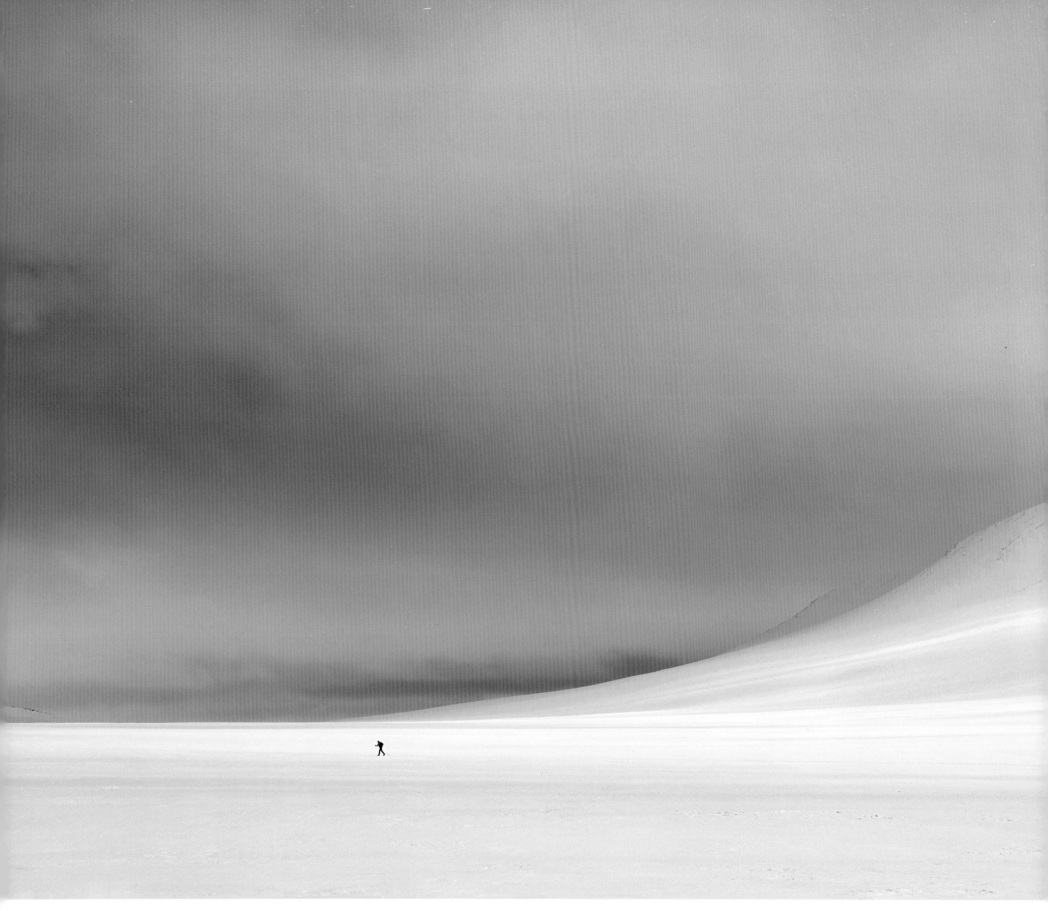

Lone skier, Rondane National Park, Norway. Lizzie Shepherd, UK

ONE SHOT

Lizzie Shepherd UK
Commended

Serene, delightful isolation.

ONE SHOT

Marsel van Oosten Netherlands
Commended

Powerful and intimidating, the king of the savanna in all his majesty. The image was captured using a monopod-mounted camera handheld out of a vehicle window. The sound of the shutter evoked this response and the threat was real.

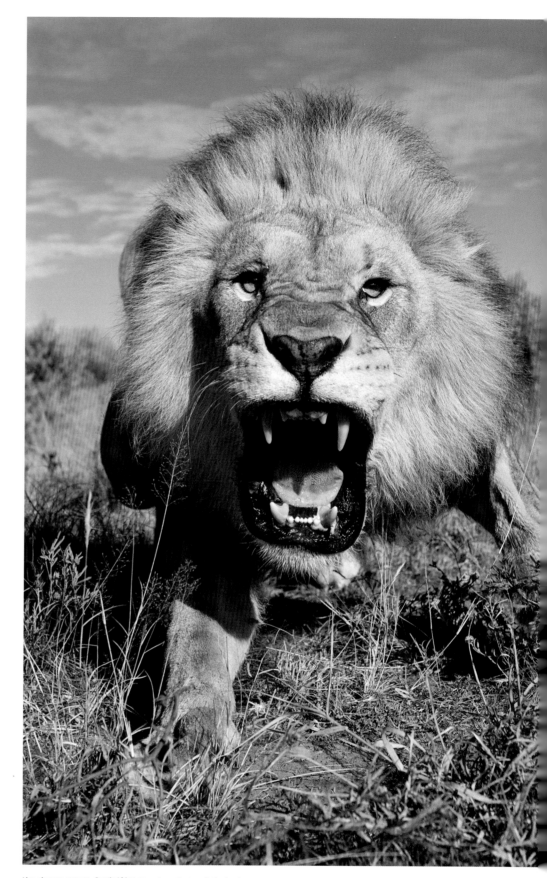

Lion charges camera, South Africa. Marsel van Oosten, Netherlands

NEW TALENT 2010 — SELL IT!

The New Talent category encourages and supports aspiring photographers who want to make a career in photography. A key skill for a professional photographer is to be able to produce images which encapsulate a destination and sell it to the viewer. Even though he had flat, uninspiring light, Eric Kruszewski has done just that with his Alaska experience — bringing together experiences which convey the varied elements this place offers.

Sponsors of this award:

Intrepid Travel, Adobe, Lexar, Photo Iconic, Plastic Sandwich

Passage Alaska expedition vessel, Alaska, USA. Eric Kruszewski, USA

Passage Alaska expedition vessel, Alaska, USA. Eric Kruszewski, USA

Sitka, Alaska, USA. Eric Kruszewski, USA

NEW TALENT

Eric Kruszewski USA
Winner

Eric Kruszewski's love of photography began in 2008 after his travels throughout India. The country's constant energy, true emotion, vibrant colour and pure culture inspired him to capture everyday life. His sense of curiosity and passion for photography take Eric across the globe, where he immerses himself in different cultures and illustrates life through the lens. Eric's passion lies in finding simple, beautiful moments in an otherwise busy and complex world. He currently lives in America's Pacific Northwest while he continues to practice his art.

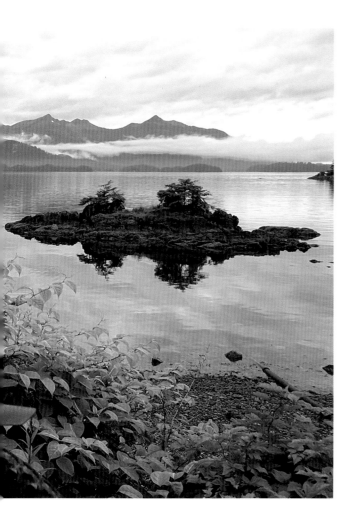

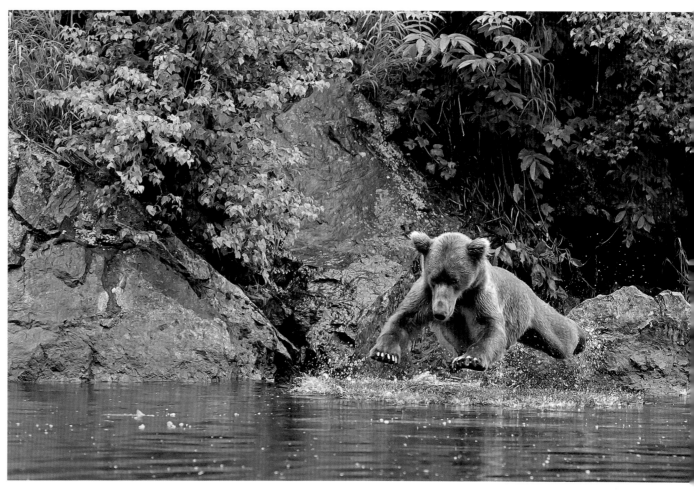

Redoubt Bay, Alaska, USA. Eric Kruszewski, USA

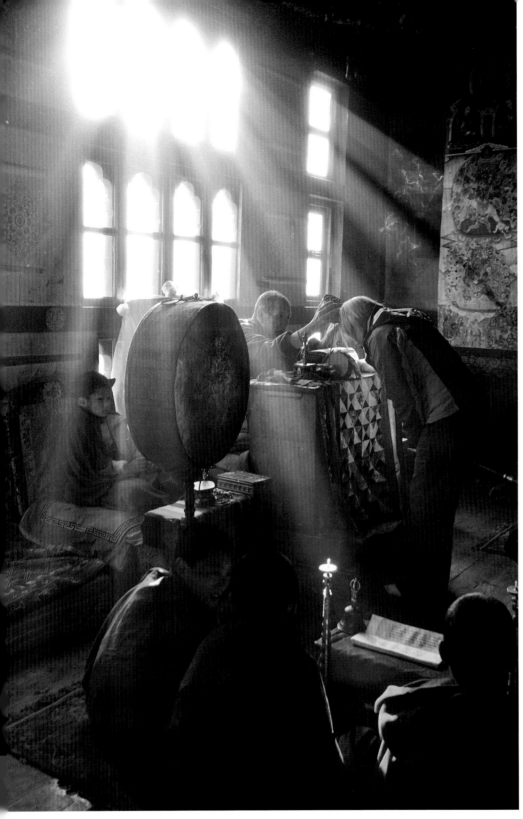

Ura temple Bumthang Valley, Central Bhutan. Kim Walker, USA

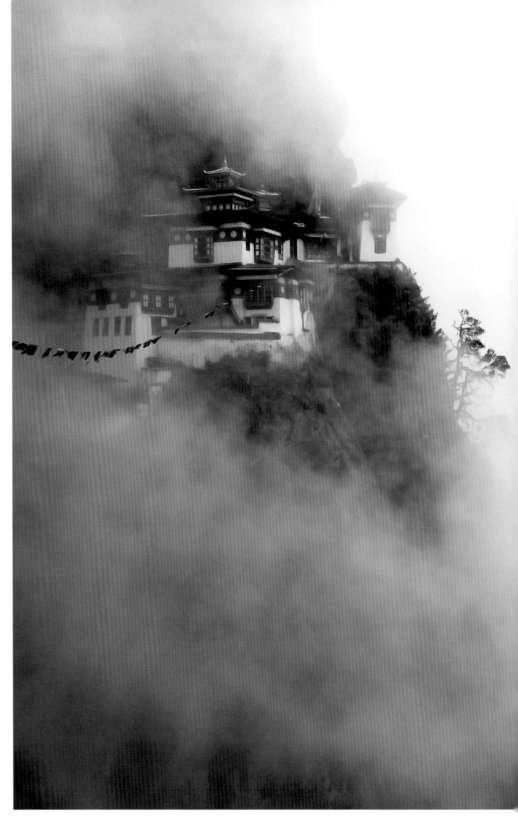

Tiger's Nest (Taktshang Goemba), Paro Valley, Bhutan. Kim Walker, USA

NEW TALENT

Kim Walker USA
Runner Up

Kim provides us with beautiful glimpses into a hidden
Himalayan kingdom slowly opening its doors to travellers.

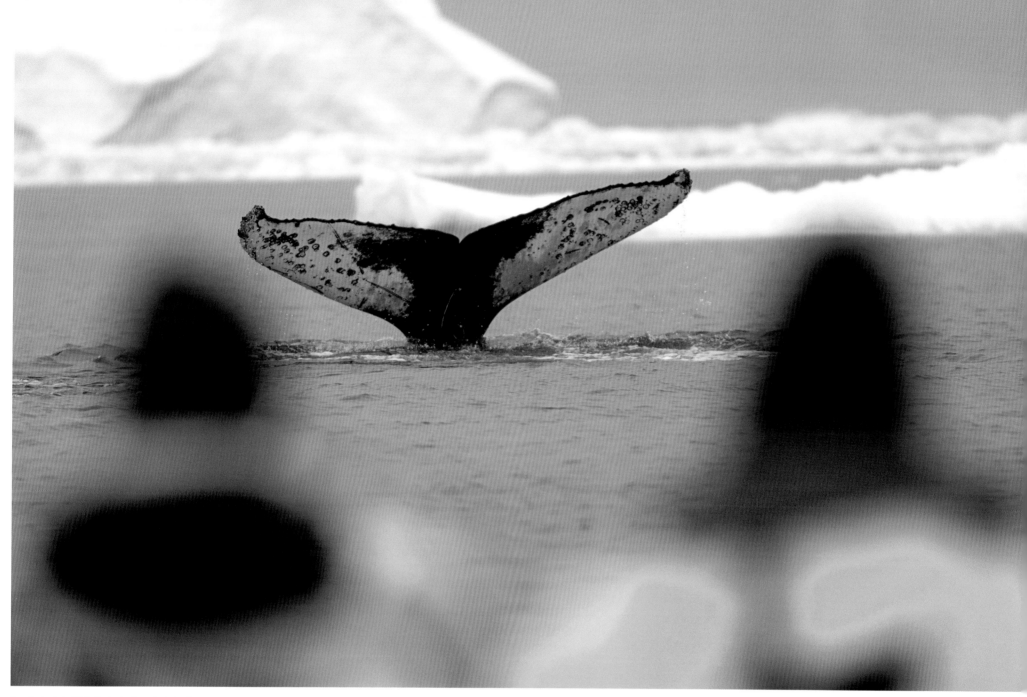

Humpback whale, Trinity Peninsula, Antarctic Peninsula. James Cresswell, UK

NEW TALENT

James Cresswell UK
Highly Commended

James give us the opportunity to experience, rather than just observe, the destination by connecting traveller and environment to great effect.

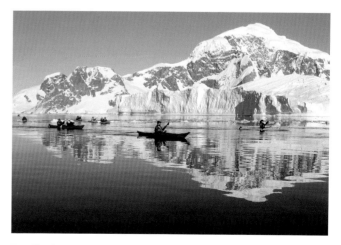

Cuverville Island, Antarctic Peninsula. James Cresswell, UK

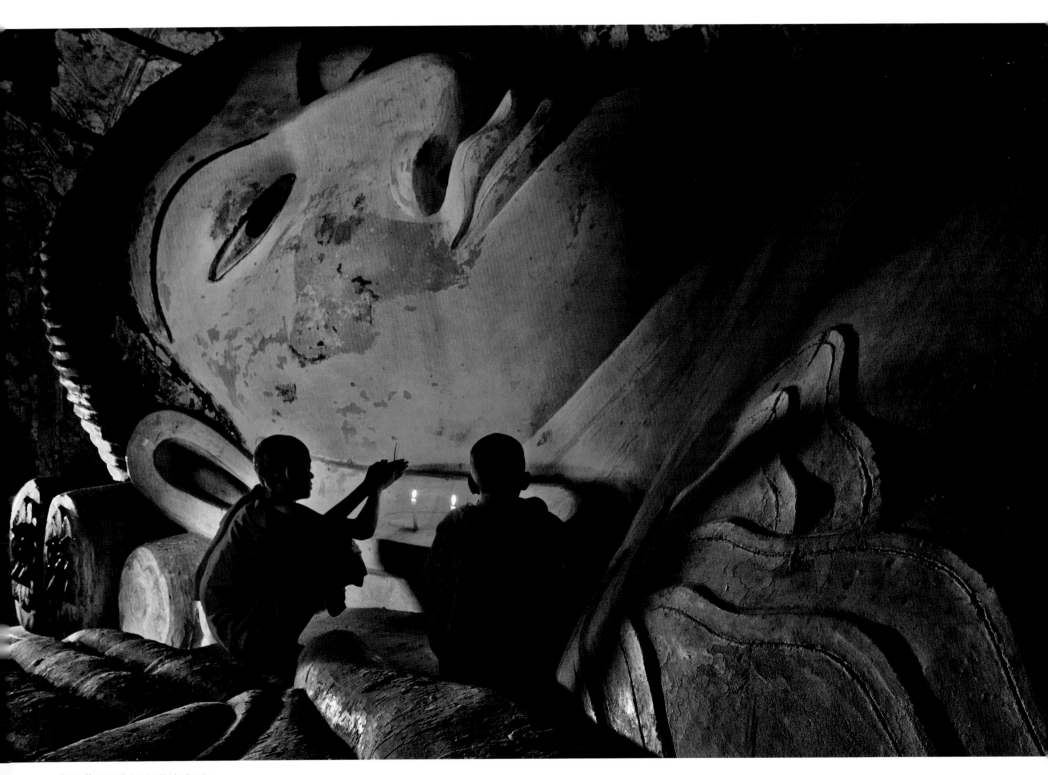

Bagan, Myanmar. Christopher Martin, Canada

NEW TALENT

Christopher Martin Canada
Commended

Christopher's portfolio delivers a good sense of engagement without intruding on the moment.

NEW TALENT

Jari Vipele Finland
Commended

The dynamism of a big city comes through in Jari's vibrant night shots.

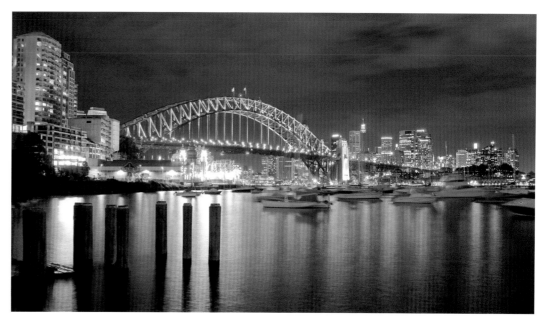

Sydney, Australia. Jari Vipele, Finland

Bagan, Myanmar. Christopher Martin, Canada

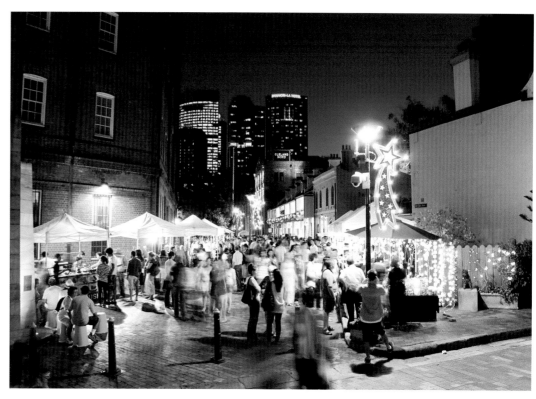

Roxy Pro Gold Coast surfing competition, Coolangatta, Australia. Jari Vipele, Finland

FIRST SHOT 2010 —
FESTIVAL OF COLOUR

The First Shot category is for less experienced, amateur photographers who are still learning their craft. The judges chose the two winners on the basis that their images show great potential and because they feel they will benefit most from the tuition on offer as a prize. Runner up and Commended entries were also chosen.

Sponsors of this award:

Adobe, Photo Iconic

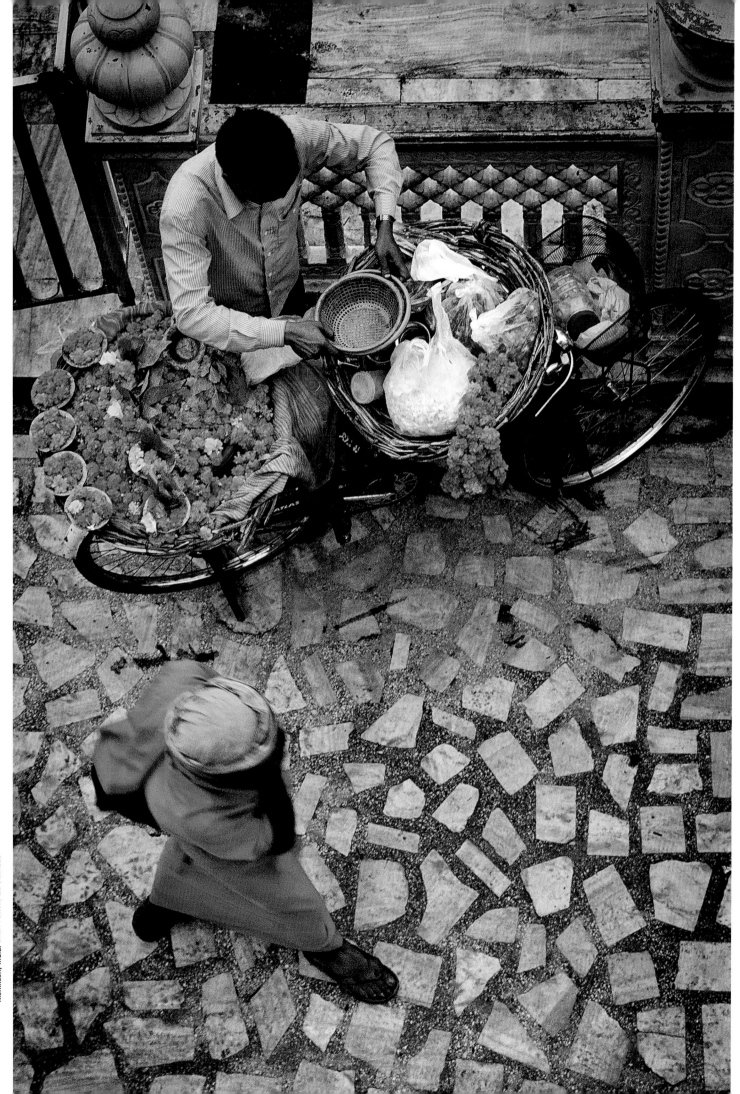

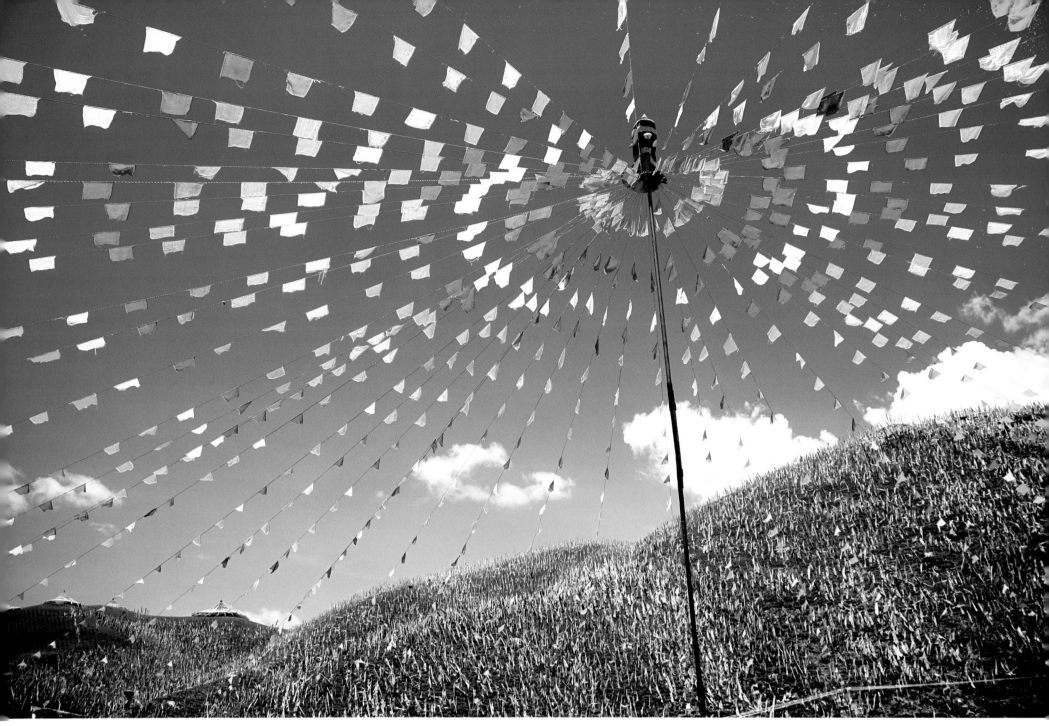

Tagong Grassland, Sichuan, China. Stuart Beesley, UK

FESTIVAL OF COLOUR

Stuart Beesley UK
Winner

Stuart's lively and deceptively busy image is cleverly simplified
by a riot of colour and geometric shapes.

Brian Powell USA/Canada
Winner

The unusual viewpoint adds emphasis as vibrant colour sings
out against an almost monochrome background.

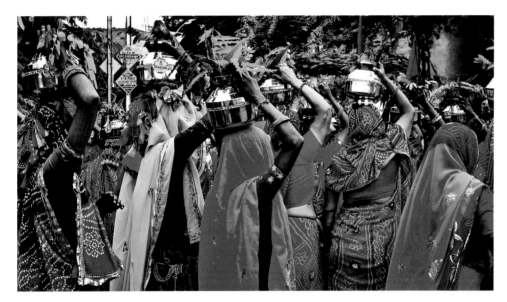

Wedding parade in Jaipur, Rajasthan, India. Maddie Shrotri, UK

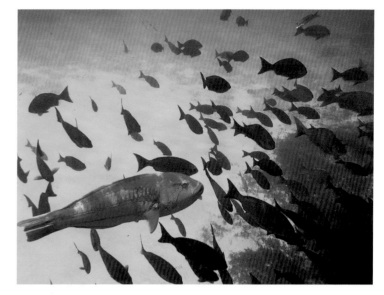

Lord Howe Island, Australia. Luke Regan, UK

FESTIVAL OF COLOUR

Maddie Shrotri UK
Runner Up

A riot of colour explodes from Maddie's image to give the essence of India.

Luke Regan UK
Runner Up

The coloured parrotfish contrasts well with the direction and tone of the other fish in Luke's picture.

Jeanette Seflin Sweden
Runner Up

Jeanette has subtly introduced colour and direction to good effect through shape and texture.

Peace & Love Festival, Borlänge, Sweden. Jeanette Seflin, Sweden

Playa Blanca, Cartagena, Colombia. Natanya van der Lingen, South Africa

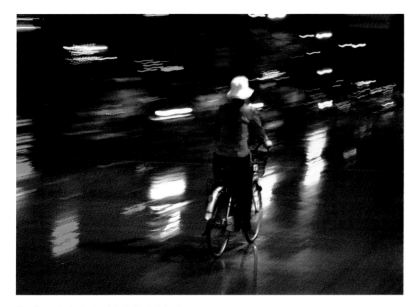

Siem Reap, Cambodia. Dominik Siedlecki, Poland

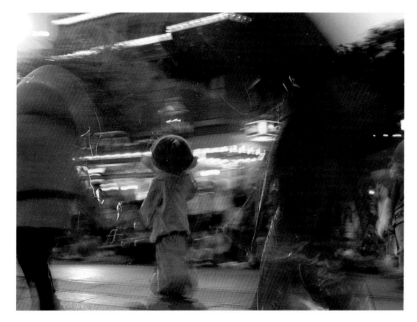

Disneyland Parade, California, USA. Emily Craven, Australia

FESTIVAL OF COLOUR

Commended

Natanya van der Lingen South Africa
Dominik Siedlecki Poland
Emily Craven Australia
Jeff Howard USA/UK

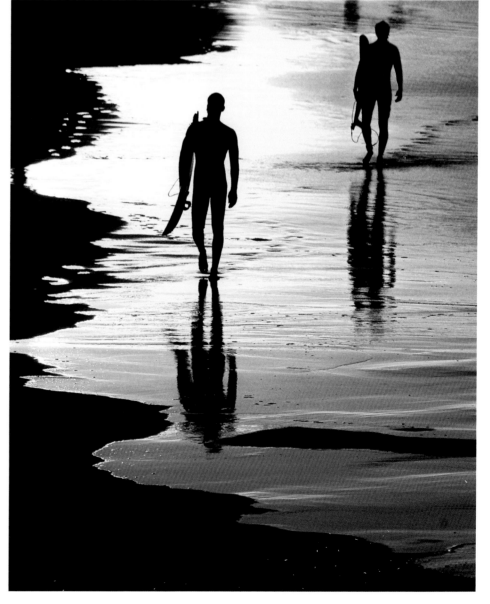

Byron Bay, Australia. Jeff Howard, USA/UK

BEST SINGLE IMAGE IN PORTFOLIO 2010

Each year there are many portfolio entries which don't win prizes, but which contain outstanding individual images. In 2010, such images were chosen by the judging panel from all three portfolio categories, with further images of note awarded special mentions.

Sponsors of this award:
TPOTY, Genesis Imaging, Royal Geographical Society (with IBG)

Bamiyan, Afghanistan. Alex Masi, Italy

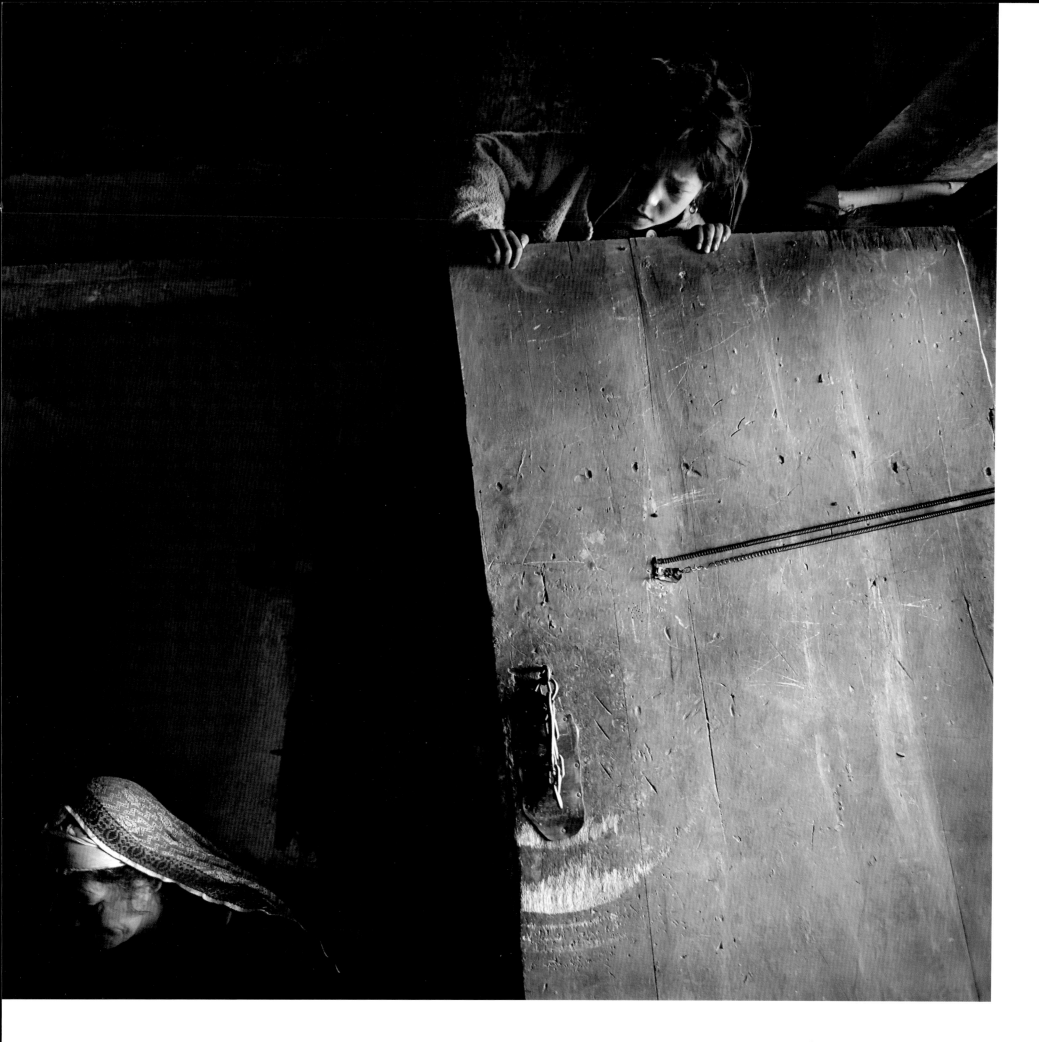

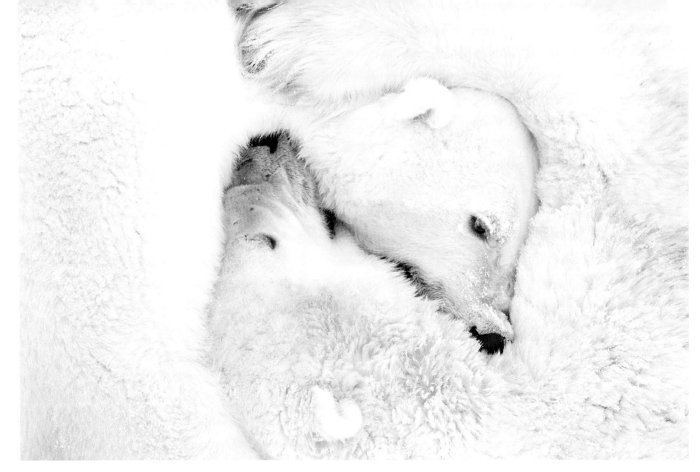

Wapusk National Park, Manitoba, Canada. Daisy Gilardini, Switzerland

ENCOUNTERS

Alex Masi Italy
Winner

Ironically, there's a real sense of interaction in Alex's image without any interaction actually taking place.

Daisy Gilardini Switzerland
Judges' Special Mention

How could anyone not fall in love with Daisy's incredible image?

Poras Chaudhary India
Judges' Special Mention

Vivid, energetic and mysterious all describe this striking image.

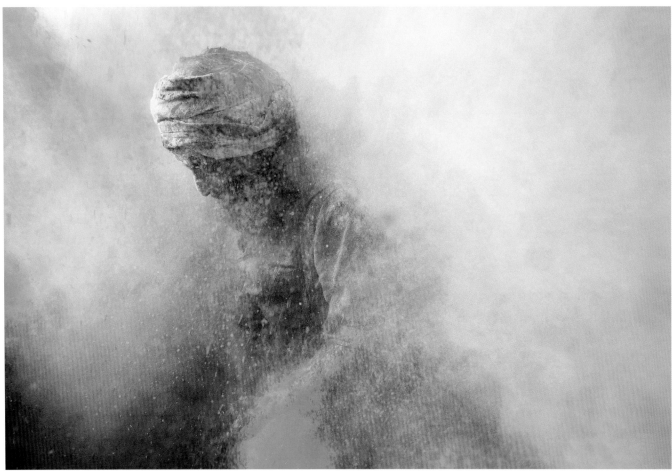

Festival of Holi, Mathura, Uttar Pradesh, India. Poras Chaudhary, India

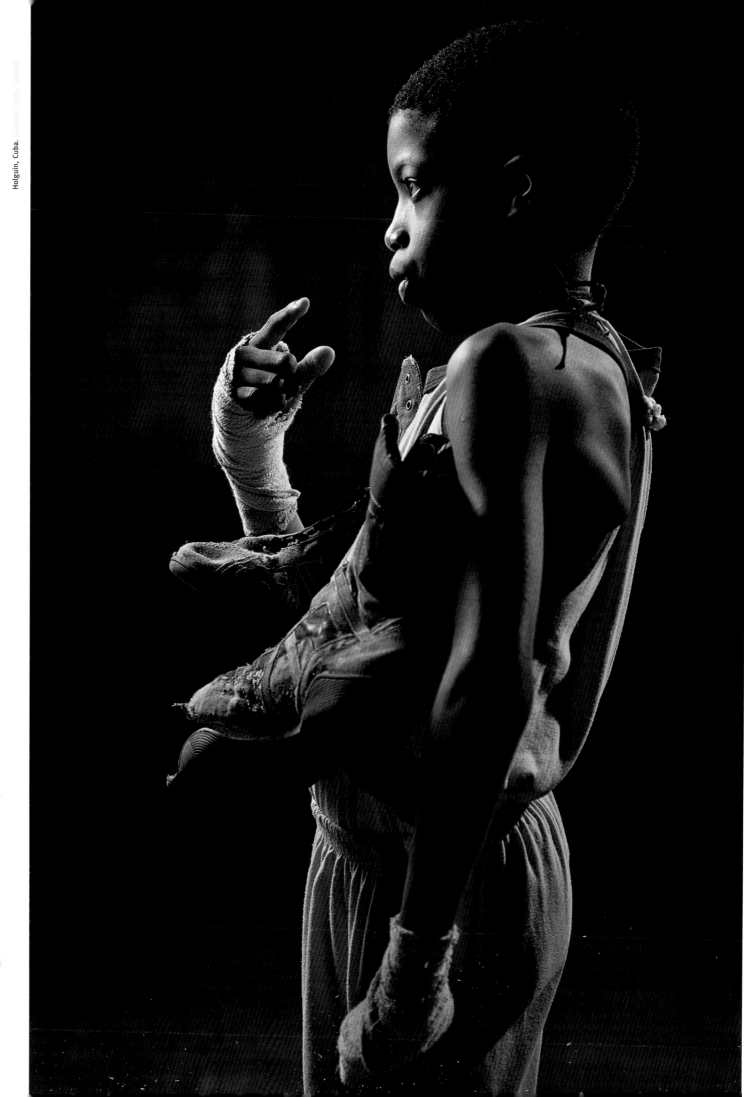

ENCOUNTERS

Guylain Doyle Canada
Judges' Special Mention

This beautiful portrait exudes an air of melancholy thoughtfulness.

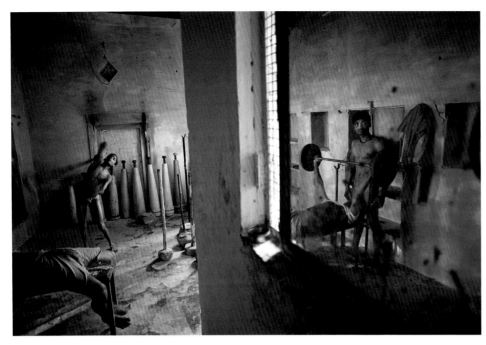

Ghat training centre, Varanasi, India. Matjaz Krivic, Slovenia

ENCOUNTERS

Matjaz Krivic Slovenia
Judges' Special Mention

The intriguing viewpoint of this photograph leaves you wondering what is hidden around the corner.

AMAZING PLACES

Richard Murai USA
Judges' Special Mention

A simple scene transformed into something peaceful and enigmatic.

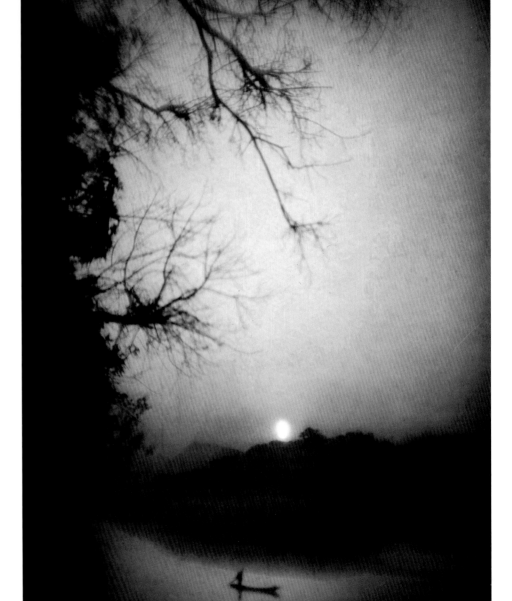

Mekong River, Northern Laos. Richard Murai, USA

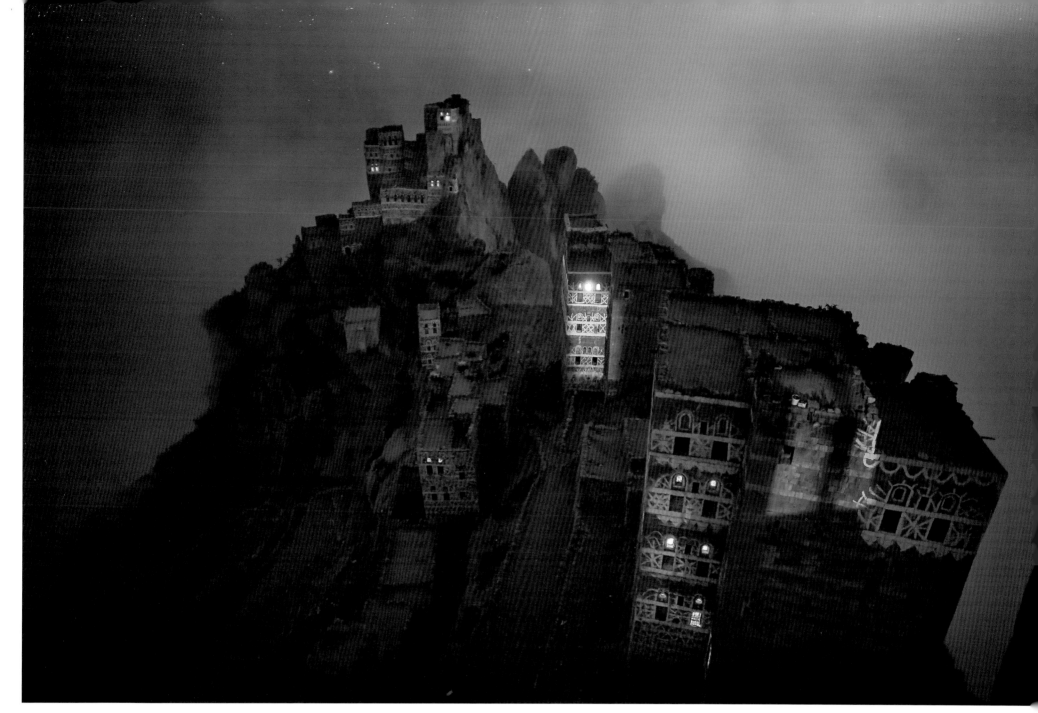

Shugruf, Yemen. Matjaz Krivic, Slovenia

AMAZING PLACES

Matjaz Krivic Slovenia
Winner

Wonderfully atmospheric and delicate.

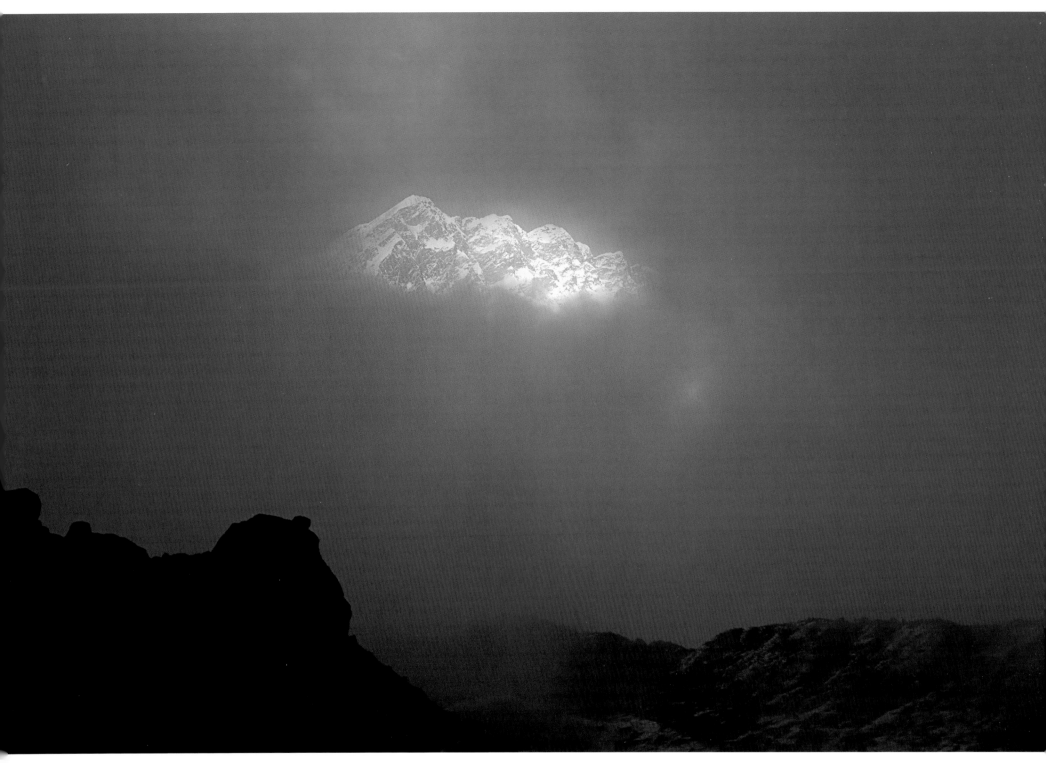

Near Lobuche, Nepal. Lukasz Kuczkowski, Poland

AMAZING PLACES

Lukasz Kuczkowski Poland
Judges' Special Mention

An alluring glimpse into a world beyond the clouds.

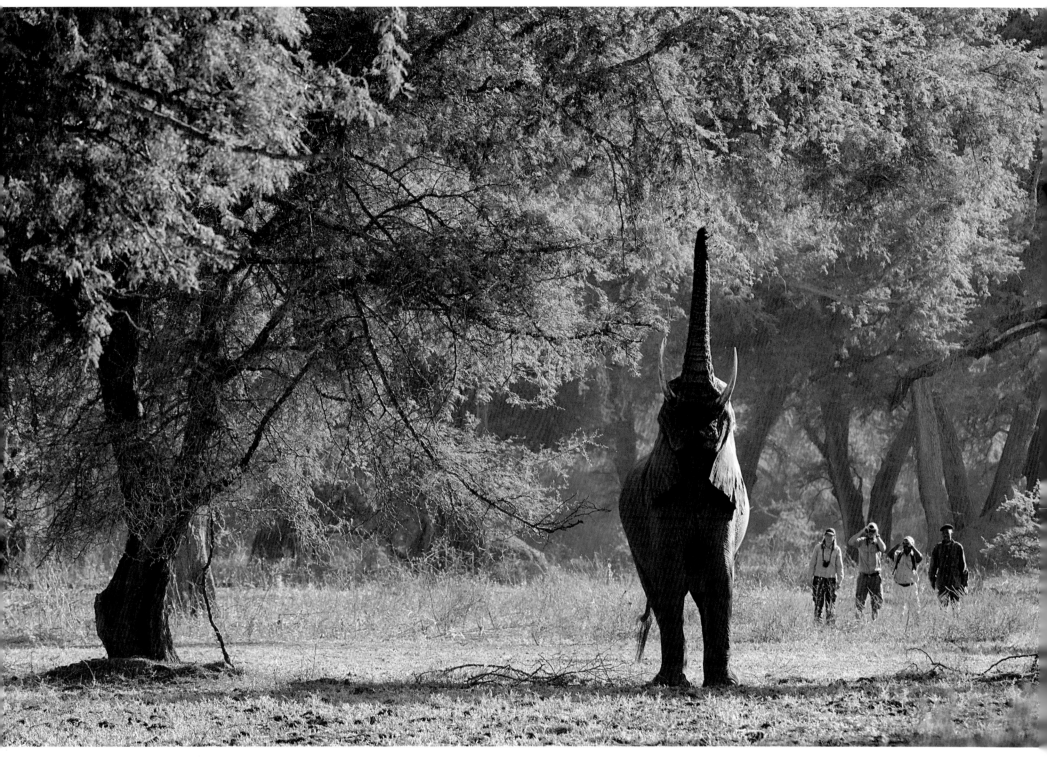

Elephant feeding on leaves, Namibia. Marsel van Oosten, Netherlands

ENCOUNTERS

Marsel van Oosten Netherlands

Judges' Special Mention

Who wouldn't enjoy such a special opportunity to marvel at these incredible creatures?

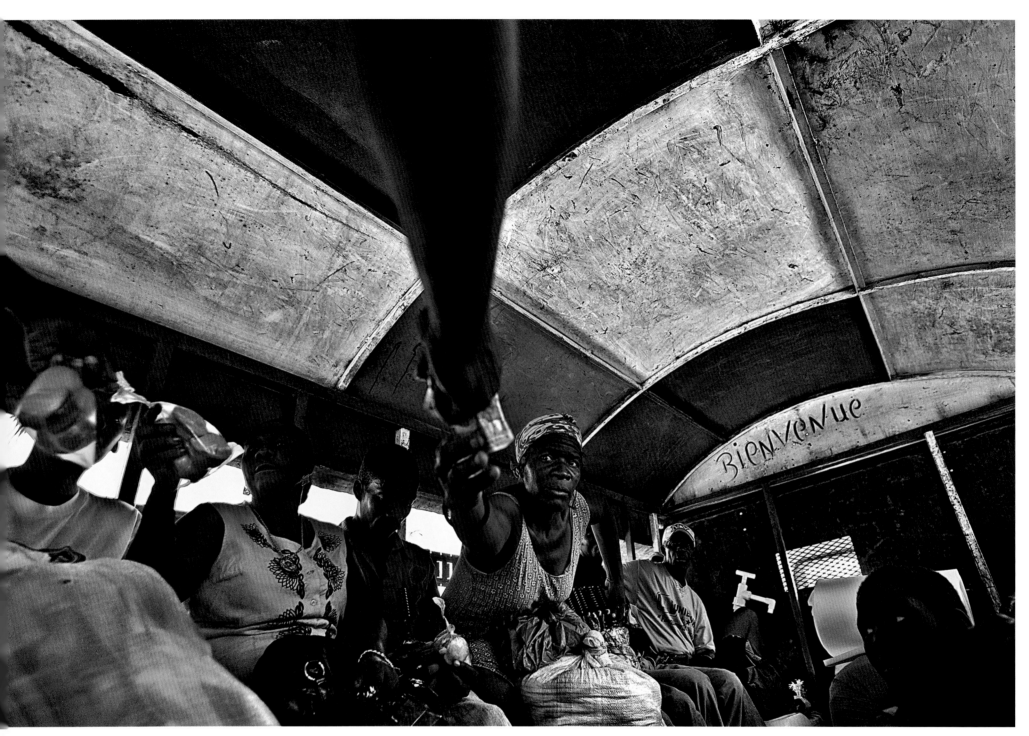

Port-au-Prince, Haiti. Jordi Cohen Colldeforns, Spain

WORLD IN MOTION

Jordi Cohen Colldeforns Spain
Winner

There's a great sense of interaction and participation
in this moment.

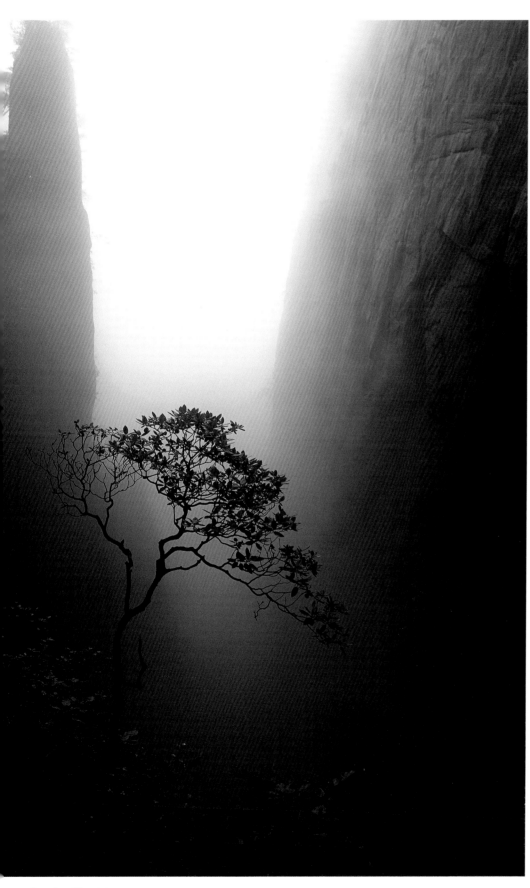

Huangshan, China. Chris Berragan, UK

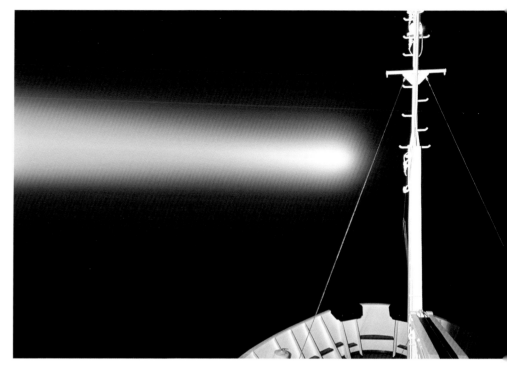

The ship *Professor Mochano*, **Southern Ocean.** Daisy Gilardini, Switzerland

WORLD IN MOTION

Daisy Gilardini Switzerland
Judges' Special Mention

A mysterious light in the darkness.

AMAZING PLACES

Chris Berragan UK
Judges' Special Mention

Tranquility and peace in the natural world.

BEST OF THE REST

As the first, pre-dawn glow of a new day creeps above the horizon, all around the world photographers will be among the first to greet those golden rays. There is something about photography which makes lack of sleep and the chill morning air seem so much more bearable. The search for that elusive and intriguing light drives us on, when sanity would tell us to close our eyes and snuggle back under the duvet.

I sometimes wish, when I'm out in some remote, breathtaking location, that I could share the experience and convey what drives us to such apparent madness. But then that's where the photographs come in!

The challenge is rewarding in its own right, but to capture not only the visual but also the sounds, the smells, the atmosphere, the sense of place, in a two-dimensional image is what makes photography so exhilarating for the photographer, and so engaging for the viewer.

Over the last few years, there's been an accelerating trend towards less predictable and more changeable weather in many regions of our planet. As an observer, it is not for me to pontificate on the reasons for this, but as a photographer change – and, with it, changing light – presents so many stimulating opportunities for interesting images.

The next journey beckons, but in these days of state-of-the art technology and increasingly heavy camera kit, I'm drawn towards simplifying the picture-making process and returning to basic cameras and prime lenses. Just me, my black box and a piece of pristine glass to drink in the ever-changing light. Yes...

Chris Coe, the ramblings of a travel photographer

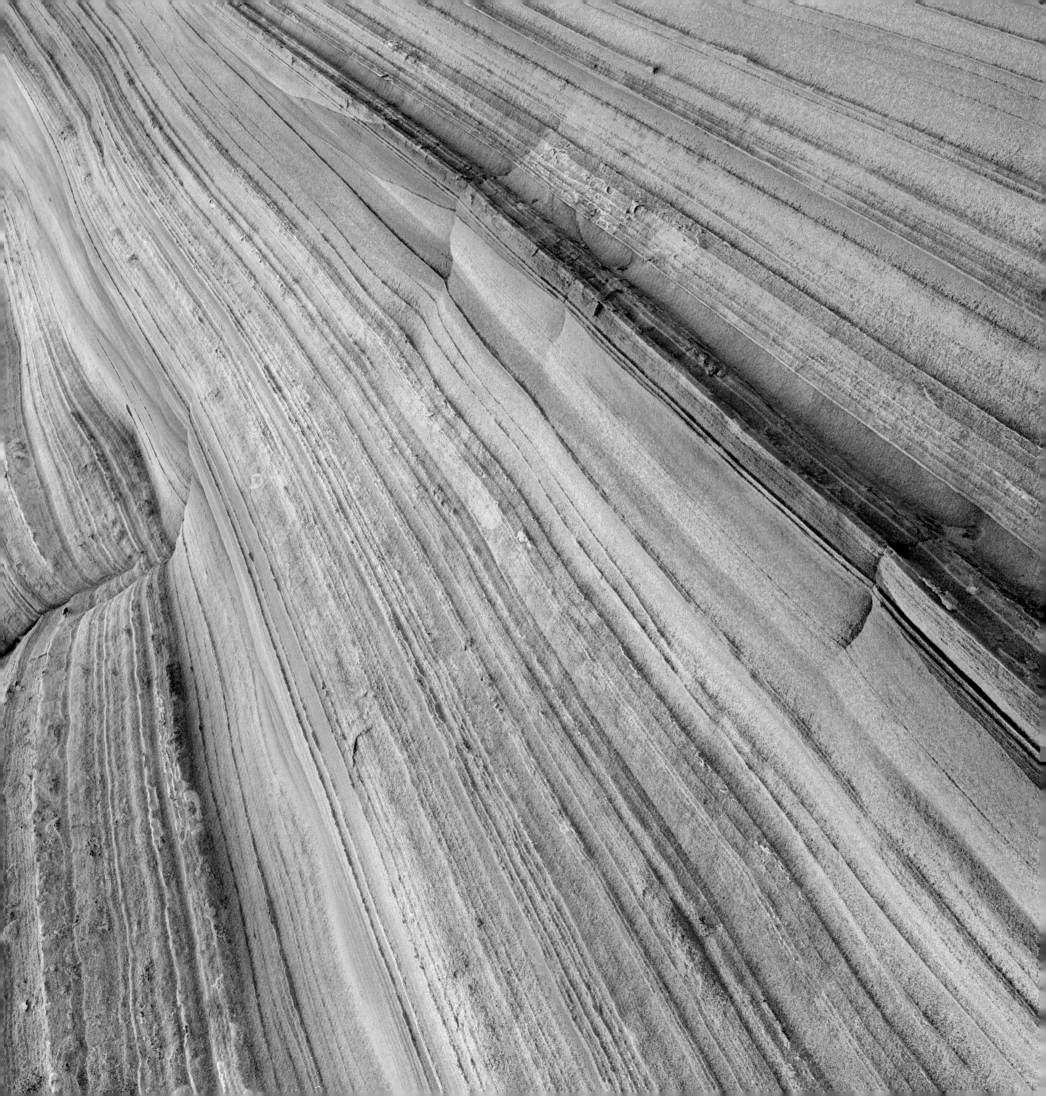

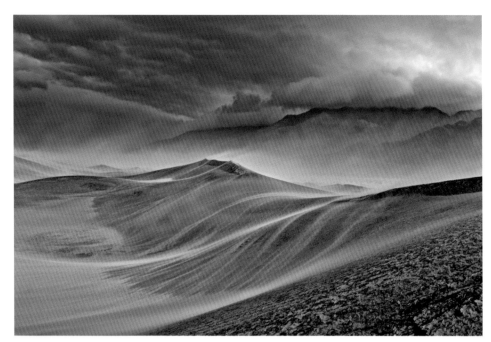

Death Valley National Park, California, USA. Louis Pattis, USA

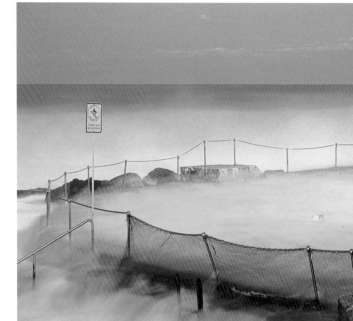

Bronte Ocean Pool, Sydney, Australia. Andrea Francolini, Australia.

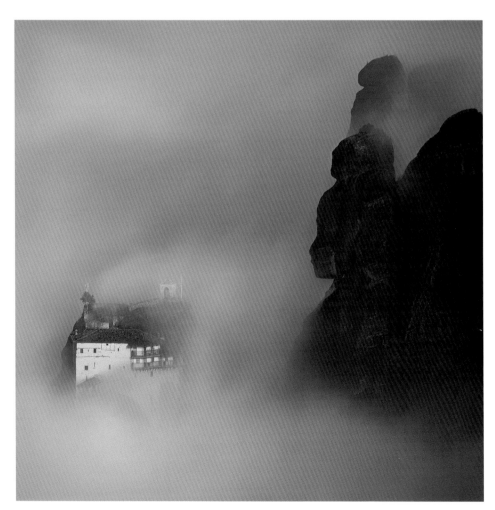

Meteora, Thessaly, Greece. Nikos Lotsos, Greece.

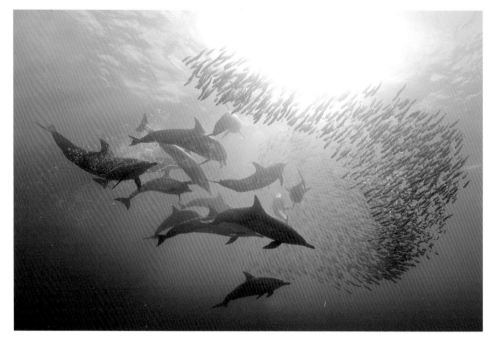

Coast of Port St. Johns, South Africa. Dmitry Miroshnikov, Russia.

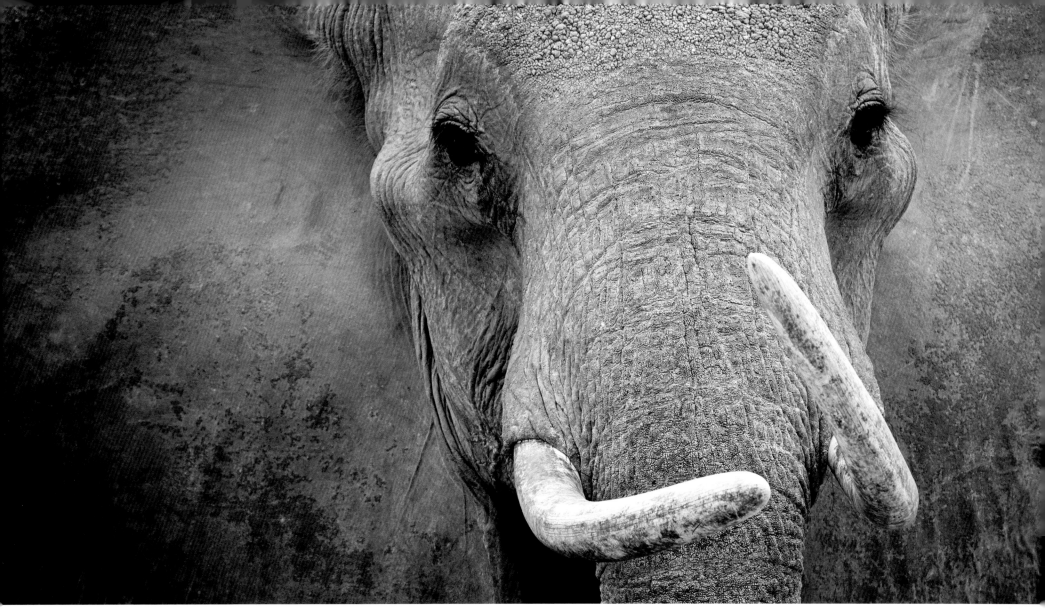

'Matriarch', Kenya. Ingrid Vekemans, Belgium

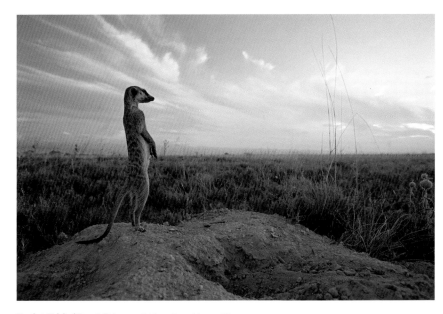

Meerkat, Kalahari Desert, Botswana. Matthew Barrard-Lucas, UK

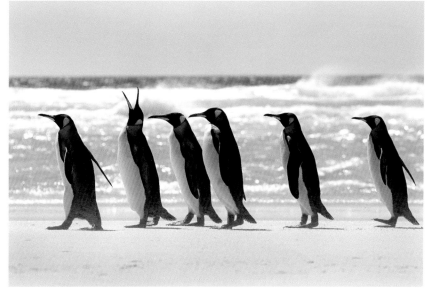

King Penguins, Volunteer Beach, Falkland Islands. Michael Helleman, UK

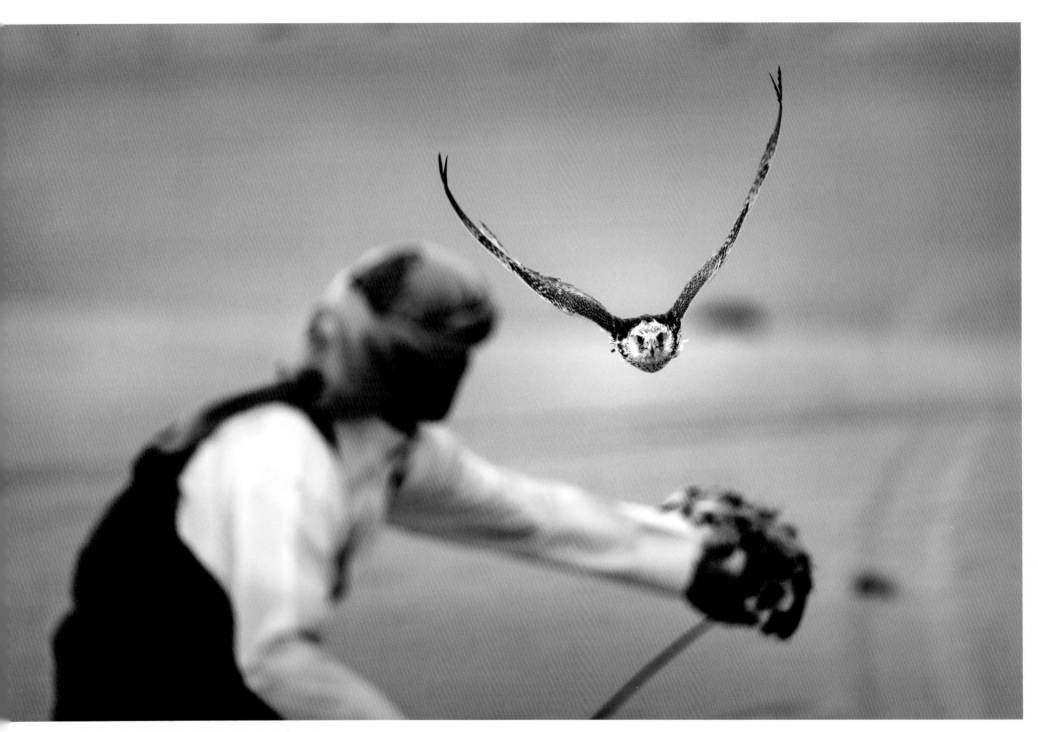

Peregrine falcon, Abu Dhabi, United Arab Emirates. Andrea Francolini, Australia.

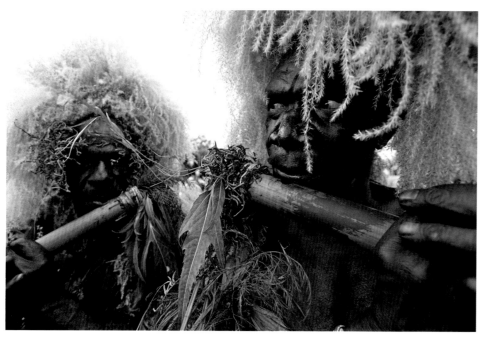

Garoka, Papua New Guinea. Jim Stephens, UK

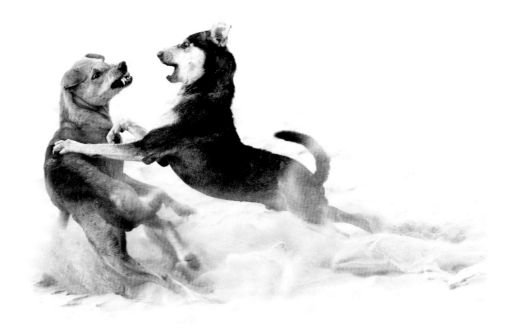

Mandva, India. Arne Strømme, Norway

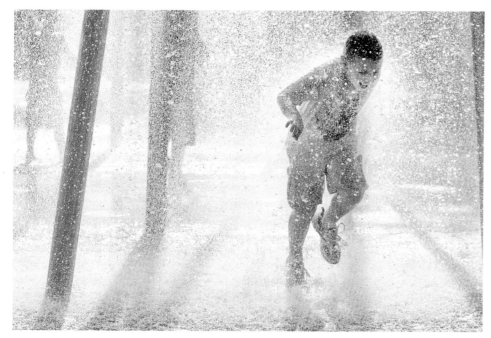

Sydney, Australia. Heidi Fok, Australia

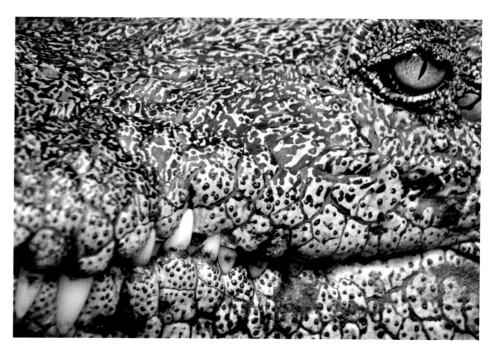

Saltwater crocodile, Sepilok, Borneo, Malaysia. Paul Houghoughi, UK

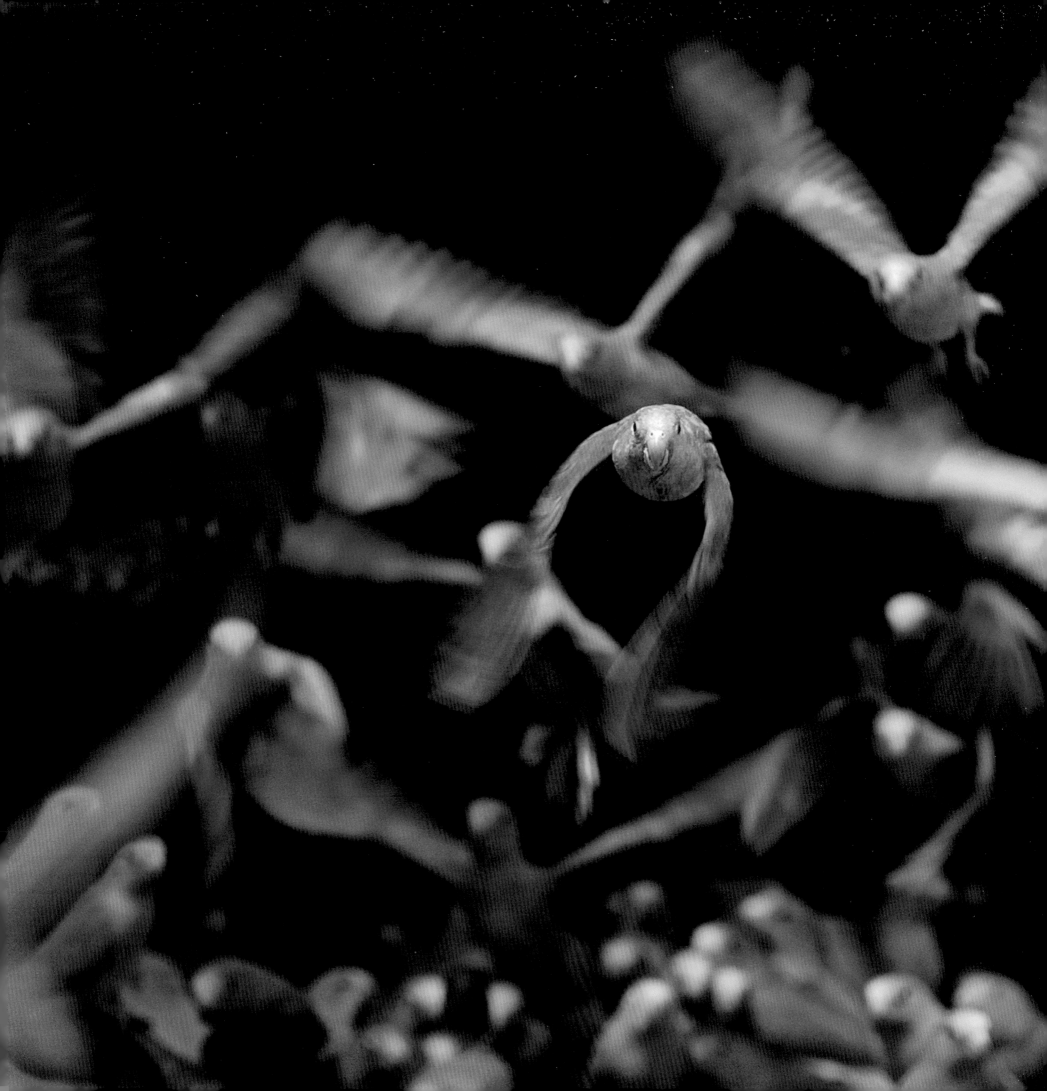

Cobalt-winged parakeets, Napo River, Yasuni National Park, Ecuador. Rebecca Yale, USA.

THE JUDGES

TPOTY judging panels are made up of experts from the worlds of photography and travel. The panel is selected to reflect a variety of backgrounds, styles and attitudes to photography and the photographic image. A key element of the panel is the wealth of visual and specialist expertise brought into the mix by our technical and creative judges.

Lay judges and past winners of these awards have also participated, bringing fresh ideas and perspectives to the judging process.

These judges give their time because they love photography, and we are immensely grateful for their efforts.

We would like to thank the following, who have featured on one or both of the 2010 and 2011 judging panels:

Andrew James – editor, Practical Photography

Brigitte Lardinois – curator, editor and lecturer in photography

Caroline Metcalfe – director of photography, Condé Nast Traveller

Chris Coe – photographer, author and lecturer

Colin Finlay – head of World Illustrated at photoshot.com

Debbie Ireland – picture editor and former
head of AA World Picture Library

Emma Thomson – former commissioning editor, Bradt Travel Guides

Erin Moroney – head of Axiom Photographic Agency

Jeremy Hoare – travel photographer, TV
cameraman, lighting expert, writer

Jerry Tavin – stock photography expert and founder
of Young Photographers' Alliance

Manfred Zollner – editor, fotoMAGAZIN

Marni Brownlees – art buyer

Mary Robert – head of photography, American International University

Matt Phillips – editor, Travel Africa magazine

Melissa De Witt – editor, HotShoe International magazine

Nick Meers – landscape and panoramic photographer, author and lecturer

Simon Bainbridge – editor, British Journal of Photography

Steve Bloom – travel and wildlife photographer

Terry Steeley – digital imaging expert

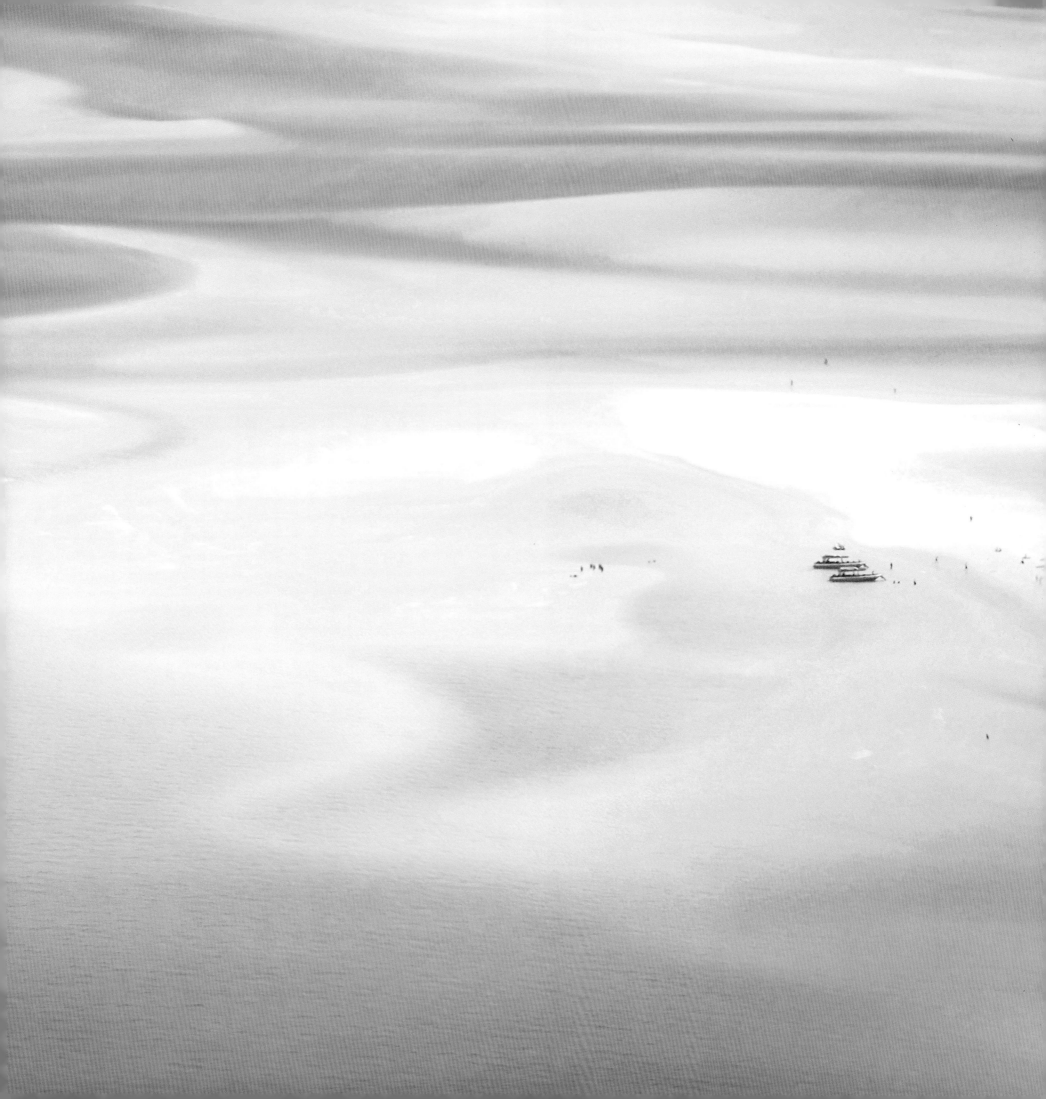

SPONSORS

Cutty Sark

Cutty Sark Blended Scotch Whisky was launched in 1923; its distinctive yellow label has graced the world's best bars and clubs for 90 years. In 2010 Cutty Sark was acquired by Edrington Distillers Ltd. The original smooth, mixable whisky, Cutty Sark was launched specifically for the sociable cocktail set and became an instant classic. Originally conceived as an export brand, Cutty Sark is available in over 40 markets around the world; it is particularly successful in the USA and southern Europe, especially Spain, Portugal and Greece.

www.cutty-sark.com

Explore

Explore has been offering small-group adventure holidays to the world's most exciting destinations for over 30 years. You can now enjoy over 400 trips in more than 130 countries, including adult discovery tours, family adventures, short breaks, wildlife, cycling and trekking trips. In 2012 we launched photography tours guided by leading travel photographers and operated in association with TPOTY. Explore has two sister brands: Explore Tailormade, which offers customised, tailor-made travel for all budgets; and Edge, off-beat, interactive and excellent value small-group trips for 18 to 39 year olds.

www.explore.co.uk

Tribes Travel

Since 1998 Tribes Travel has been offering seriously special tailor-made wildlife, nature and cultural holidays. We organise inspiring experiences such as spotting jaguars in Brazil or wild dogs in Botswana; hiking Peru's Inca Trail or Nepal's Himalayas; taking African safaris by jeep, boat, horse or on foot; and exploring the cities and cultures of India or Morocco. Travel is about the experiences we have and the incredible insights and memories we build for ourselves. Photography is key to this, so we're delighted to sponsor Travel Photographer of the Year.

www.tribes.co.uk

Tselana Travel

Tselana Travel organises high-end, tailor-made travel experiences away from crowded mass tourism routes – offering a different way to discover the diversity of preserved Africa, the enchanting Pacific and Indian Ocean islands, the sublime beauty of South America, the prominent cultural landmarks of Europe, or magical Asia. More than just a travel arranger, we provide advice on fine dining, gourmet stopovers, exhibitions and shows, and can arrange private jets and helicopters for a wide range of destinations.

www.tselana.com

Lexar

Lexar delivers high-quality, award-winning products in every memory category: USB flash drives and all popular forms of memory cards and card readers. We back our products with outstanding customer support and industry-leading warranties.

www.lexar.com

Photo Iconic

Photo Iconic offers a range of Travel Photographer of the Year photography courses, digital imaging courses, international photographic adventures and private tuition to suit all abilities and styles of photography – all tutored by award-winning photographers.

www.photoiconic.com.

Plastic Sandwich

Plastic Sandwich has been putting portfolios together for photographers and art directors since the early 1970s. It was founded and is still run by Joyce Pinto and Rob Jacobs. Between them they have unparalleled experience in the field of image presentation in its various forms and have been proud sponsors of TPOTY since 2003. Plastic Sandwich's services are also utilised by companies such as event and PR organisations, film companies, high-end presenters, and anyone whose activities or craft are best shown through the presentation of images. Plastic Sandwich is now a direct supplier to Jaguar Land Rover.

www.plasticsandwich.co.uk

Adobe

The Adobe® Photoshop® family of products is the ultimate playground for bringing out the best in your digital images, transforming them into anything you can imagine, and showcasing them in extraordinary ways. Manage, develop, print or export your images to the web using Photoshop Lightroom 4 and Adobe Photoshop CS6 for state-of-the-art imaging magic, exciting new creative options, and blazingly fast performance. Retouch with new Content-Aware features, and create superior designs as well as movies, using new and re-imagined tools and workflows.

www.adobe.com

Oman Air

Oman Air, the multi award-winning national airline of the Sultanate of Oman, flies from Muscat to a range of over 40 fabulous destinations across Europe, the Middle East, Asia and Africa. Superb service, delicious meals, plenty of leg room, the latest in-flight entertainment and the world's first in-flight mobile phone and Wi-Fi connectivity ensure that the time flies by, wherever you fly to.

www.omanair.com

Oman Ministry of Tourism

The Sultanate of Oman is a country with an enormous wealth of natural attractions, fascinating culture and warm, welcoming people. Its stunning landscape includes 3,165km of undisturbed coastline, majestic fjords, magnificent desert expanses, undiscovered rock formations, rugged mountains and an amazing quality of light. With a wide range of award-winning five-star hotels, first-class air, road and telecommunications networks, Oman is the perfect destination for leisure, business, conference, incentive travel and film/fashion shoots.

www.omantourism.gov.om

Hill Inlet, Whitsunday Islands, Queensland, Australia. Lisa Michele Burns, Australia.

Travel Photographer of the Year – Journey Four 159

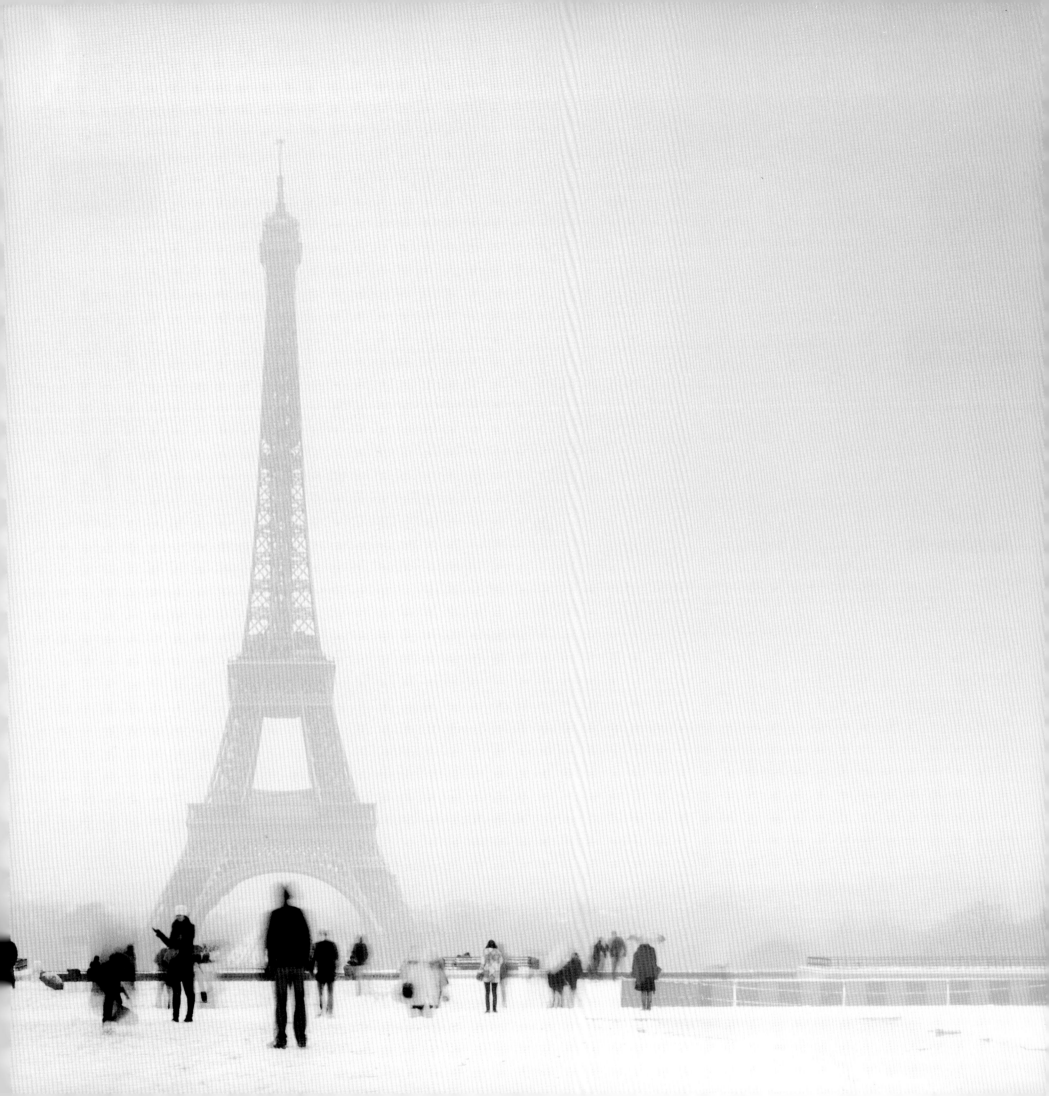

PARTNERS

Royal Geographical Society (with IBG)

The Society is the learned society and professional body for geography. Formed in 1830, our Royal Charter of 1859 is for 'the advancement of geographical science'. Today, we deliver this objective by developing, supporting and promoting geography through research, expeditions, fieldwork, education, and public engagement. In 2011 the Society embarked on a five-year partnership with Travel Photographer of the Year to host major annual exhibitions of the awards' travel photography.

www.rgs.org

Elephant Family

Elephant Family is the UK's biggest funder for the endangered Asian elephant. Working with local people and partner NGOs, we currently fund 12 projects across Asia and invest where we are needed most, in order to protect habitat, prevent conflict and reconnect the forest homes of the endangered Asian elephant.

www.elephantfamily.org

Radisson Blu Edwardian

Being a part of the world's fastest growing upscale hotel brand has its advantages, as does our bespoke approach as a privately owned company. Radisson Blu Edwardian, London gives you the best of both worlds. Blu is the sign of a cool, calm and collected hotel experience the world over. Add to that a distinctive, highly individual London brand and the experience just gets better! Locations: Central London - Heathrow - Canary Wharf - Central Manchester - Guildford

www.radissonblu-edwardian.com

Young Photographers' Alliance

The Young Photographers' Alliance (YPA) was created to help young photographers to bridge the gap between their passion for photography and professional success. Founded in New York in 2009, YPA is led by industry professionals, YPA nurtures young talent, helping develop both the photographic skills and business acumen needed to build a sustainable and successful career.

www.ypauk.org

CREATIVE AND EXHIBITION SPONSORS

Connekt Colour

Connekt Colour has 20 years of colour and colour reproduction experience. Our impressive portfolio of longstanding clients is testimony to our consistent levels of quality and service. In 2009 we were awarded Best Digital Book of The Year at the British Book Design and Production awards and in 2010 our digital partner, Litho Division, won Best Photographic Art/Architecture Monograph Book. Connekt Colour prints the Travel Photographer of the Year 'Journey' portfolio books.

www.connektcolour.com

Fujifilm

Fujifilm is a global leader in imaging technology, products and services including digital cameras, photofinishing, digital storage and recording media, consumer and professional film, motion picture film, professional video, printing systems, medical imaging, office technology, flat panel displays and graphic arts. Fujifilm develops and manufactures its own sensors, lenses and processing technology. In the UK, Fujifilm has been supplying consumers, professional and enthusiast photographers, with high quality, innovative products and services for over 25 years and has become one of the country's most popular photographic and imaging brands.

www.fujifilm.eu/uk

Genesis Imaging

One of the UK's leading photographic image printers, Genesis Imaging offers photographic printing, mounting and framing services for the creative industry. We believe photographic printing is an art. We print images of the highest calibre for some of the best-known professional photographers, artists and art galleries around — people who demand the very best quality available. Our superb Giclée fine art and Lambda prints have graced the walls of numerous famous galleries, from London's National Portrait Gallery to New York's Museum of Modern Art.

www.genesisimaging.co.uk

Iridius

Iridius offers a wide range of design and training services to a growing list of clients, including Adobe, Hewlett Packard, Royal Doulton, Porsche, Audi, Transco, and Harper Collins. Iridius designs the Travel Photographer of the Year 'Journey' portfolio books and the Travel Photographer of the Year website.

www.iridius.co.uk

Travel Photographer of the Year would like to thank all of the above sponsors, whose generosity, support and enthusiasm have been vital for the success of the awards. Without them the competition would not be possible. We would also like to thank Intrepid Travel, Lee Filters and Wacom for their much-valued support in previous years.

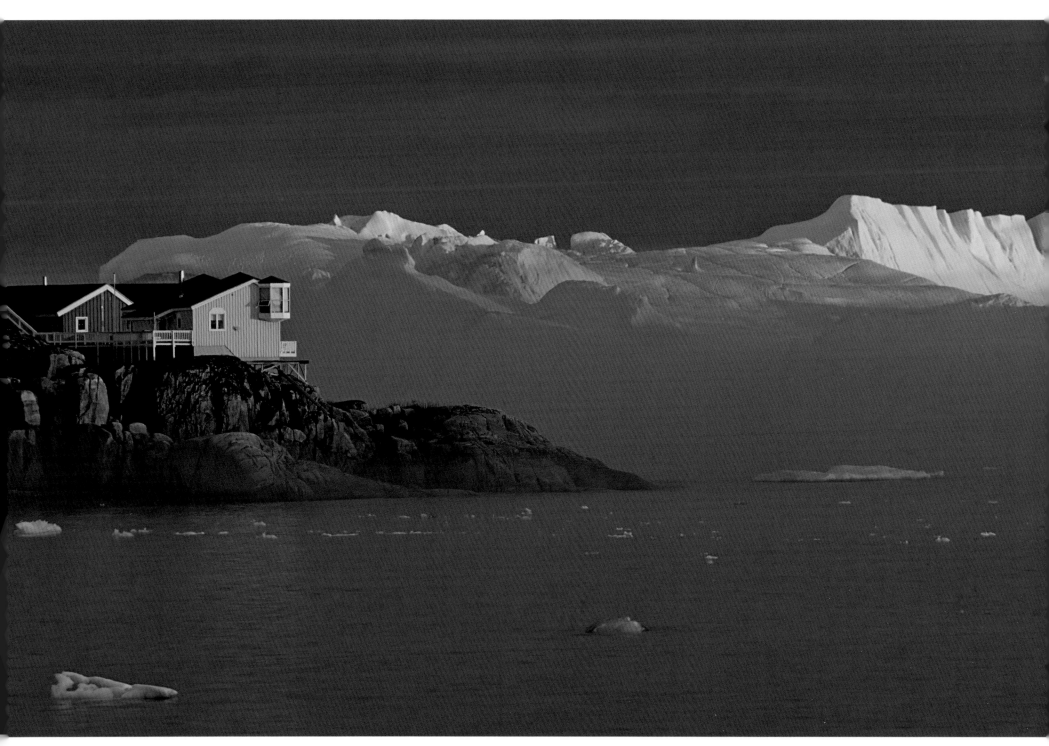

Ilulissat, Greenland. Lukasz Kuczkowski, Poland

INDEX OF PHOTOGRAPHERS

We would like to thank the photographers whose images appear in this book. Their support, along with that of all the other photographers from across the world who enter the awards, make the Travel Photographer of the Year awards and this book possible.

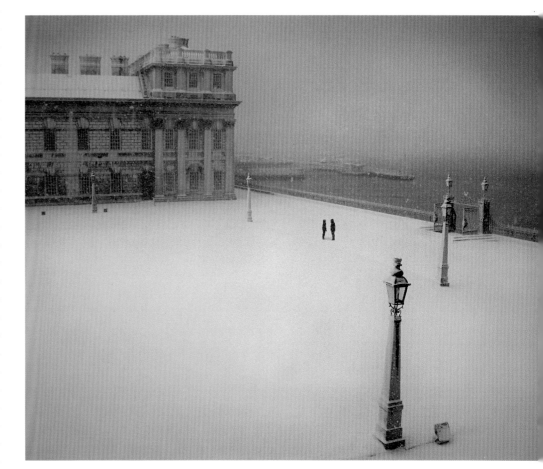

Greenwich Naval College, London, UK. Gordon Esler, UK

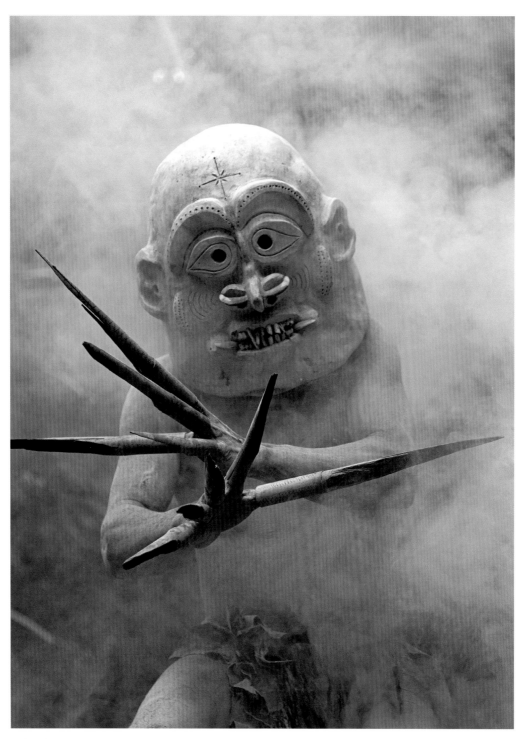

Pogla mudman, Mount Hagen, Papua New Guinea. Chris McLennan, New Zealand